U0021712

攝　不異空

朱泓熹　行攝 30 精選集

A Collection of Photography by **Hung-hsi, Chu**
30 years of Travel Images

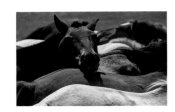
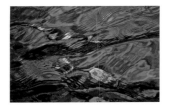

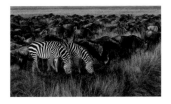
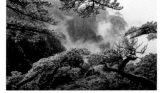

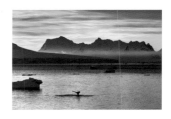
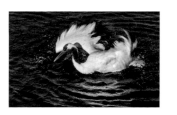

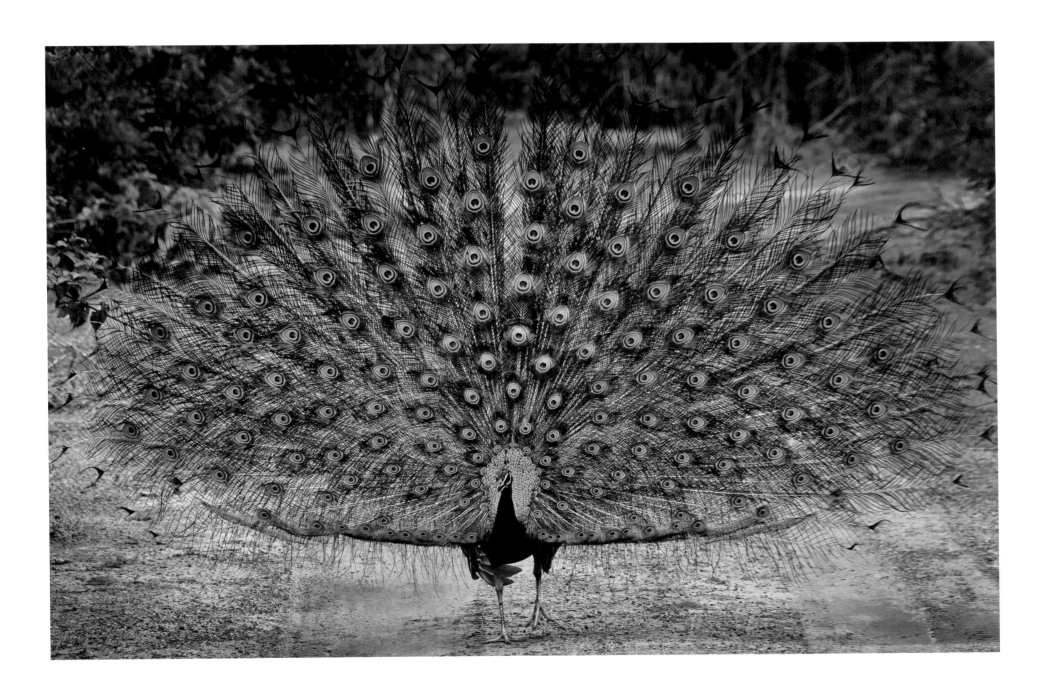

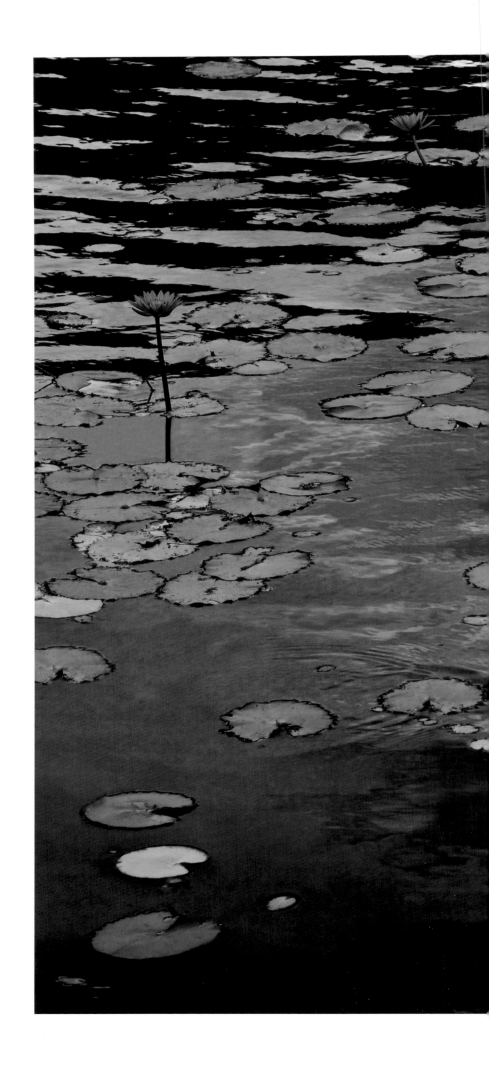

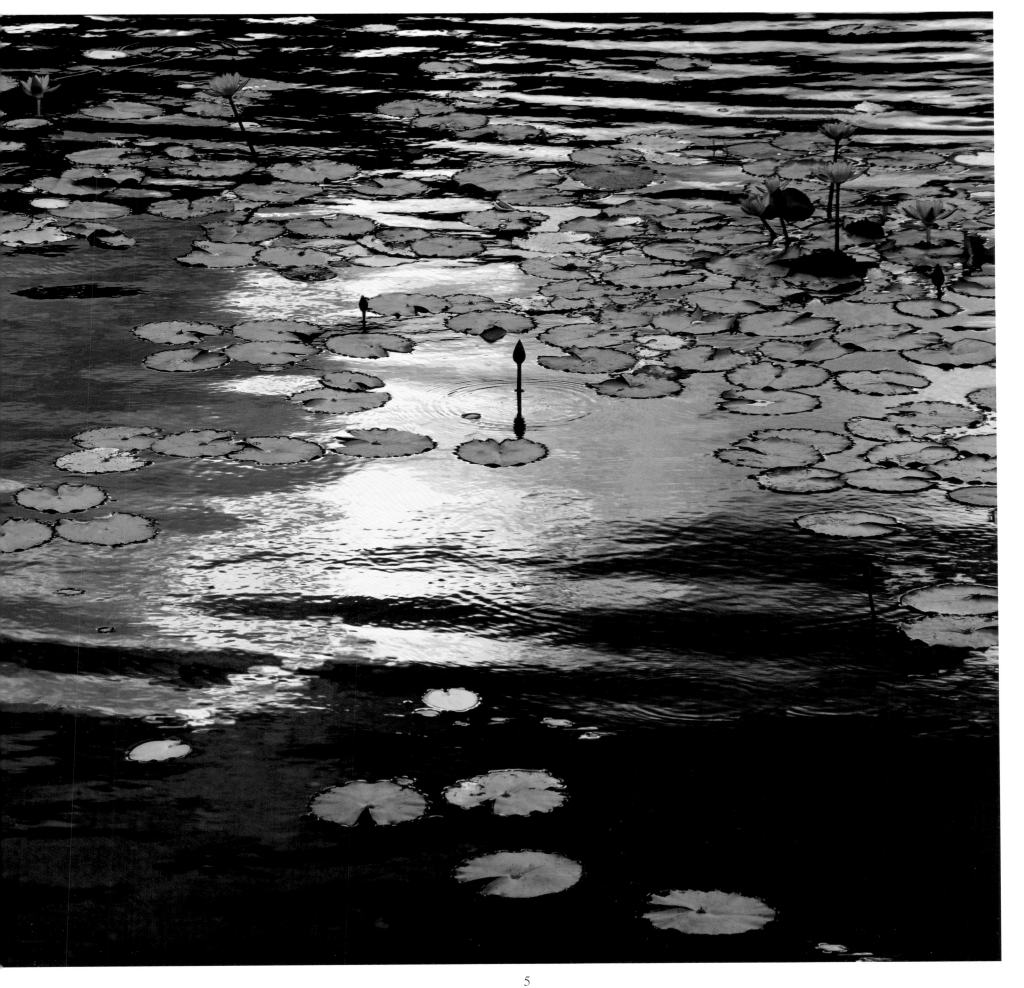

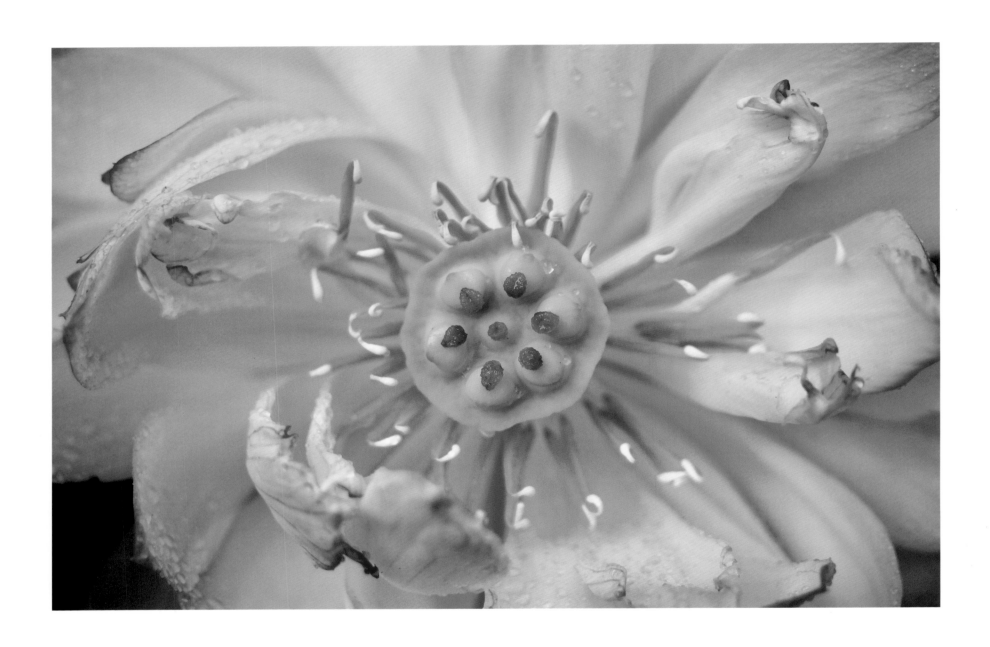

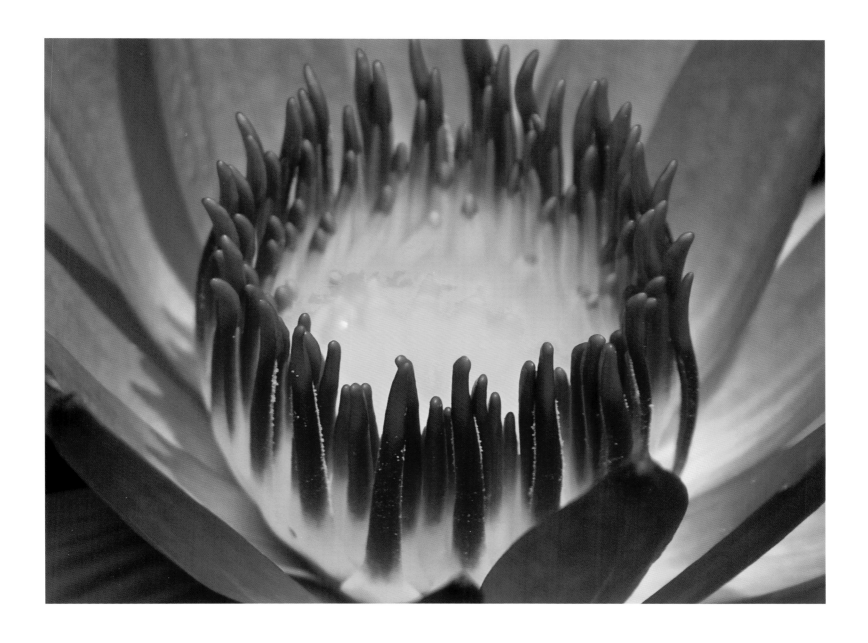

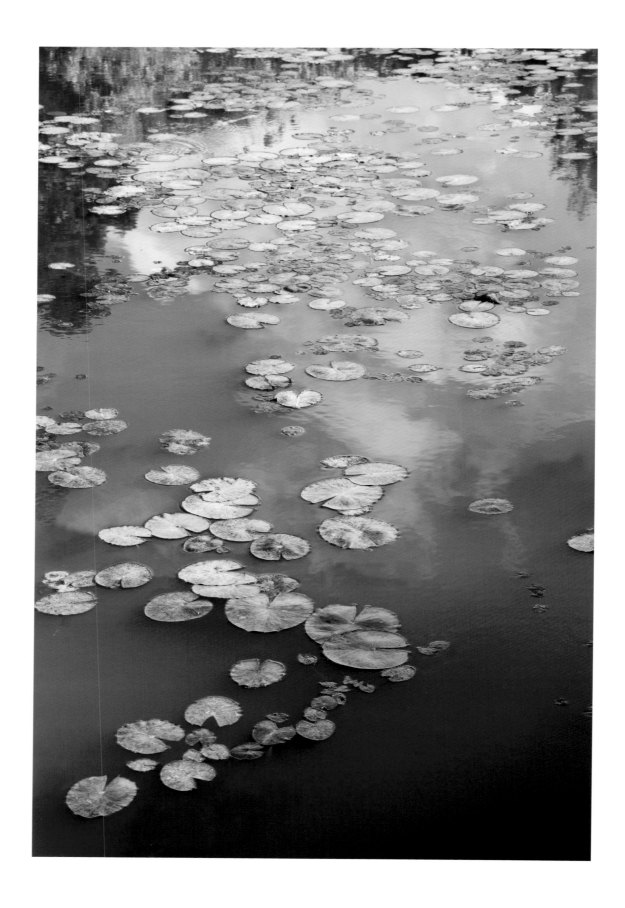

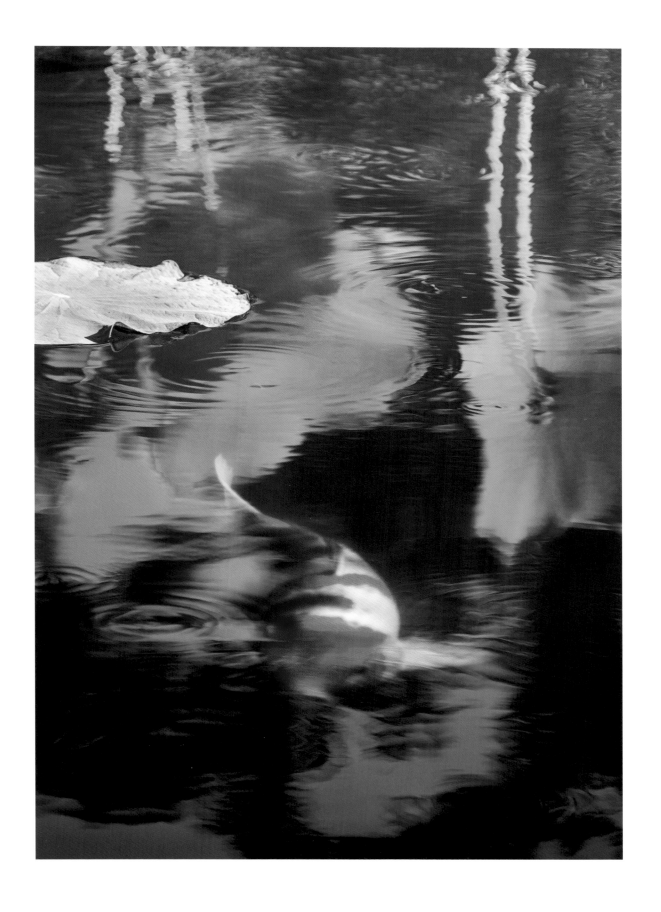

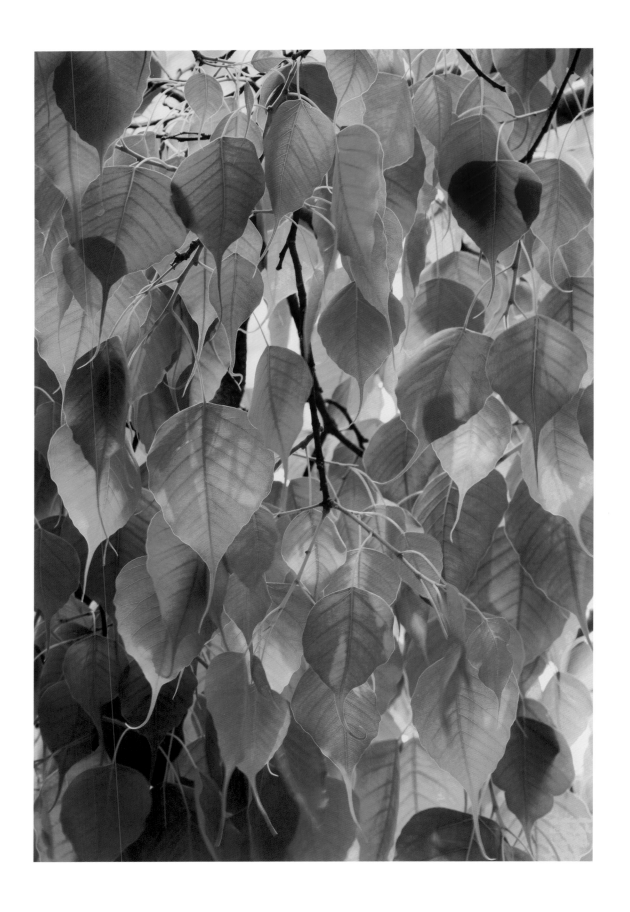

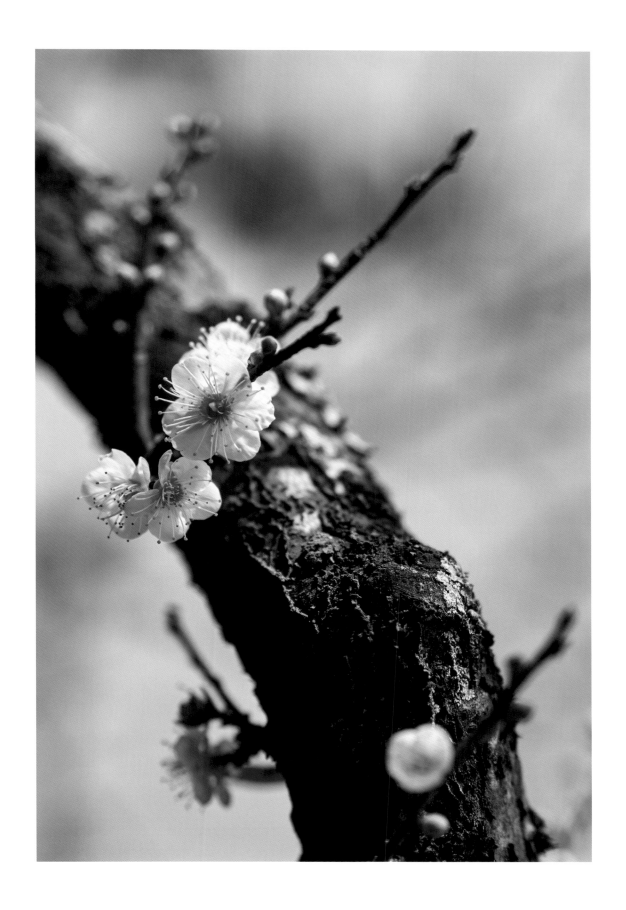

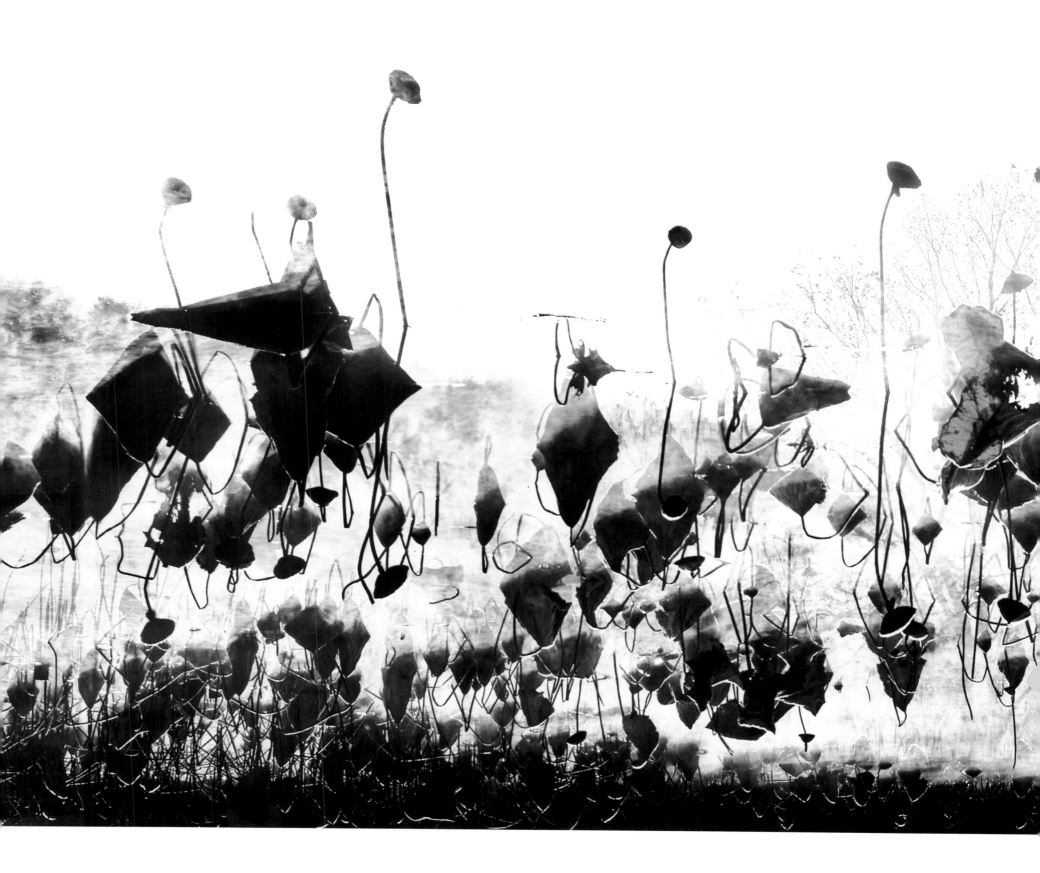

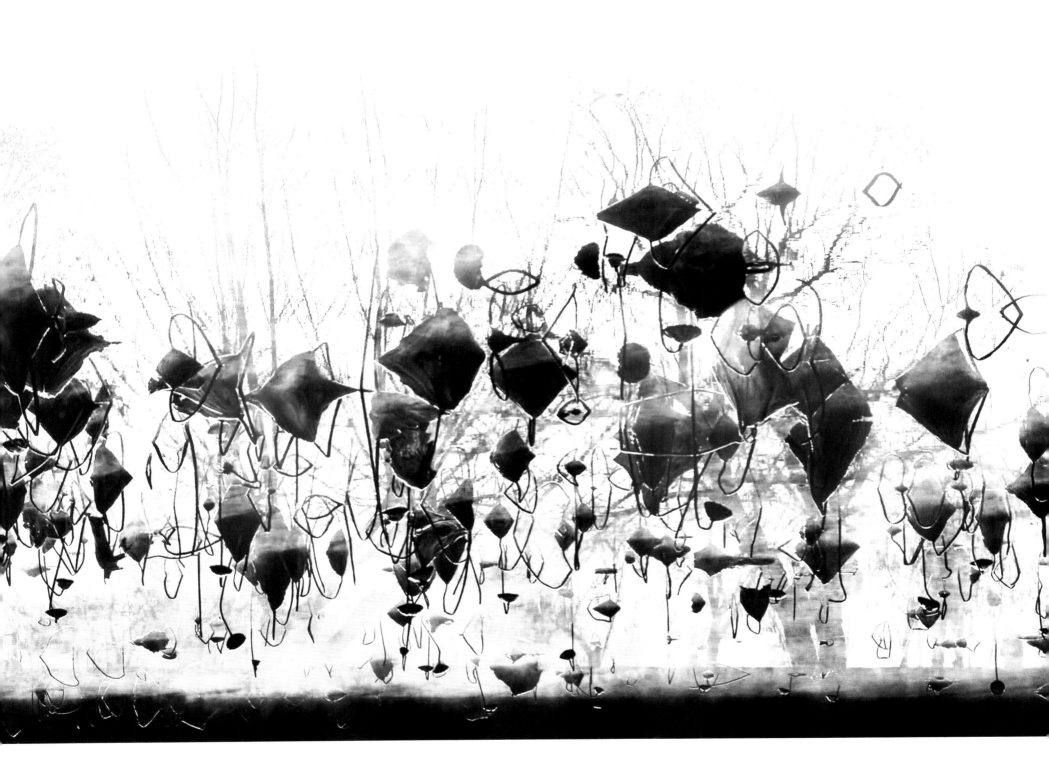

I'm proud to be recognized as one of your early mentors and have enjoyed watching your skills and career blossom over the years. Congratulations for your successes so far and I will be looking forward to following your next chapter. Savour the journey!

能夠作為妳早期的指導老師之一，我深感榮幸；多年來一直樂見妳在技術與事業上的蓬勃發展。恭賀妳迄今獲得的成就，我期待且將繼續關注妳進入攝影藝術的新一篇章。好好享受這美好的旅程！

美國國家地理雜誌專業攝影師　麥可・山下

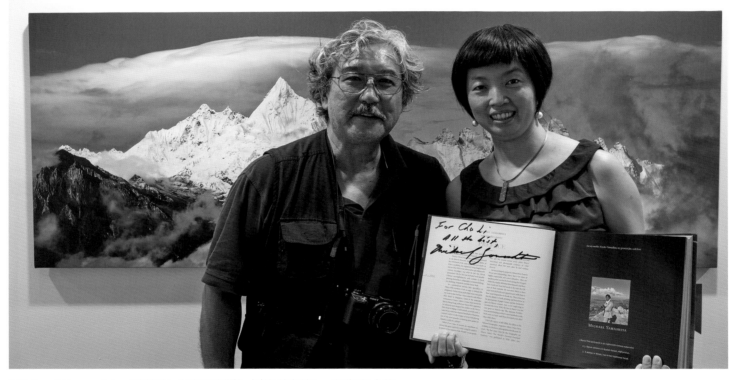

Michael Yamashita 贈著作《馬可波羅》攝影集祝賀,與作者合影。
/ 2015 台北藝術攝影博覽會

Picture of Mr. Michael Yamashita giving his photography book, "Marco Polo", to the author as a congratulation gift.
/ Taipei Art Photo Show 2015

自 序

「美」！原本是無需語言的。正如佛家的「悟」！是言語道斷。禪宗的「不立文字」，「以心印心」。

如何透過鏡頭來看世界之大美？美國國家地理攝影大師麥可山下老師教我「把一個主題，拍出前所未見的新意。」這確實是一大挑戰！

時光飛逝，2023 年即將邁入人生行攝的 30 年。該坐下來理一理，回首雪泥鴻爪的歷程中，是否留下過感動？

此書收錄的作品地點，迄今為止，主要是斯里蘭卡國家公園多次的巡遊。 南極與北極、東非肯亞各去了兩趟。黃山四趟，丹頂鶴遷徙，含括亞洲三個國家，日本、韓國、中國 ，一共執行五趟的拍攝以及蒙古國的馬。豐富的行程，曾讓我的生活變得馬不停蹄。連睡覺作夢，居然還會夢見出門竟忘了帶望遠鏡頭，而從夢中驚醒！話說「平常心」容易，壓力卻難放下。因而攝影過程中，修行「觀照自我」也是很好的練習方式之一。

三十年行攝歷程，要感謝的人太多。首先是我的皈依恩師 聖嚴法師，師父慈悲，讓我拿著相機充當攝影師，跟前跟後拍攝了 16 年的光陰。擔任攝影義工多年。日漸積累了福報，讓我日後全心邁向專業攝影創作時，總有意外的好運氣。而啟發我對攝影的熱情，是我的兩位攝影老師——Michael Yamashita、Frans Lating 老師的攝影家精神，啟發觸動了我。也是在老師的肯定與鼓勵，讓我有了信心，訂定目標去努力不懈。

一路上，協助的貴人很多，心中默默感恩。每當，看到您們的辦公室或家裡，牆壁上掛著我的作品，書櫃裡珍藏著我的書本，或是擺放在書桌上的文創小品，都深受著感動！我想說，這裡面有我的感恩與祝福！

藉由生態攝影，尊重生命平等。影像也扮演重要的角色，讓更多人們重視生態環境保護，愛地球，彼此和諧共存。攝影藝術無國界，可超越文化、種族，廣結善緣。也正是我樂此不疲的初衷。

泓熹

Preface

Beauty, like the Buddhist term "Bodhi", is beyond words. It is also the ultimate truth, according to Ch'an Buddhism, "wordless" in the sense of "employing your heart rather than speech".

How do we see beautiful wonders of the world through the lens? The master photographer of National Geographic, Mr. Michael Yamashita, once told me, "shoot a subject with new ideas that no one has seen before." This was indeed a big challenge for me.

Time flies. In 2023, my career as a travel photographer will have spanned thirty years. It is time to recollect the path I walked to see if I left behind any sparks of passion.

The locations where I took the photographs included in this book were mainly the National Parks of Sri Lanka. I have also included photos from two trips to each of the following locations: the Antarctic, the North Pole, and Kenya in the East Africa. Four trips to shoot Mount Huangshan, five trips to follow the migration of red-crowned cranes from among Asian countries, Japan, South Korea, and China, and a trip to photograph horses in Mongolia. Because of the jam-packed itinerary, I have been travelling almost nonstop throughout my career. Once I even dreamt I forgot to bring a telephoto lens along on a trip and woke up with a start! This reminds me to keep calm and take things easy in spite of the pressure of a heavy workload. It is also a good method to practice "intelligent contemplation" while taking photographs.

I have so many people to thank for my thirty years of travel photography. First of all, I would like to show my gratitude to my mentor, Master Sheng-Yan. He has always been kind and merciful, allowing me to act like a photographer with my shooting gear. I have been working with him as a photography volunteer for sixteen years. Working with him has been a blessing. Later, when I fully devoted myself to professional photography, I have been fortunate to always have good luck. It was my two photography teachers, Mr. Michael Yamashita and Mr. Frans Lating, who inspired my passion for photography. Their spirit as photographers became my aspiration. Their affirmation and encouragement gave me the confidence to set goals and work tirelessly.

Along the way, I received help from many people, and my heart is full of gratitude. I feel deeply touched whenever I see my works hanging on the walls in their offices or homes, or see that my books are prominently placed in their bookcases, or when the design products of my works are placed on their desks. My gratitude and blessings are in it all!

Through wildlife photography I pay respect to the equality of life. Images play an important role. They can turn people's attention towards environmental protection and inspire them to love and live harmoniously with each other on earth. The art of photography has no borders. It transcends cultures and races, and form strong ties. These are the reasons why I chose photography as my career path, and my passion for it has never ceased.

Hung hsi (CHU Li)

佛 陀 聖 地

Buddha's Holy Sites

朝禮佛菩薩聖地，一步一腳印，一步一蓮花，是我的最愛。不為拍攝，而是祈求身心的加持，能更接近佛陀的慈悲與智慧。

放下身心，遠離塵囂，雲霧四周環繞，變化多端，任由想像。

2002 緬甸

2007 / 2009 尼泊爾

2012 泰國 / 印度 / 斯里蘭卡

2013 中國

The tour to pay homage to the holy sites of Buddhas and Bodhisattvas took place in stages over a long period of time, and each stage was an enlightening experience. Of all my tours, I treasure it the most. It was not for the sake of photography, but a prayer for the blessings of body and mind, so as to be closer to the compassion and wisdom of Buddha.

There I let go of my body and mind, stayed away from the hustle and bustle, surrounded with changeable clouds and mist, and let my imagination roam free.

Myanmar in 2002, Nepal in 2007 and 2009, Thailand, India, and Sri Lanka in 2012, and China in 2013

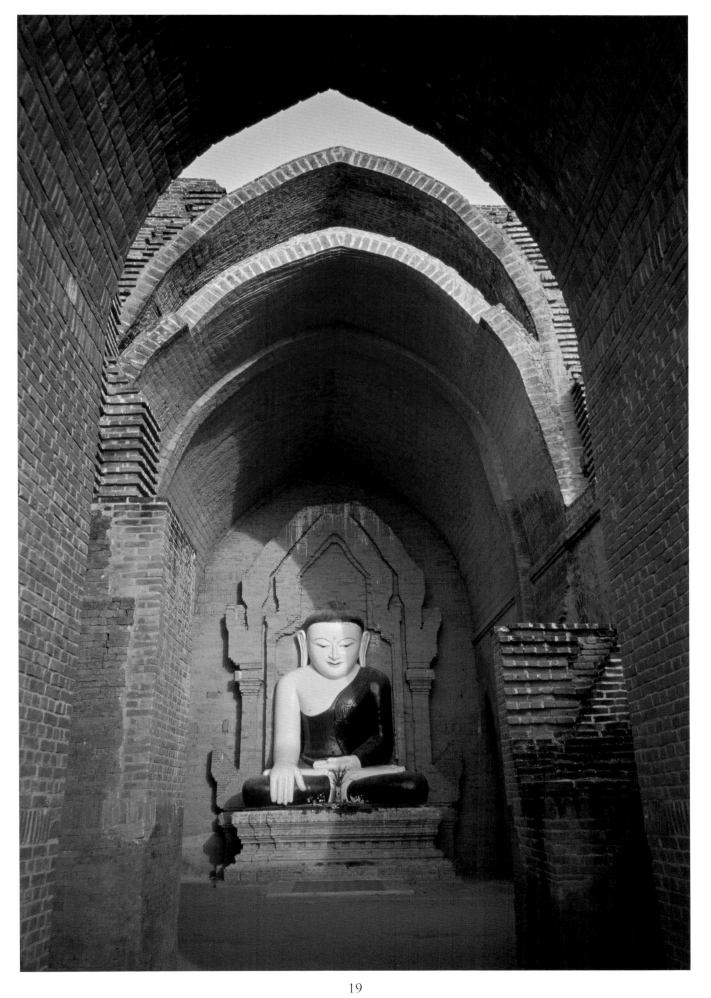

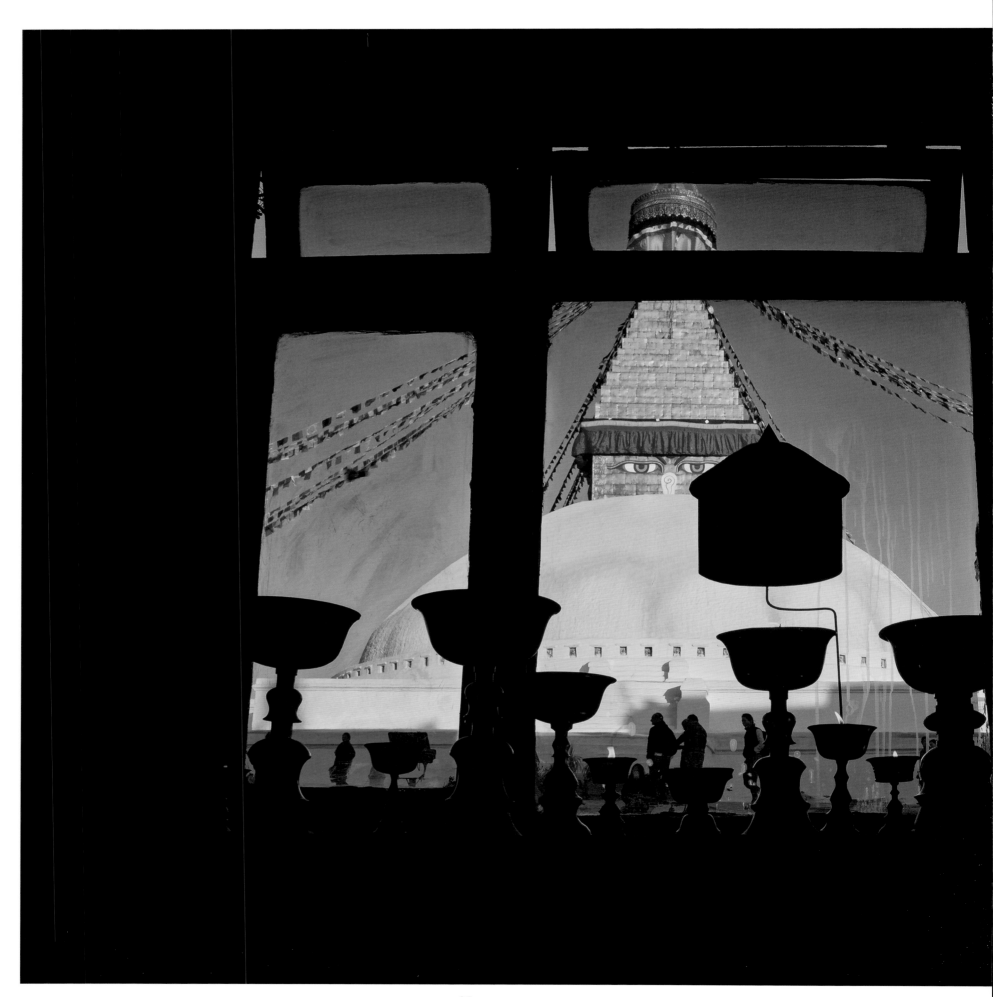

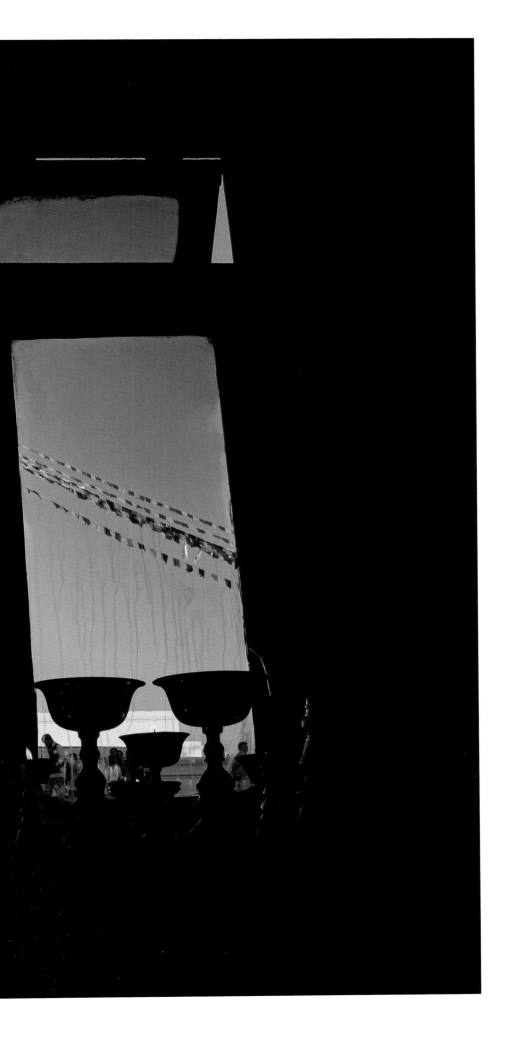

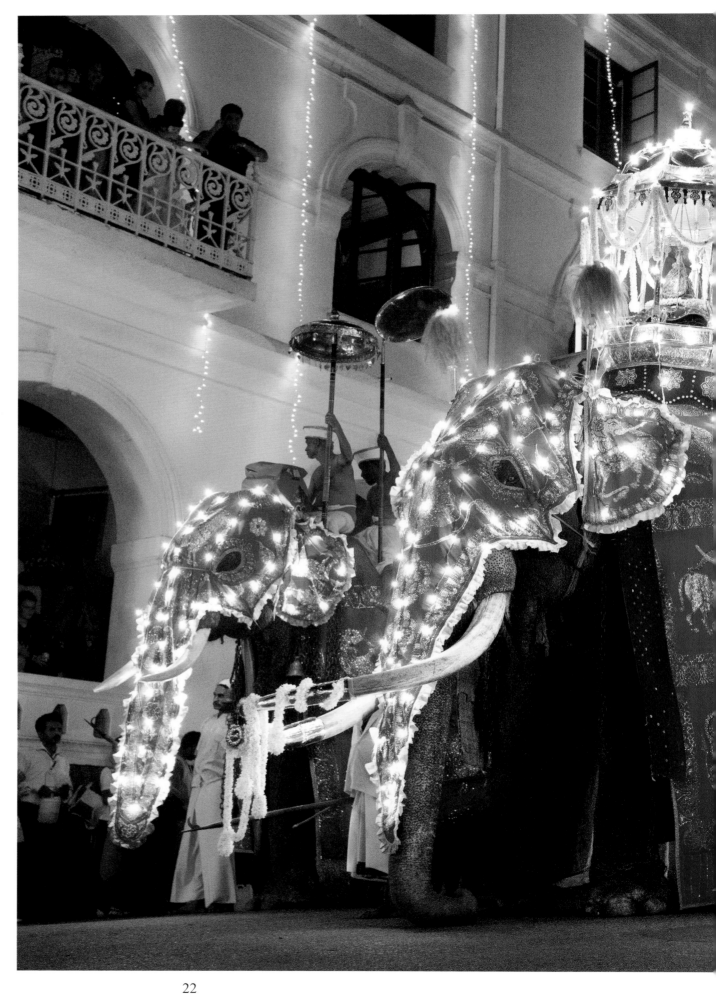

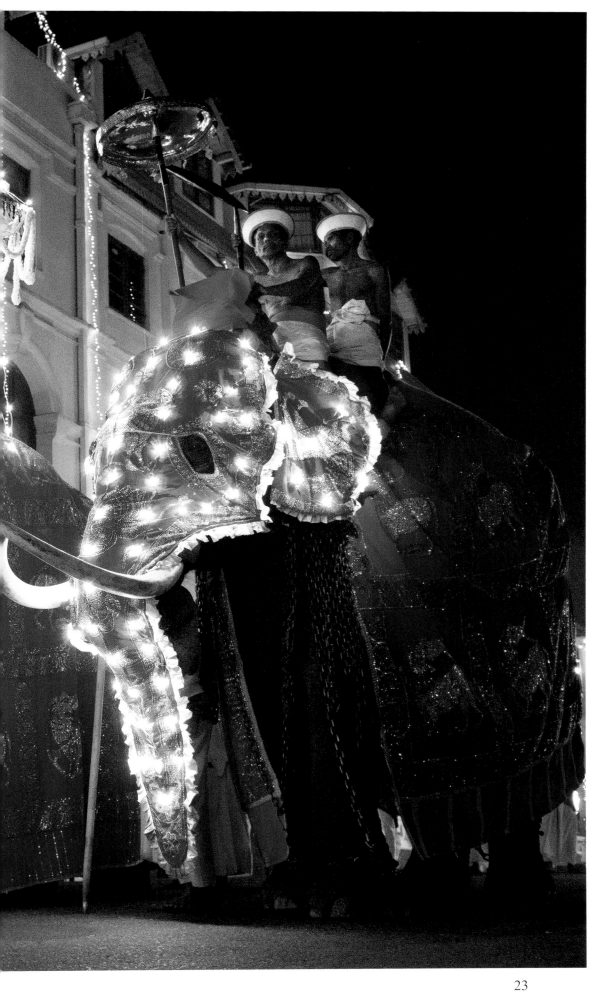

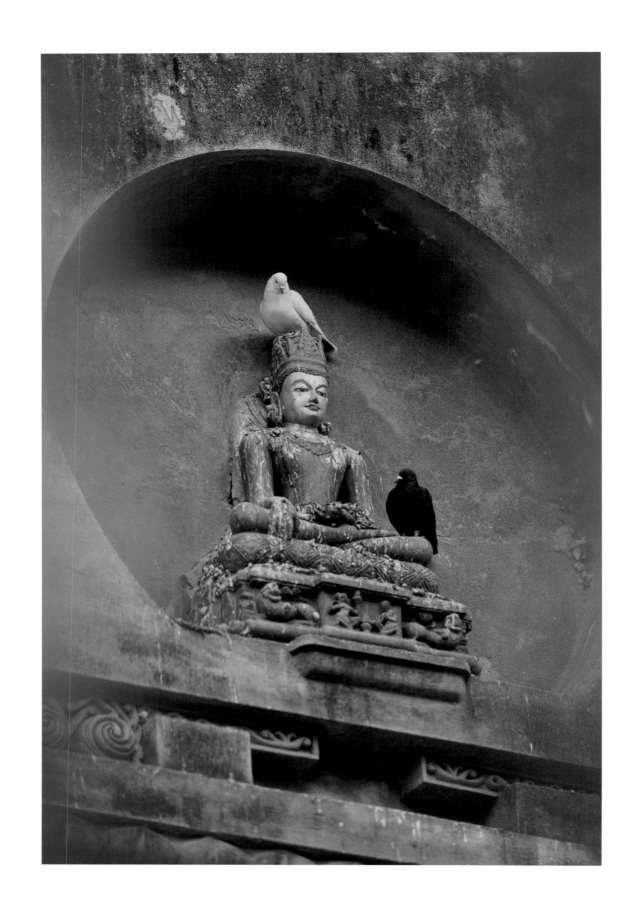

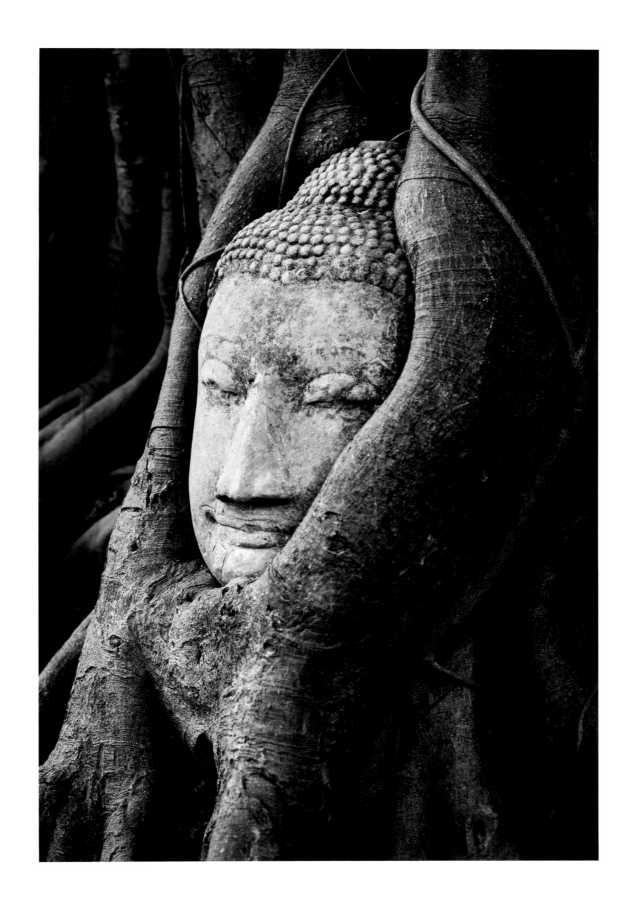

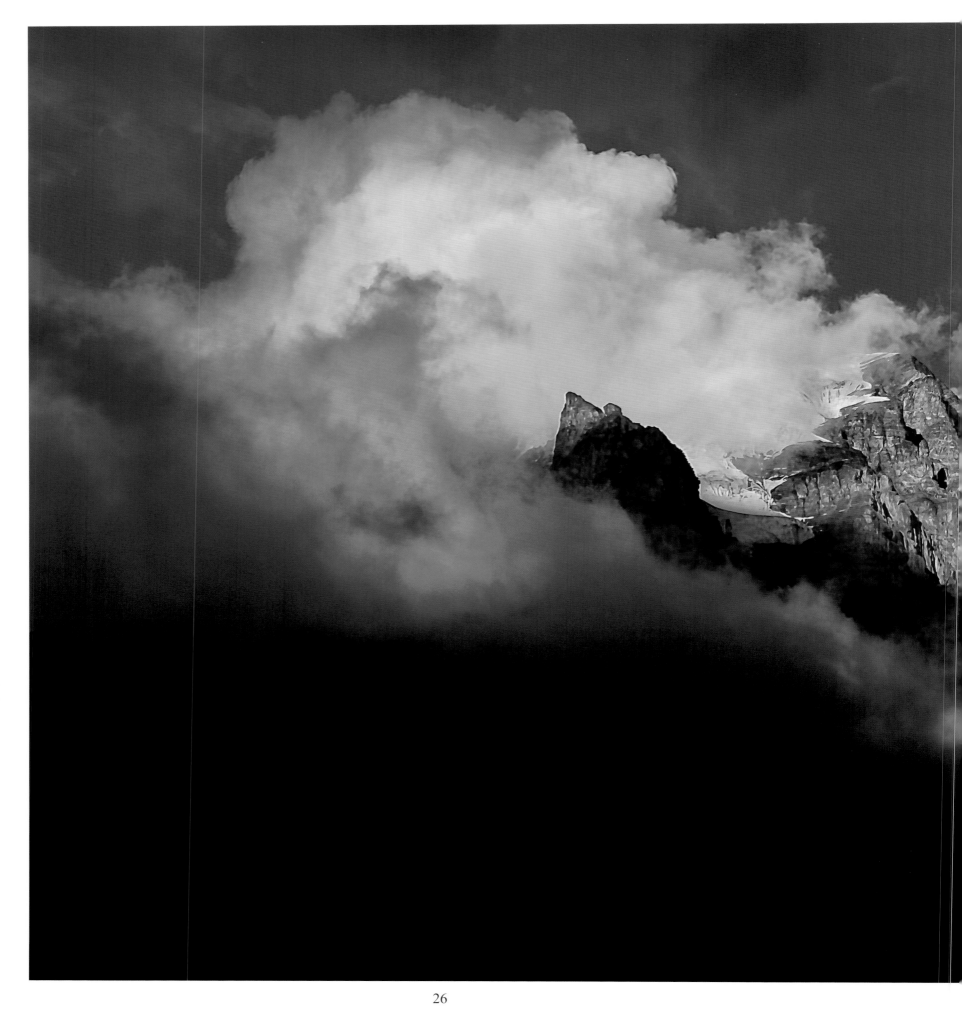

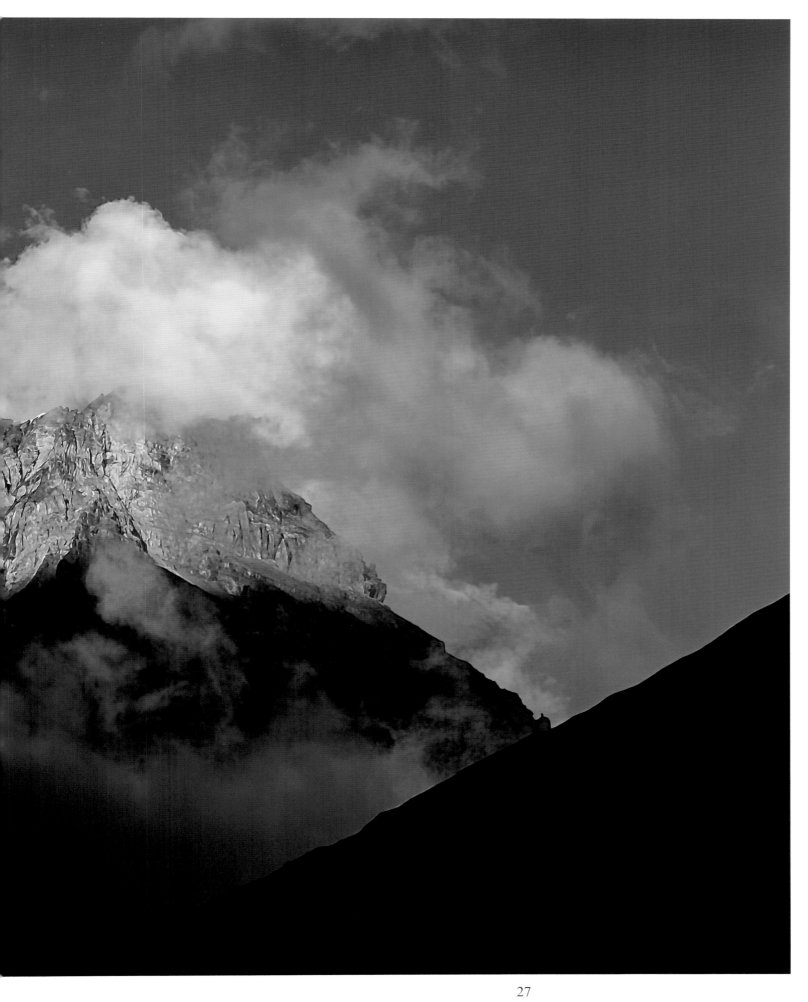

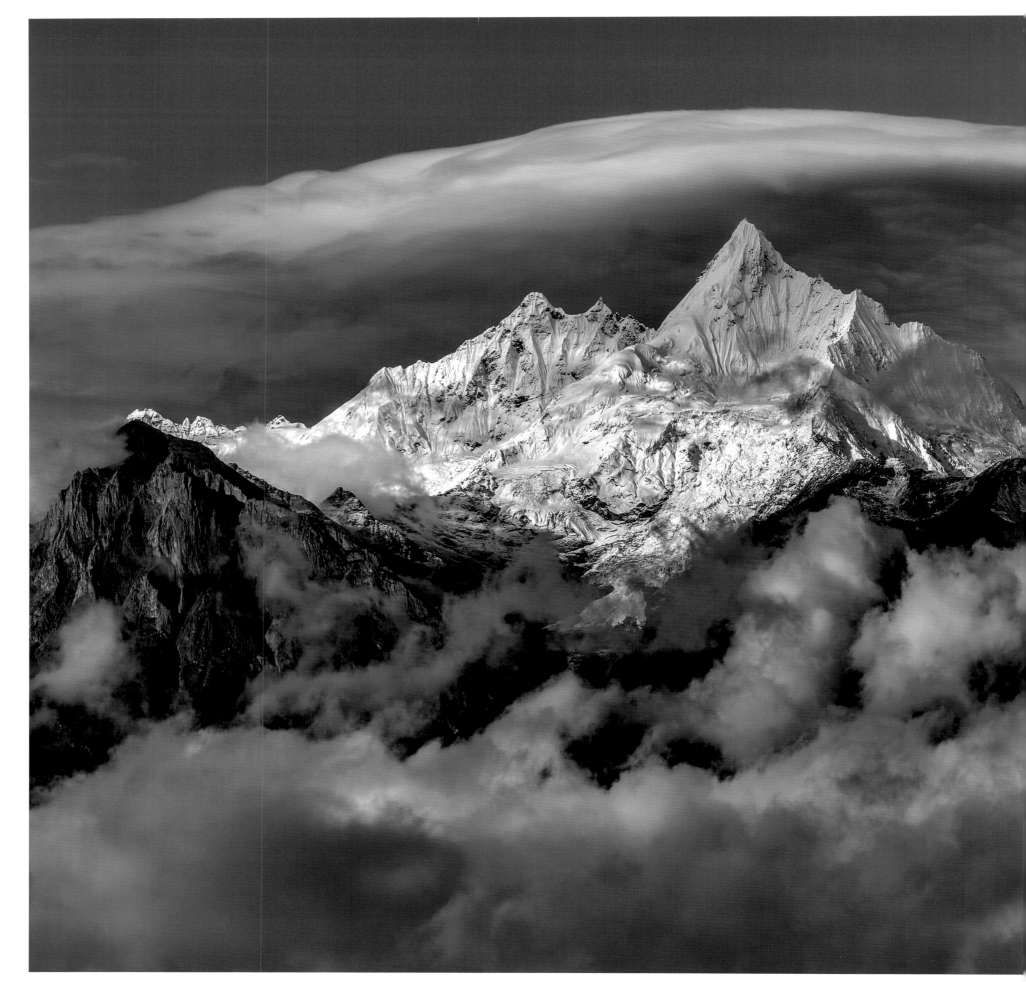

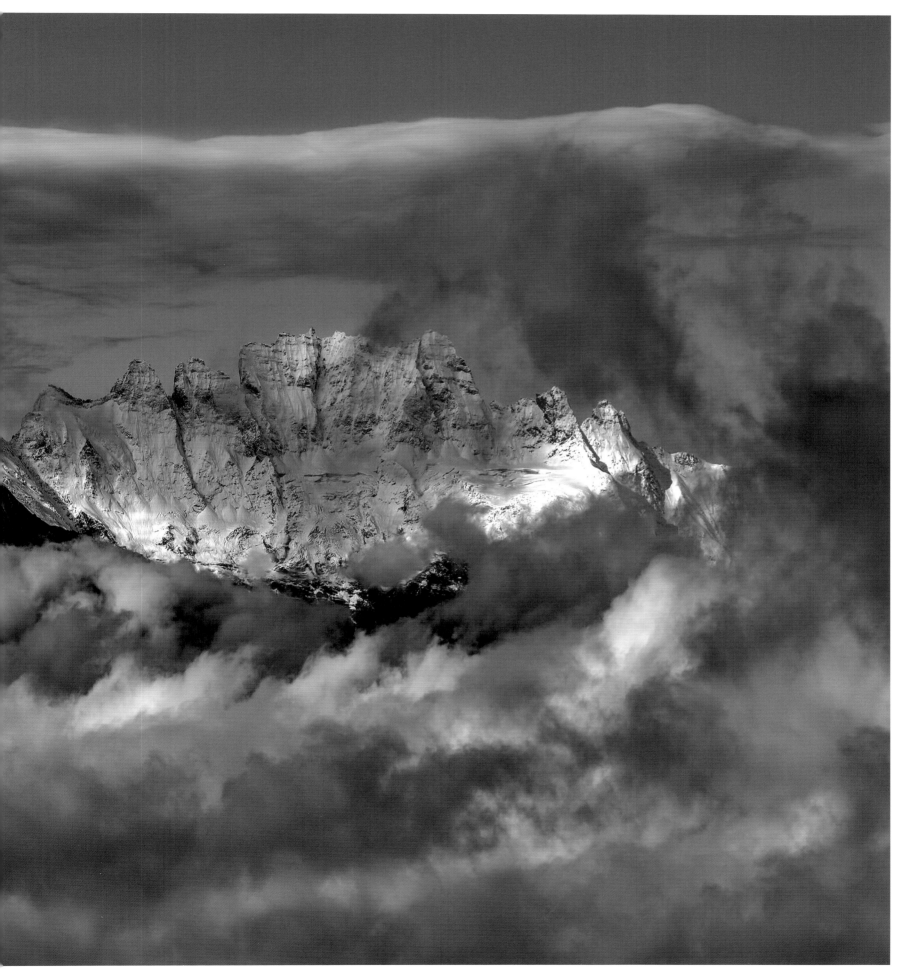

水
Water

水，無色無味，流向萬方，十足地千變萬化！

試問：「如何使一滴水，永不乾涸？」。答案是：「流入大海」。

我喜歡創作「水」。於我而言，總有意外的驚喜畫面，前所未見。

2013 南極 / 中國九寨溝 / 亞南極

2016 / 2022 台灣

Water has no color and odor, and it flows in all directions, ever-changing.
Someone asks, "How to make a drop of water never dry up?" The answer is, "Let it flow into the sea."
I like to take photos of "water". It always offers unexpected surprises that I have never seen before.

Photos taken in Antarctica, Jiuzhaigou Valley, China, and Sub-Antarctic Islands in 2013, and Taiwan in 2016 and 2022.

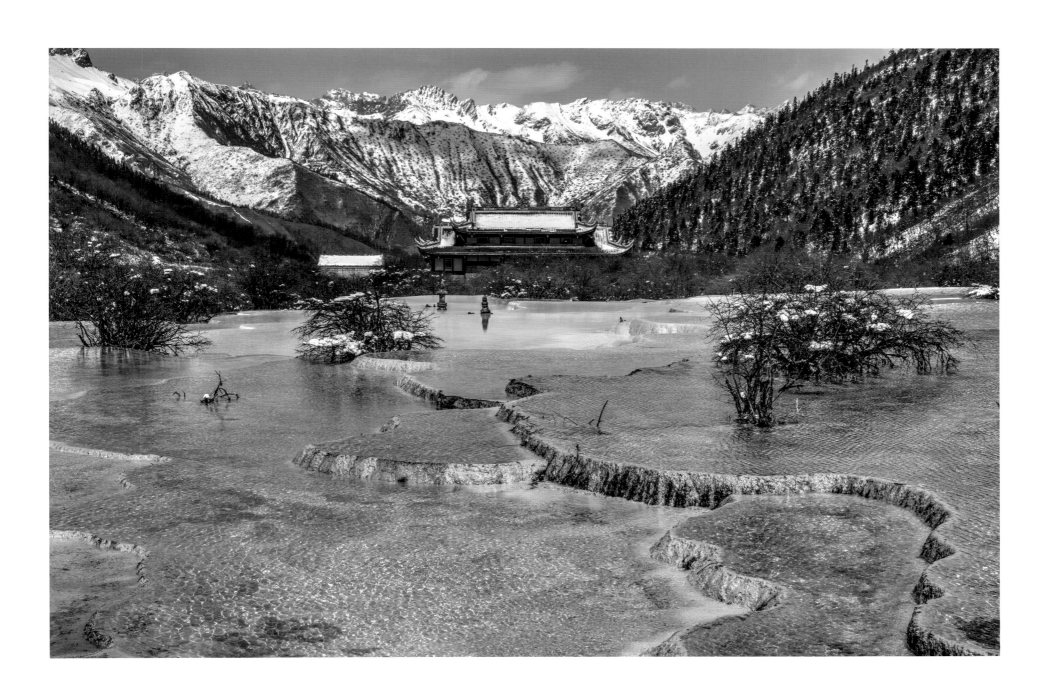

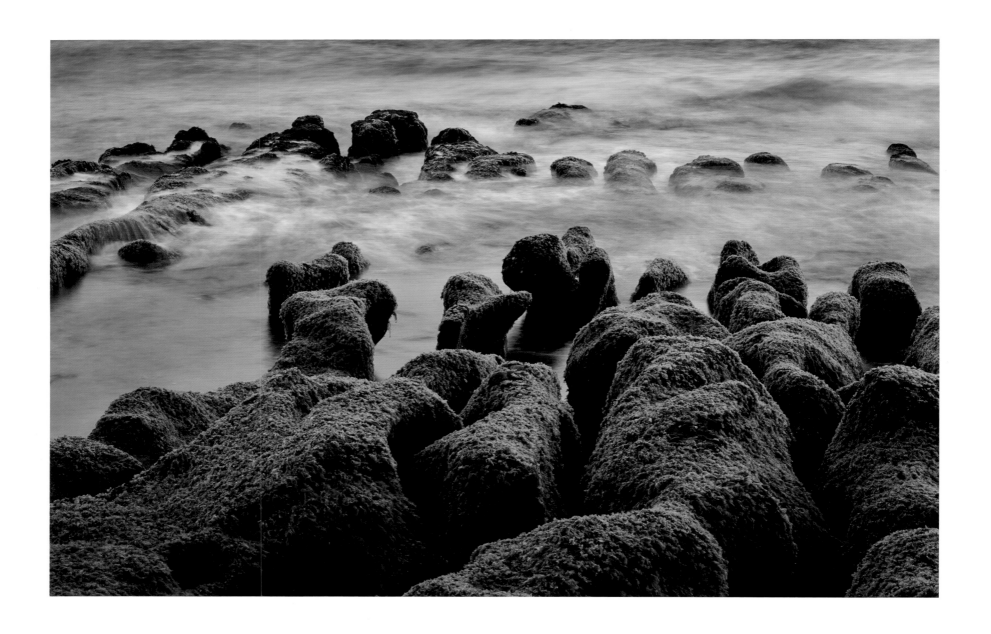

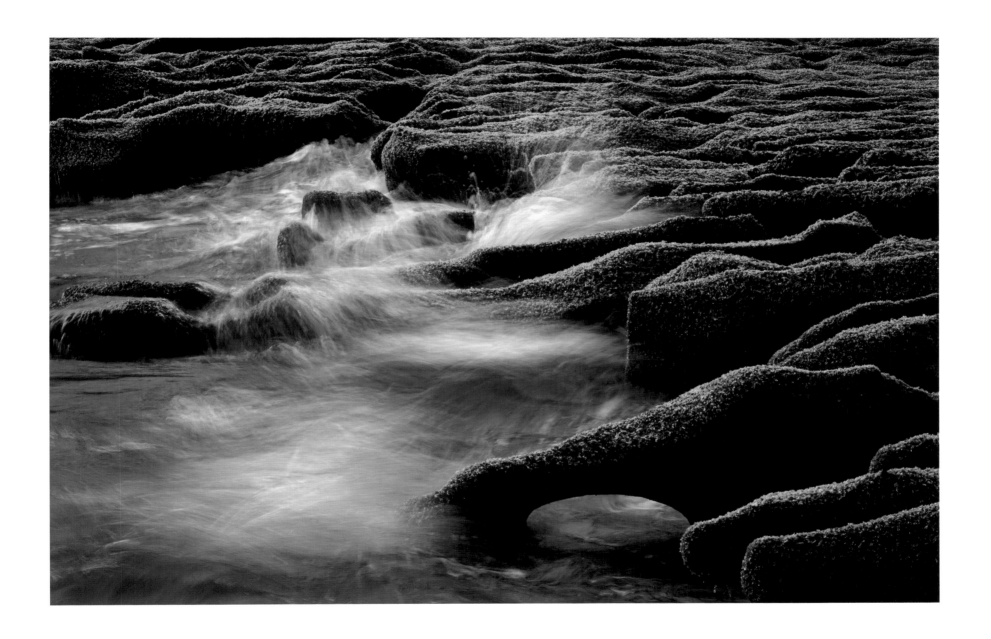

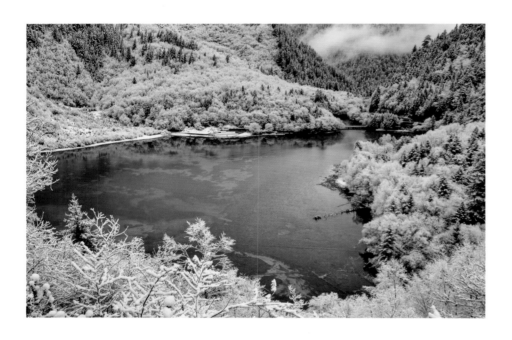 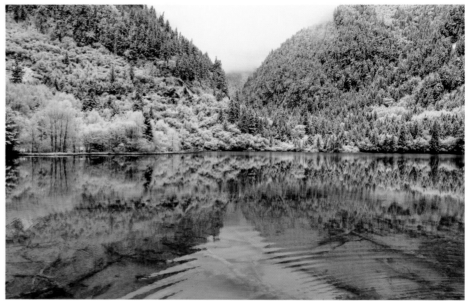

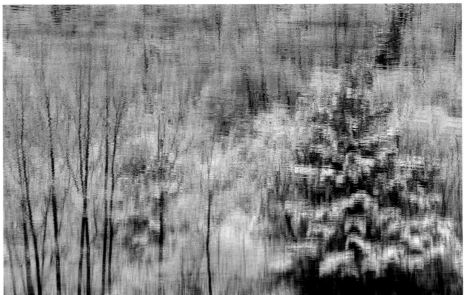

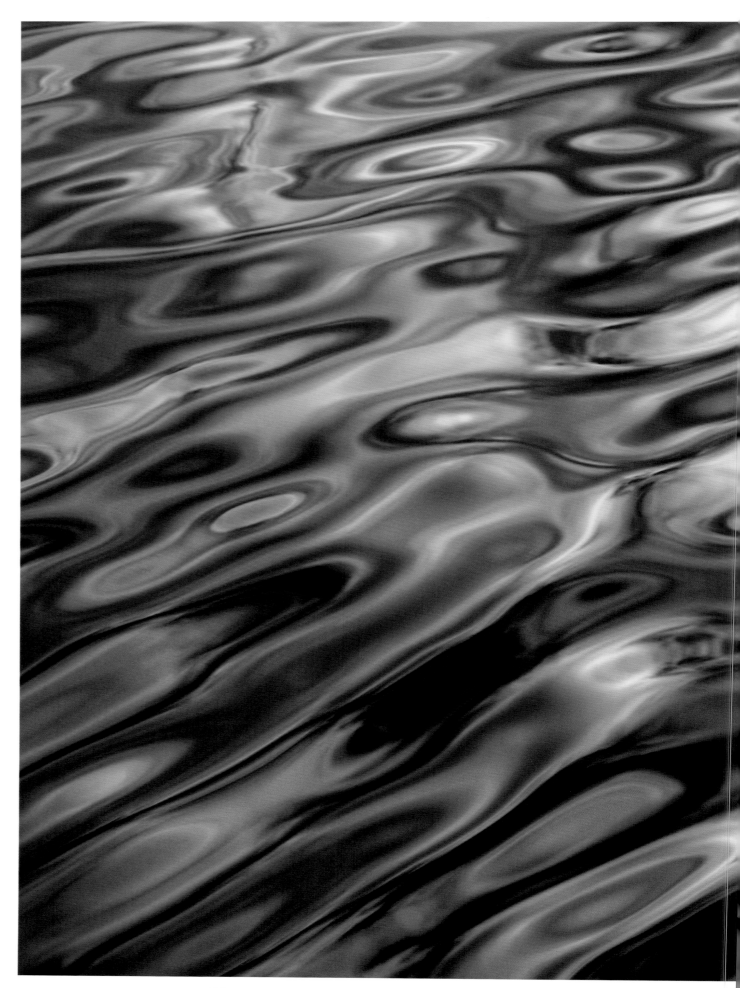

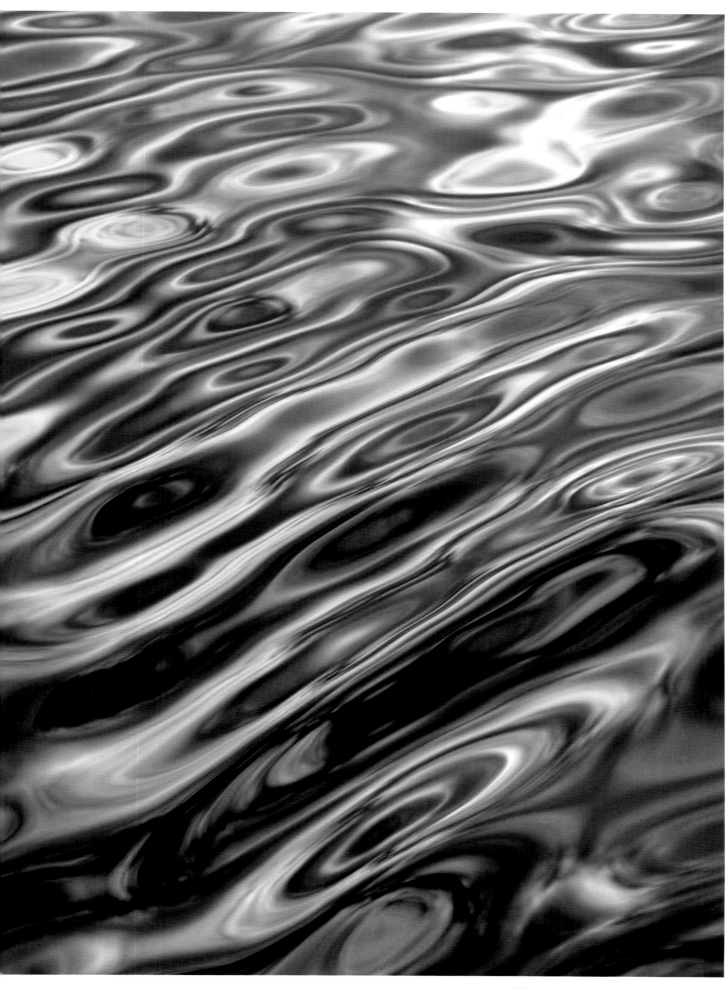

北極

Arctic

兩次前往都是三月，正值北極的夏天。平均溫度約攝氏零下 25 度至 35 度。

極光又稱為幸福之光。很感恩，兩趟不同路線的北極行攝，雖然低溫寒冷，在廣袤的夜空下，滿天星斗。我們擁有美麗的邂逅。

命名為「母愛」的母子熊，為我贏得 2018 年國家地理雜誌的獎項。

2015　美國阿拉斯加
2018　加拿大 Wapusk 國家公園

Both trips took place in March, which coincides with the Arctic summer. The average temperature was about minus 25 to 35 degrees Celsius.

The aurora is known as the light of happiness. I feel grateful that I went on two trips to the North Pole travelling different routes. The temperature was low and although I felt the bitter cold under the vast night sky, the sky was full of stars. We had a beautiful encounter.

The photograph of a female bear and her cub, titled "A Mother's Love", won me the 2018 National Geographic award.

Alaska, USA in 2015, and Wapusk National Park, Canada in 2018

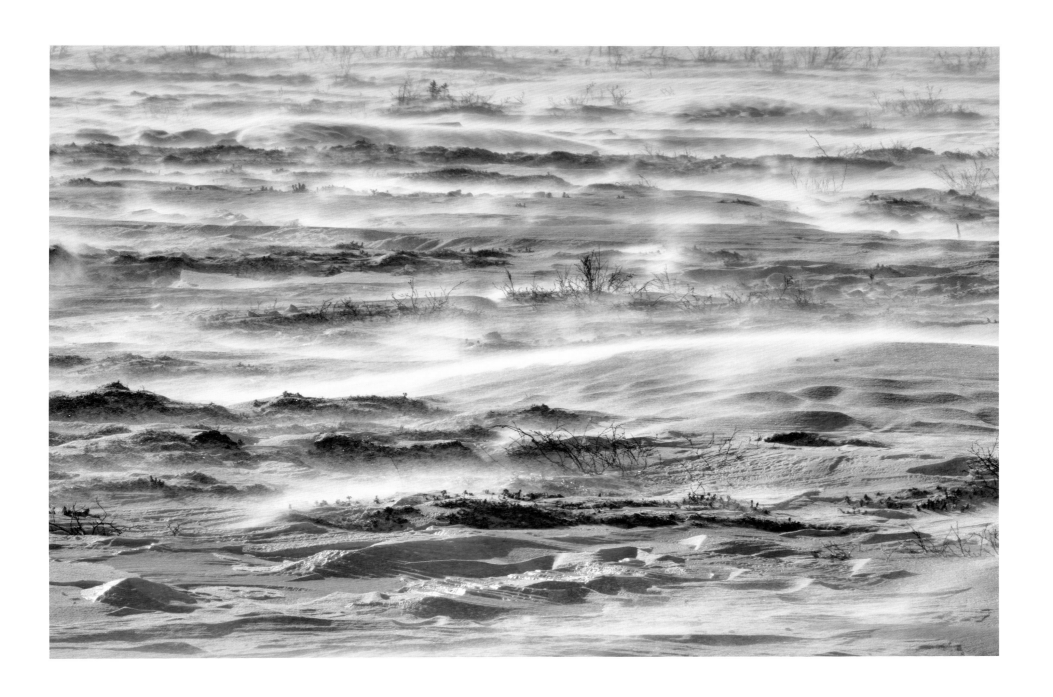

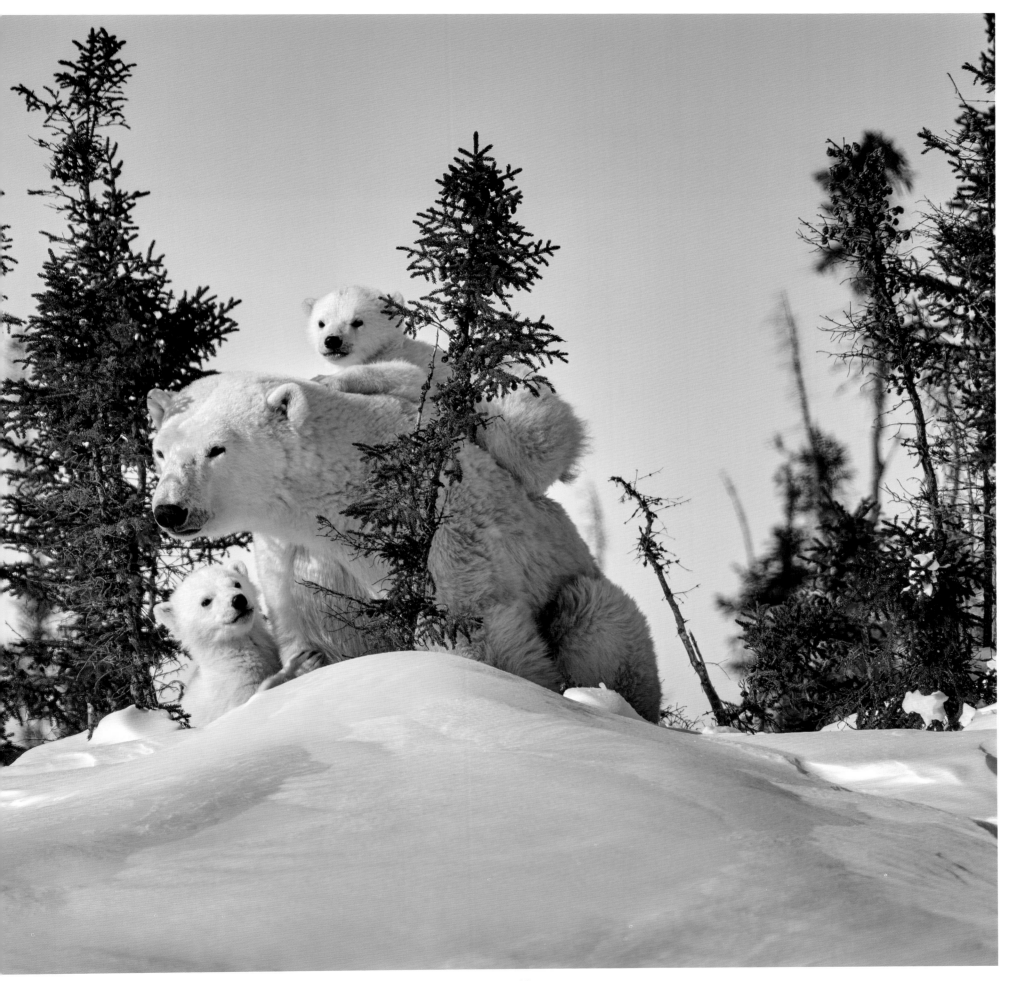

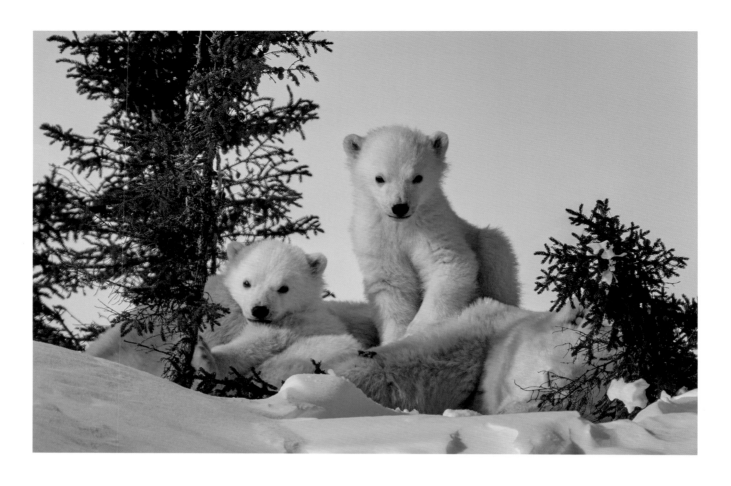

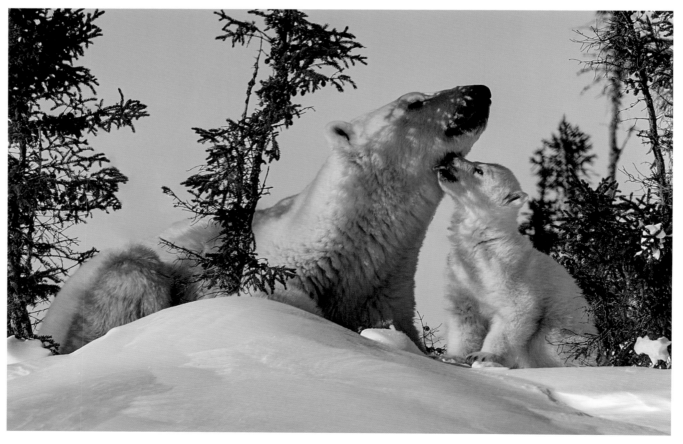

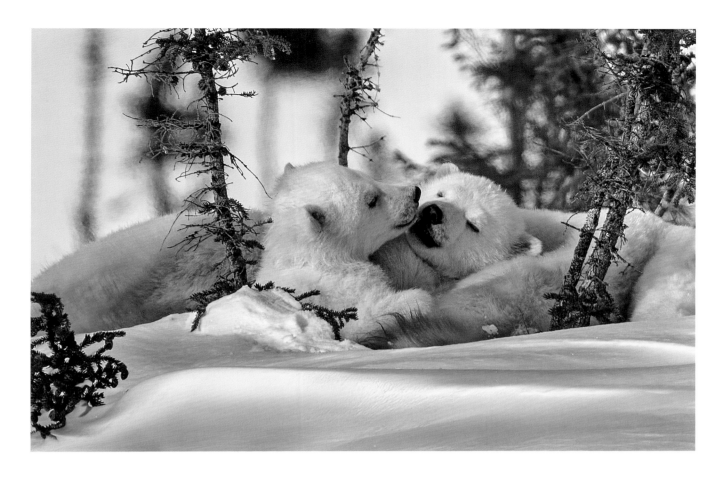

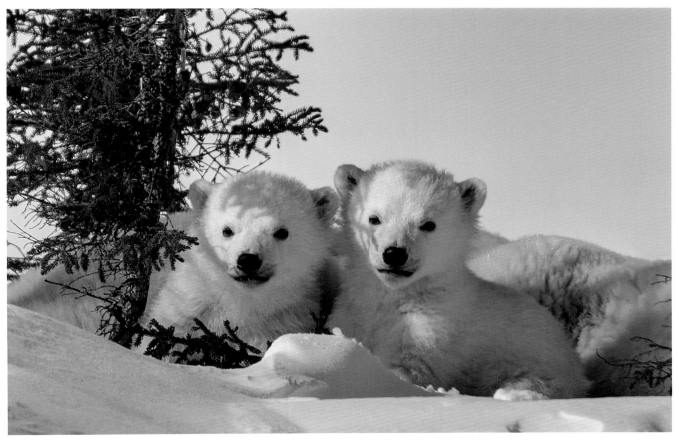

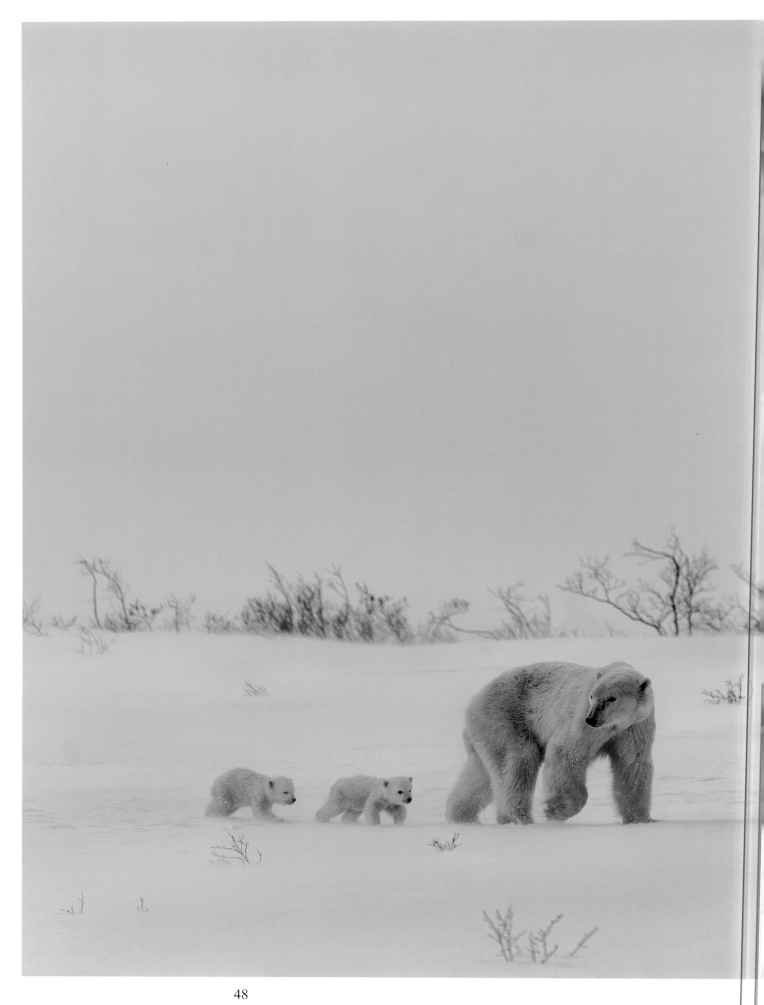

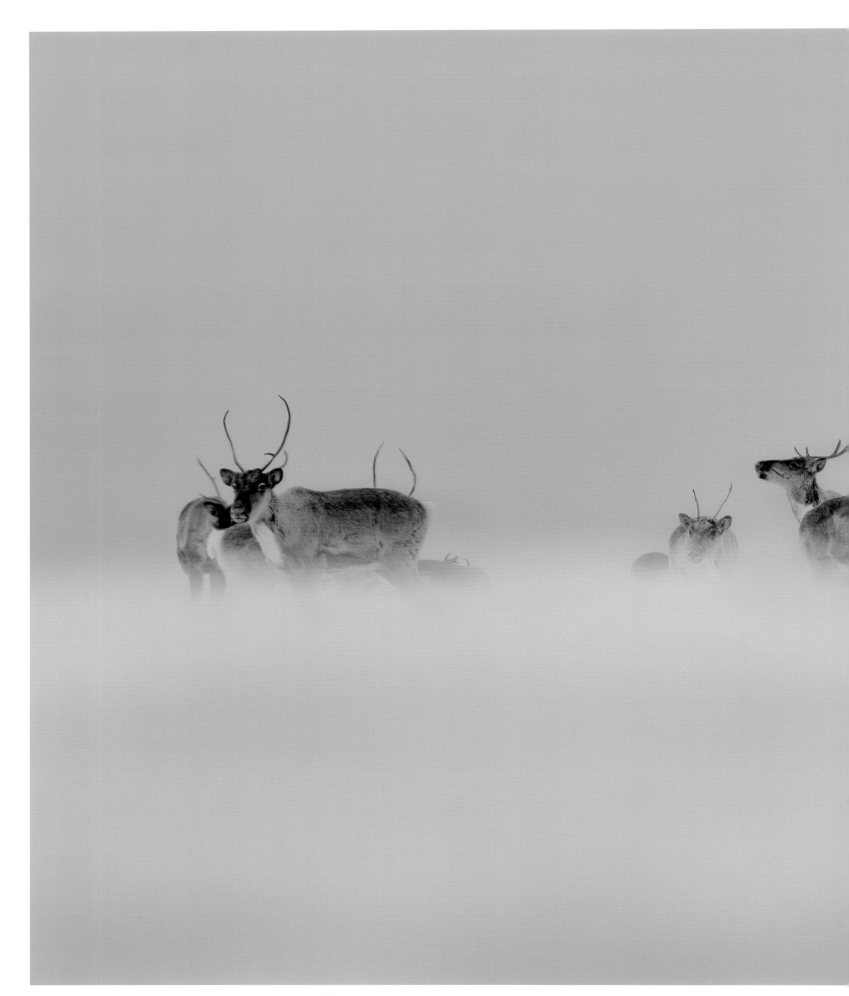

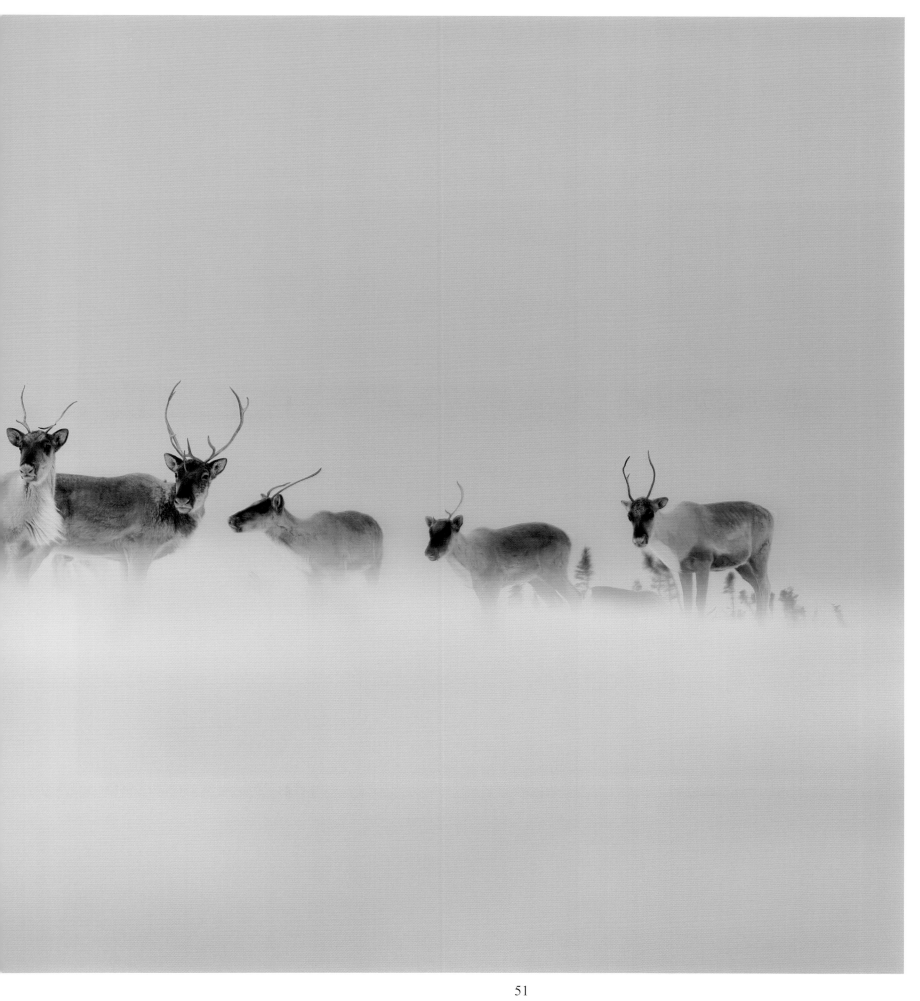

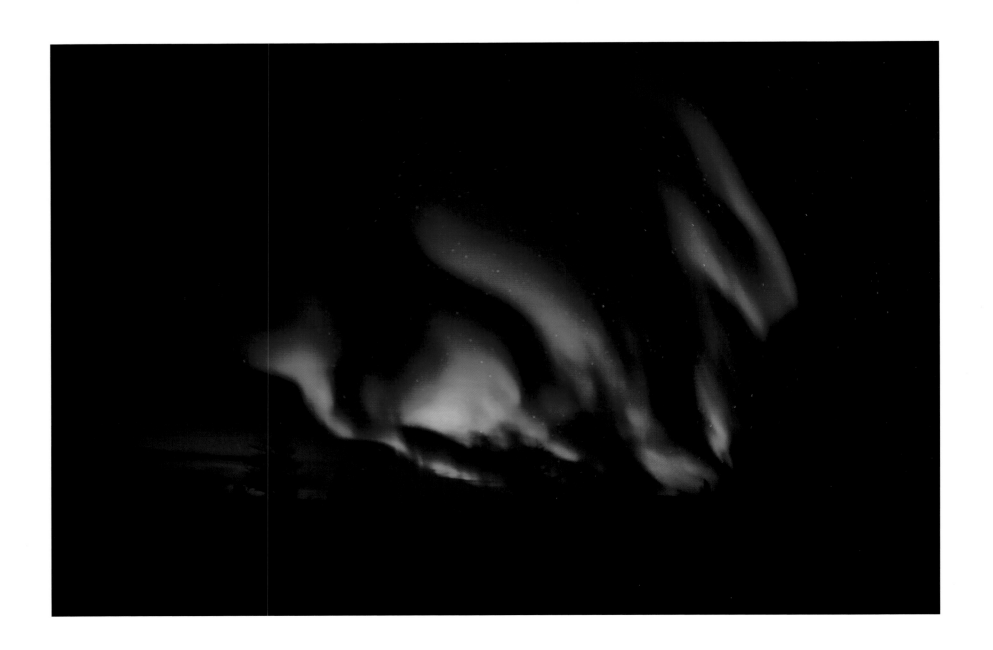

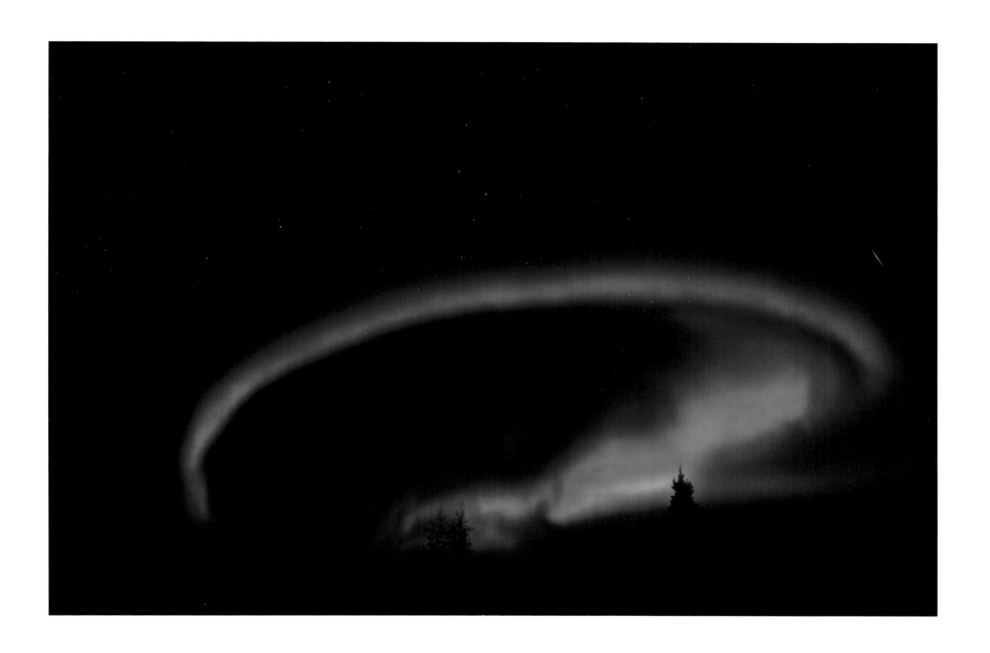

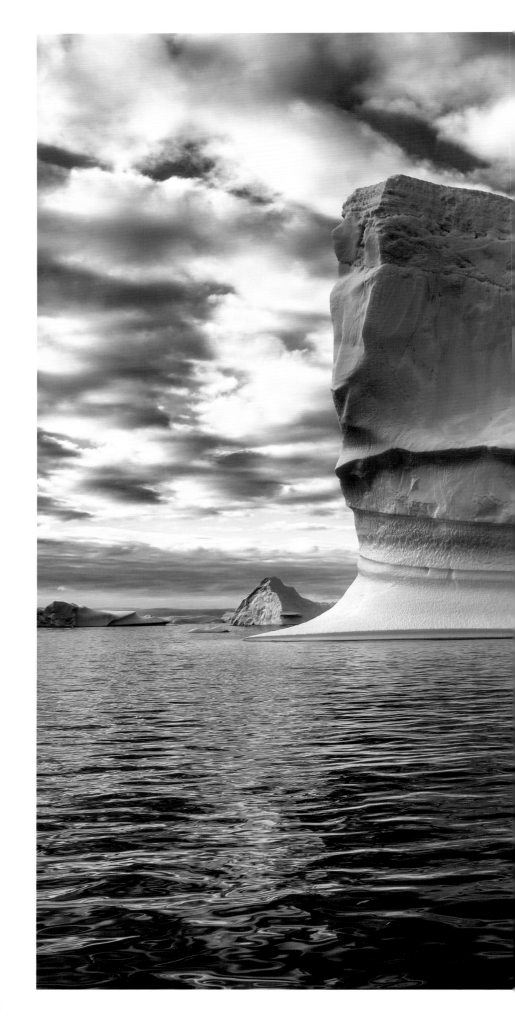

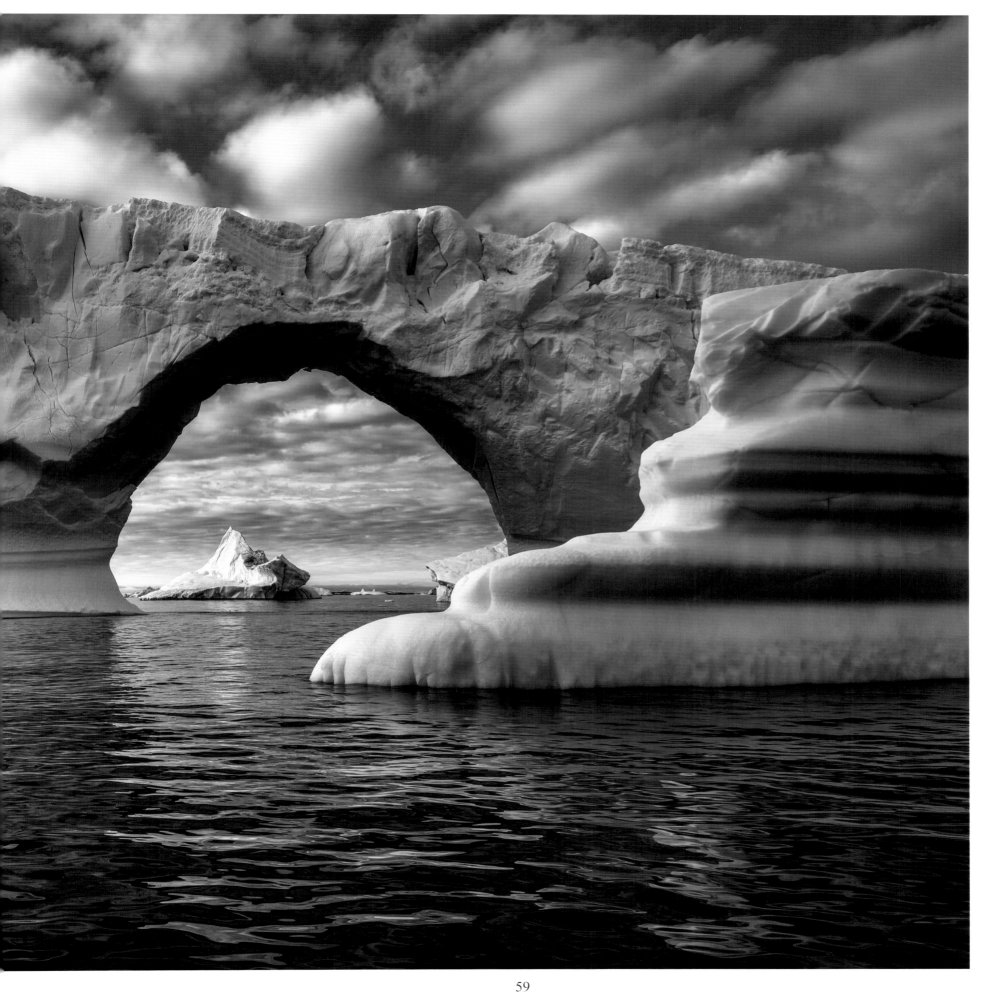

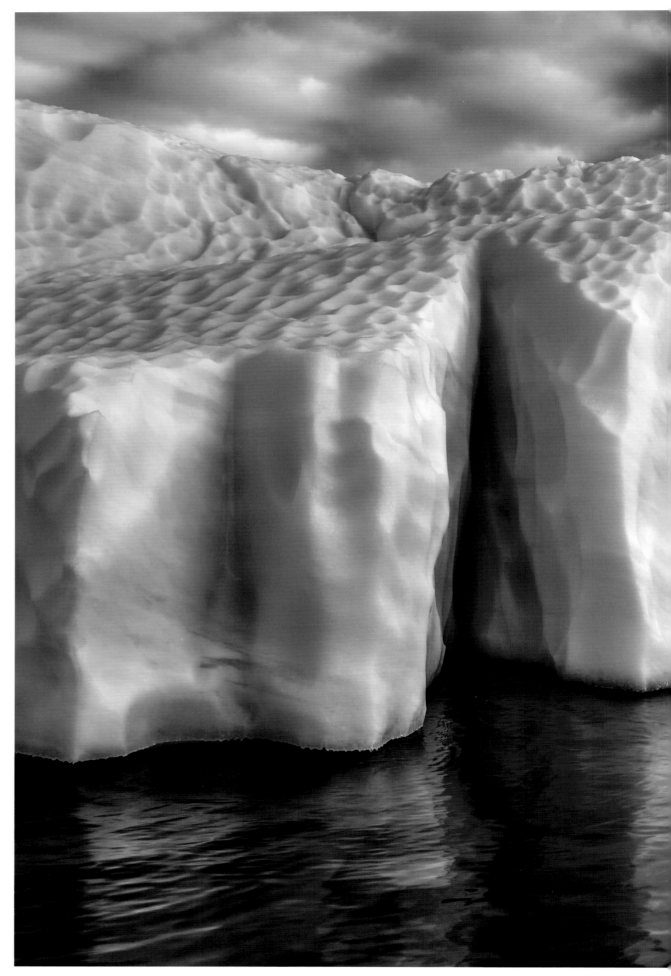

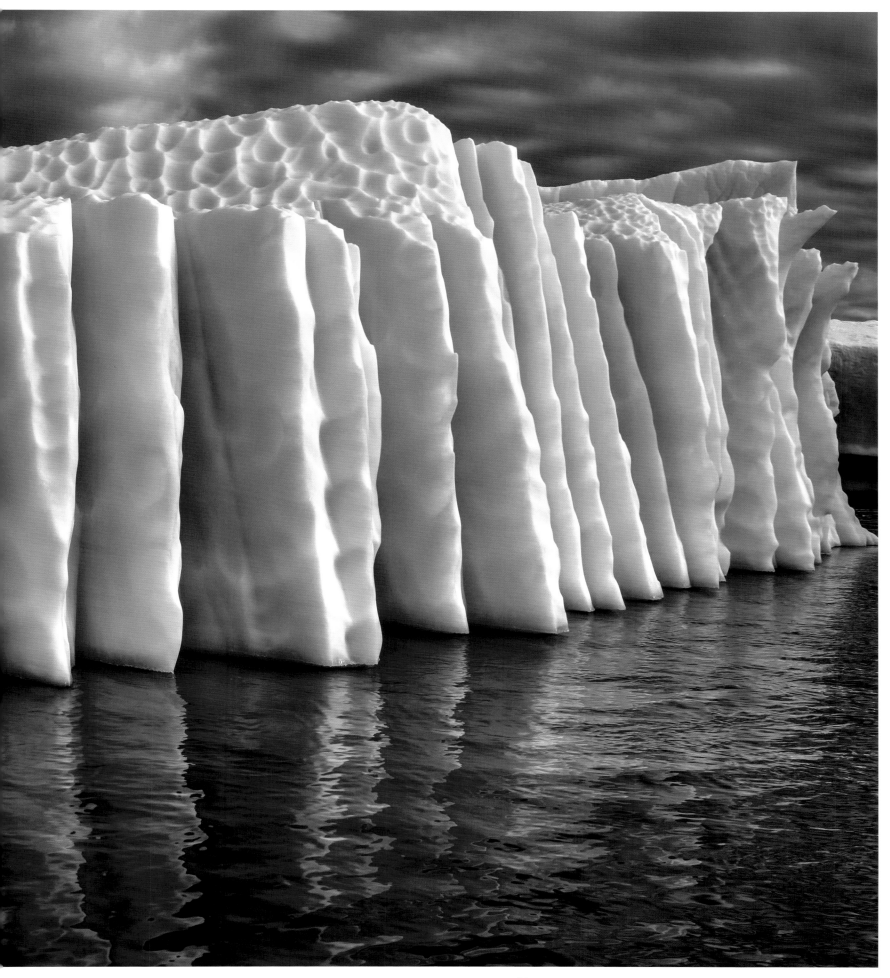

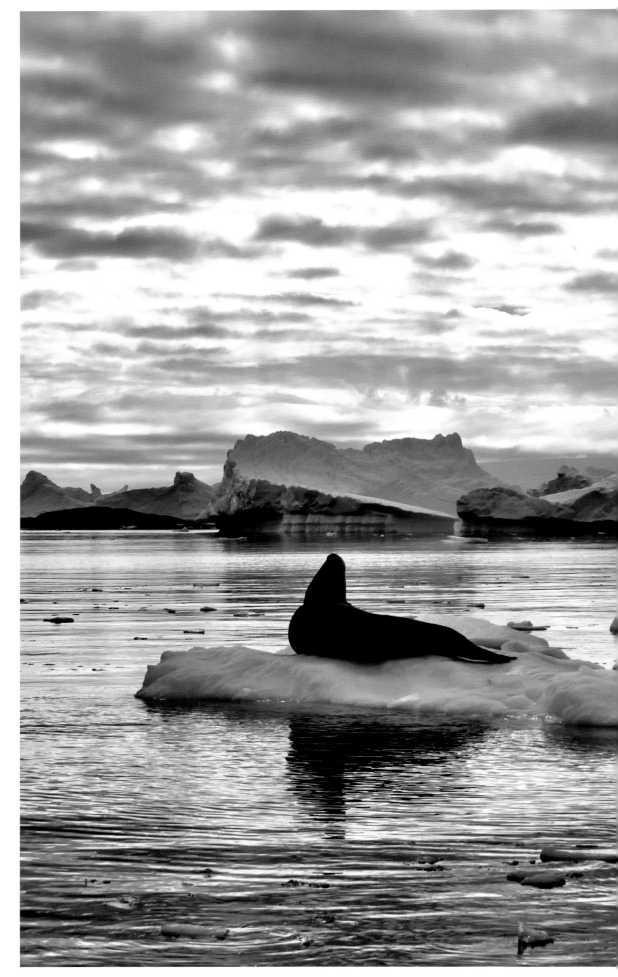

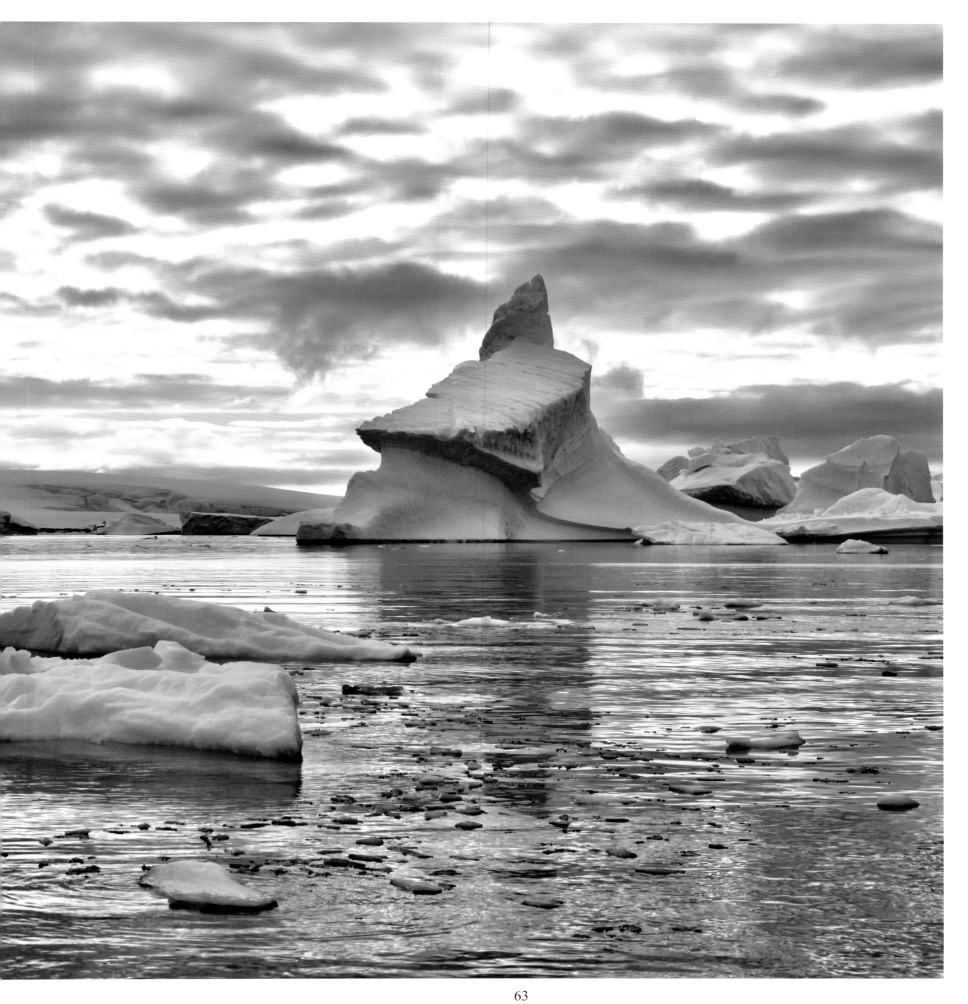

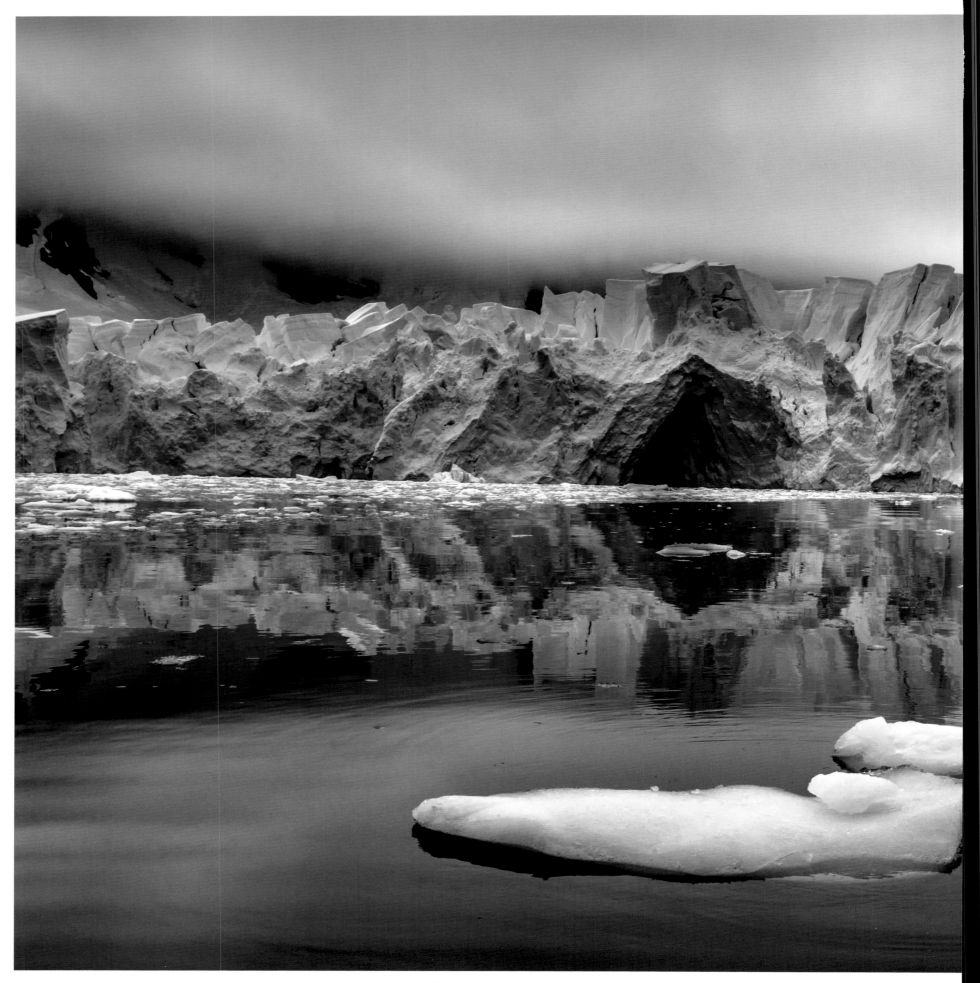

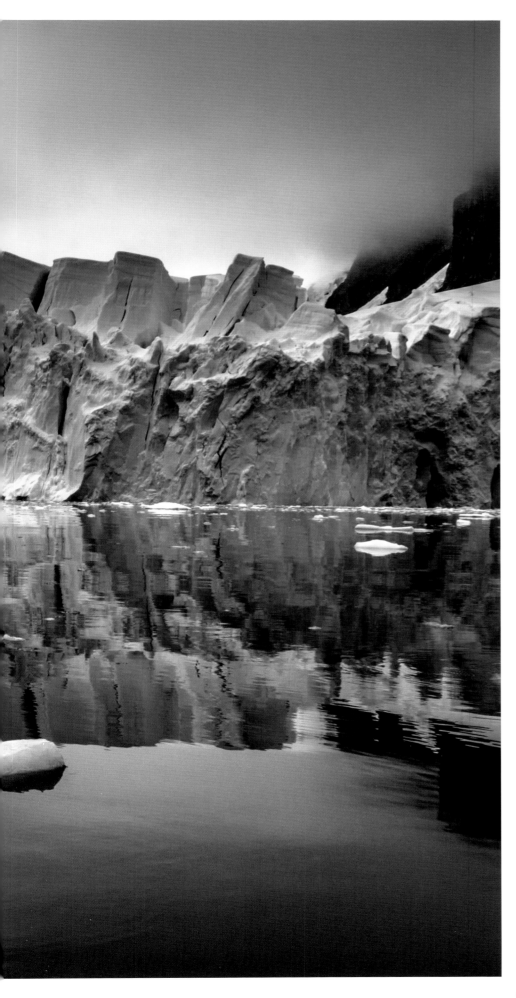

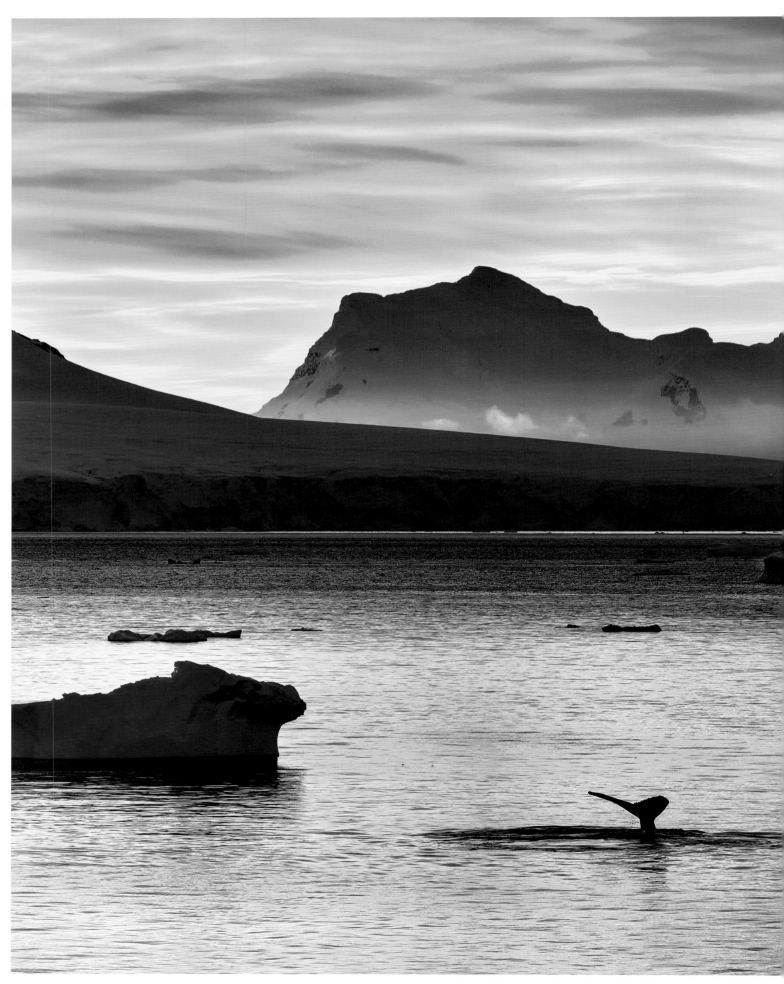

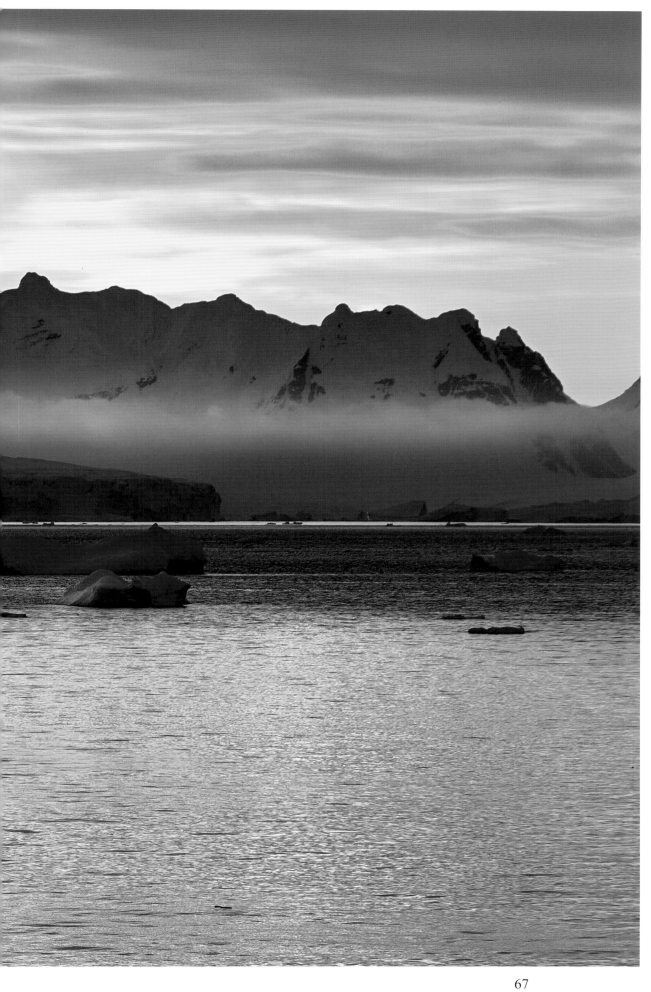

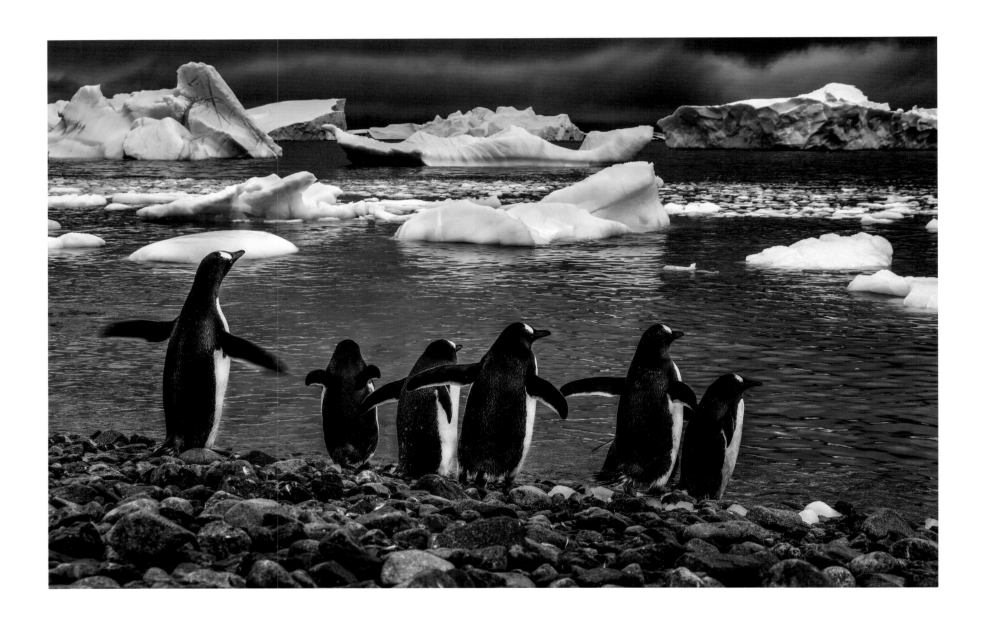

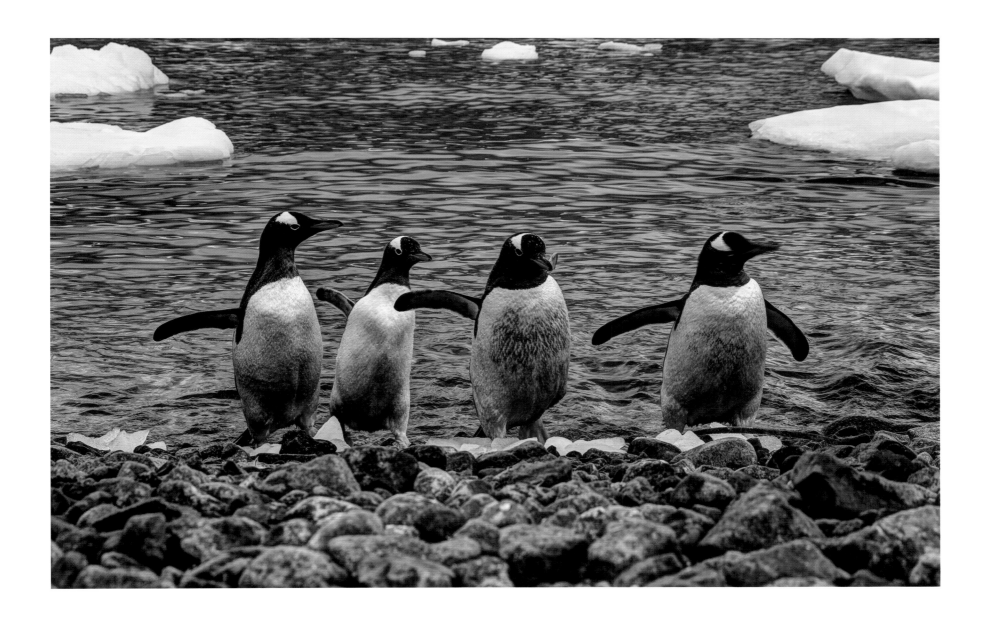

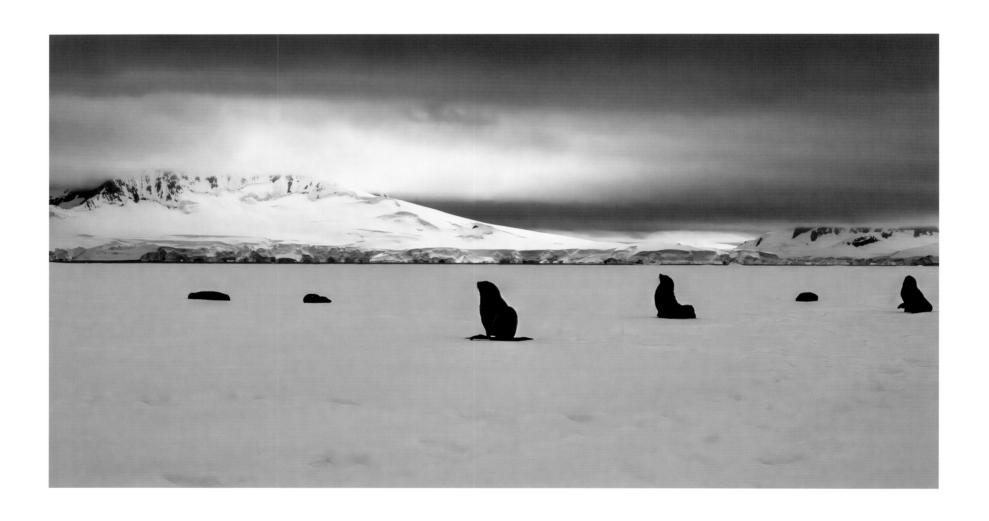

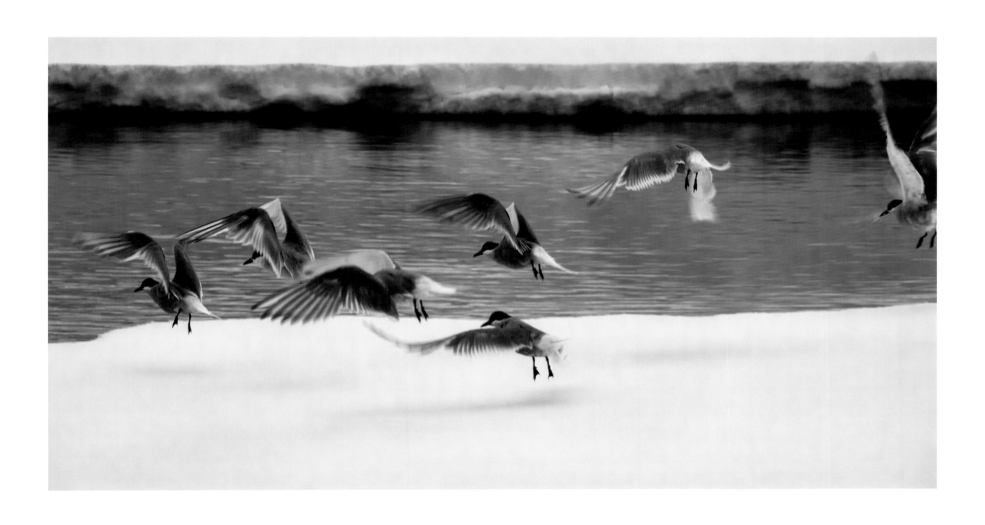

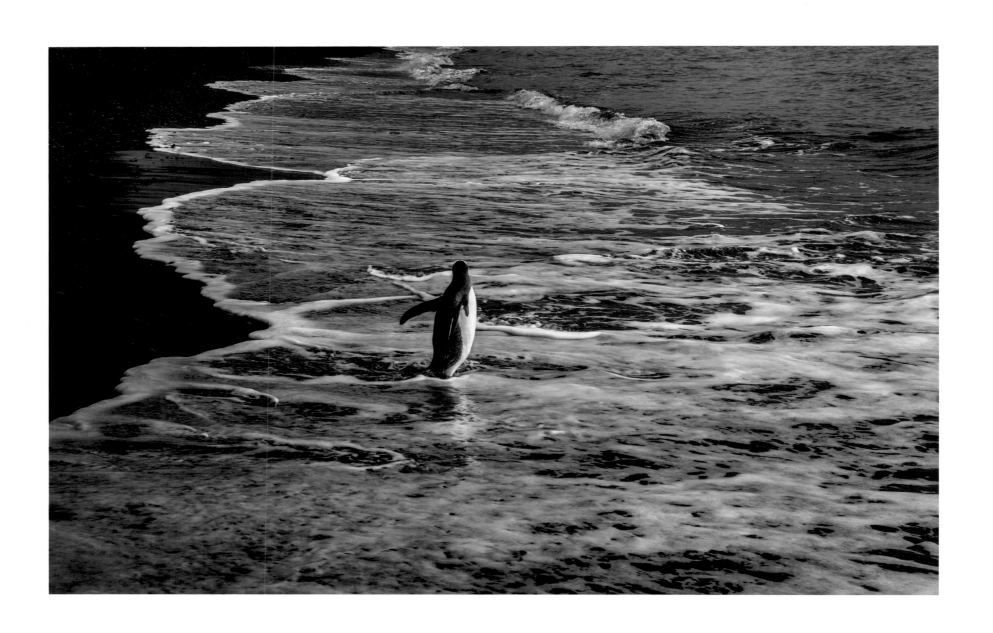

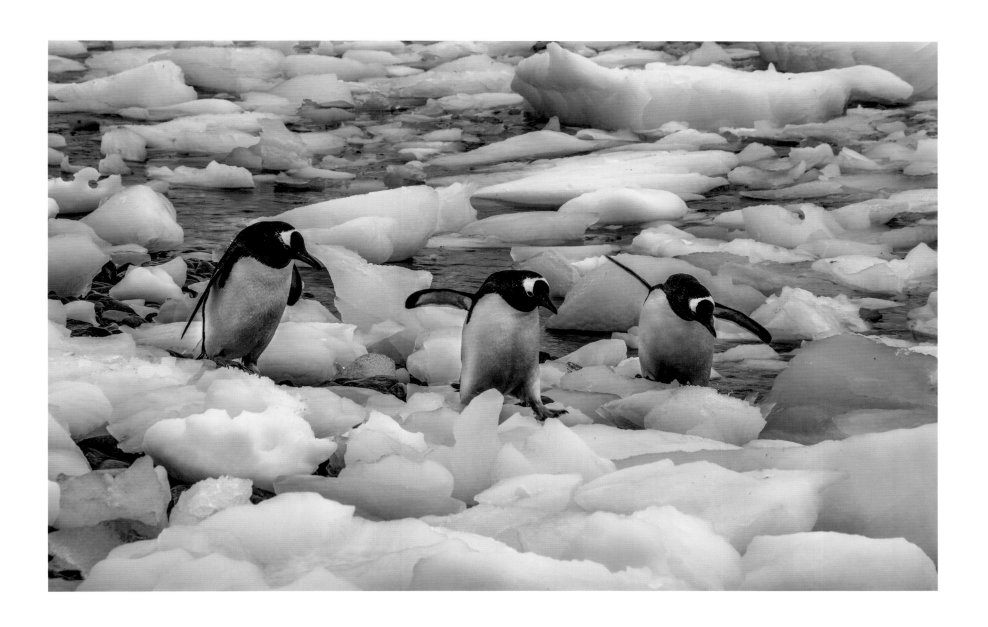

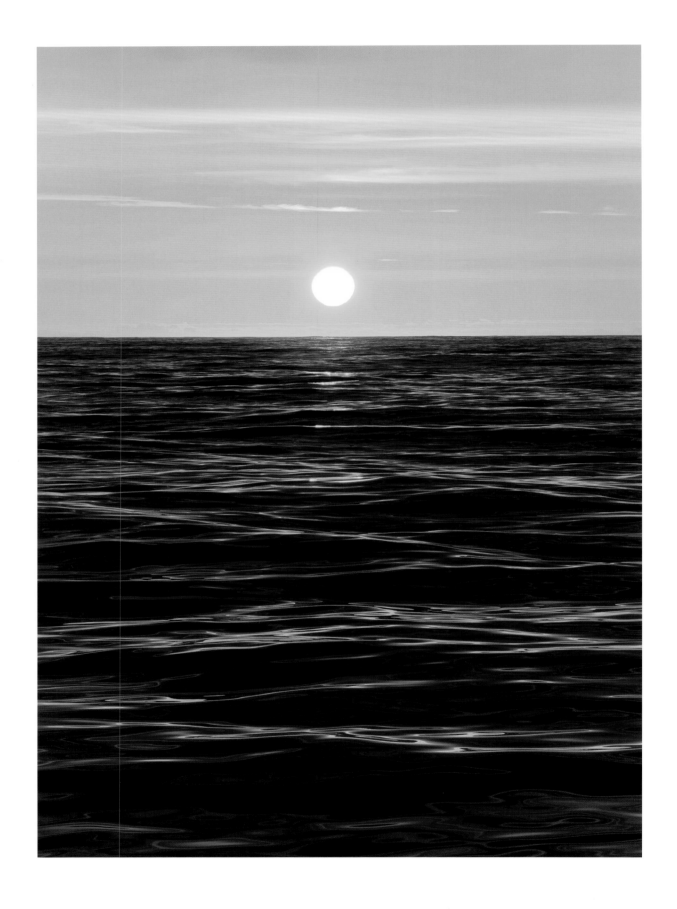

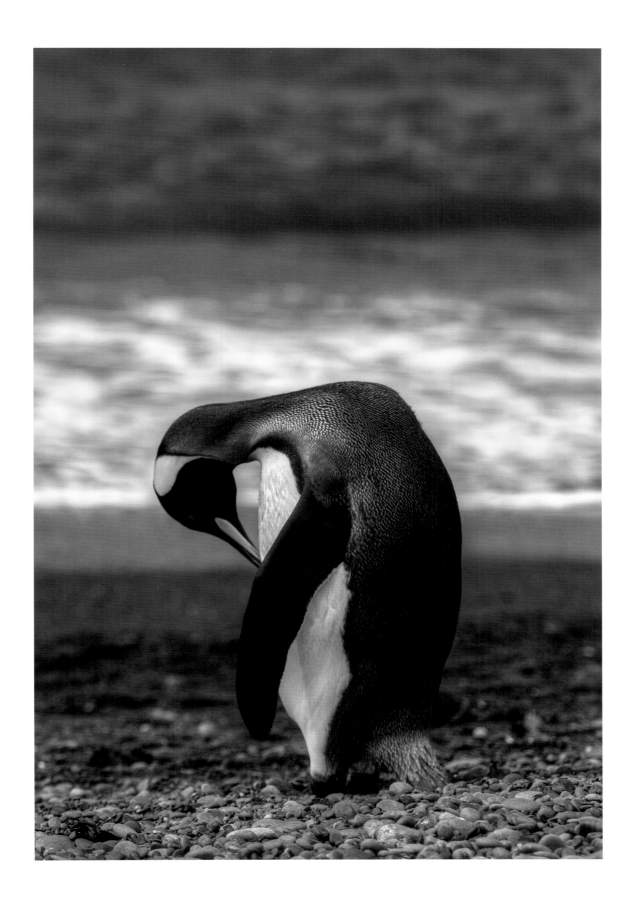

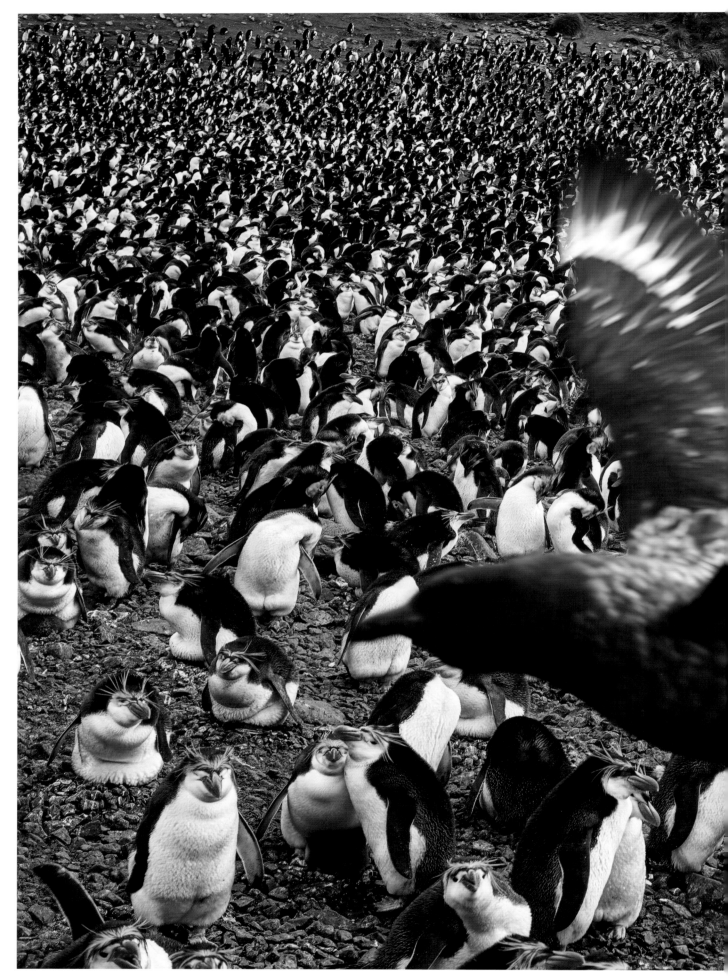

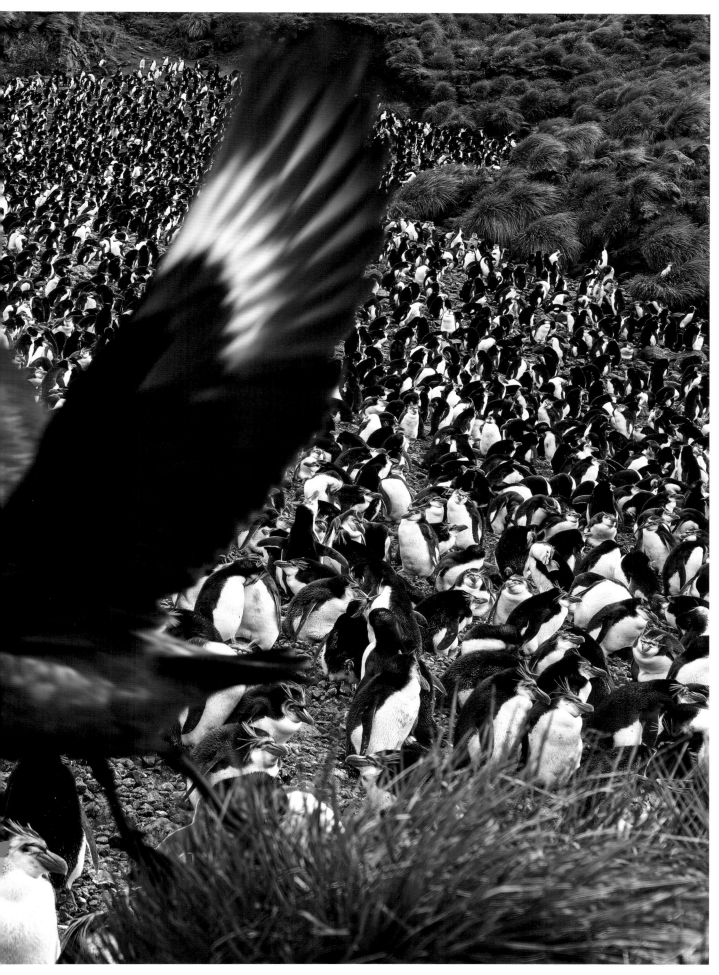

蒙 古 馬

Mongolian Horse

聽說，蒙古人自小還不會走路，就先會騎馬了。

十二生肖裡面，我是屬馬的，自小對「馬」情有獨鍾。長大後，也喜歡收藏以「馬」

為主題的藝術品。

「馬年大吉」是 2014 年我在台北社教館舉辦個展的主題。

祝福觀眾，馬到成功！

2013 蒙古國

It is said that the Mongols know how to ride horses before they can walk.
I belong to the Horse sign of the Zodiac, and I have had a soft spot for horses
since I was a child. In my adult years I began collecting art with horses.
"Auspicious Year of the Horse" was the theme of my solo exhibition held at Taipei
Municipal Social Education Hall in 2014.
Blessings to the audience. Wish you a successful year of the horse!

Mongolia in 2013

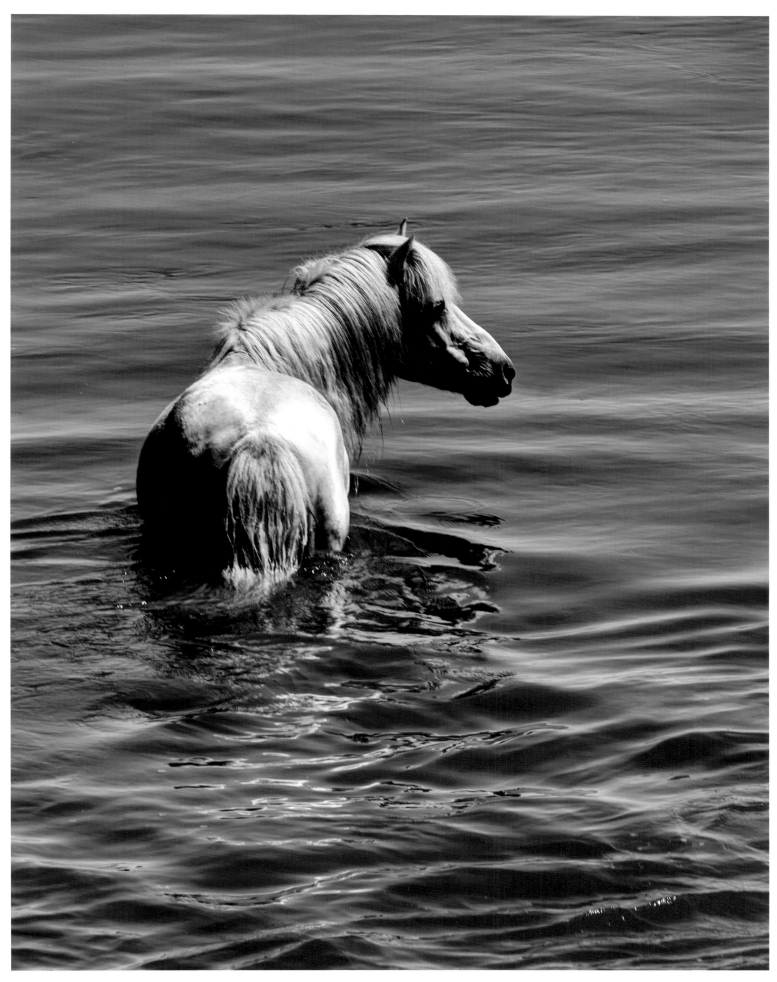

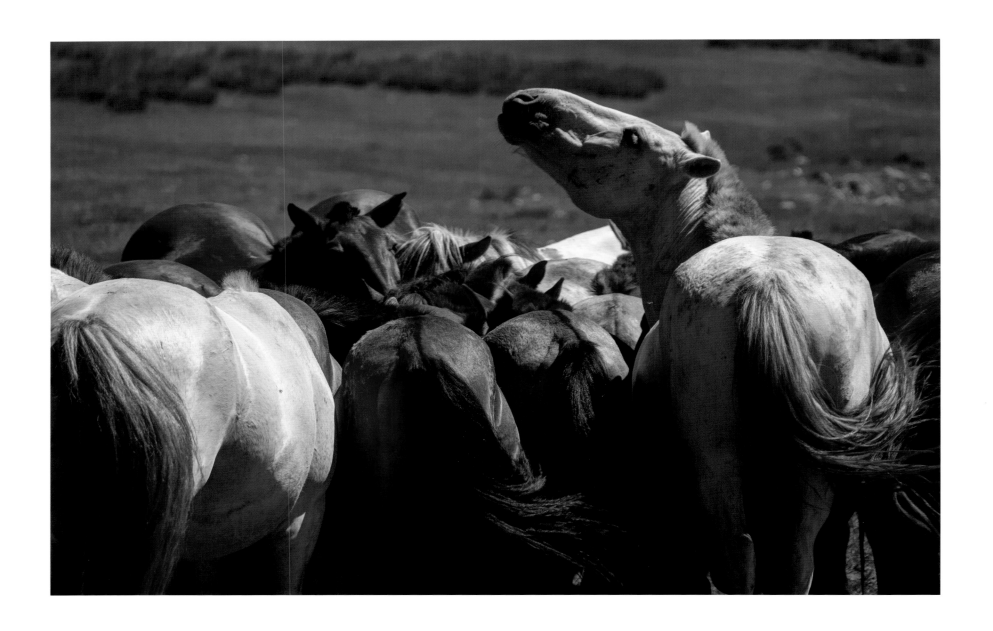

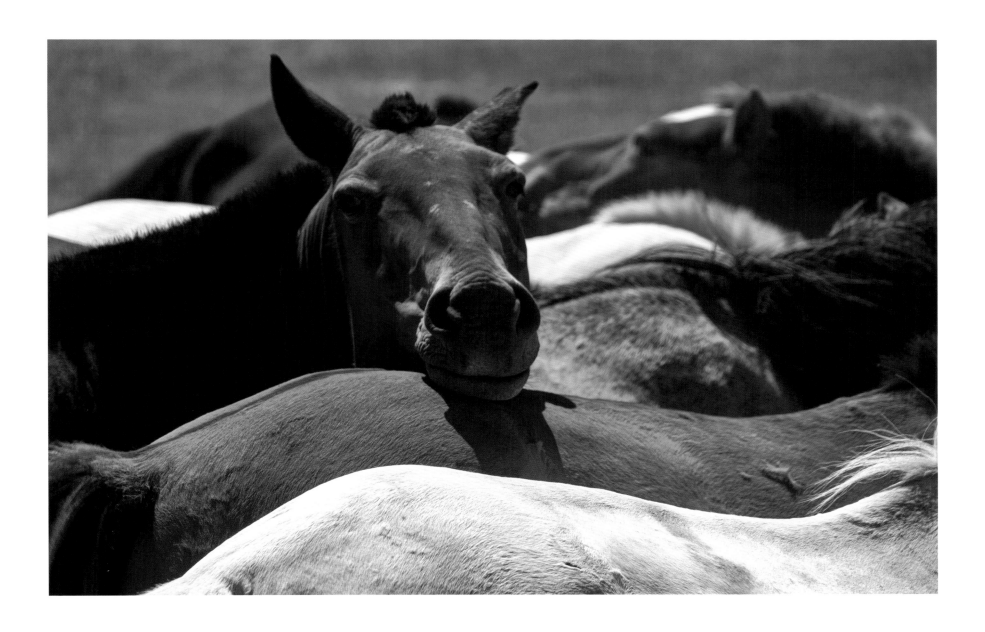

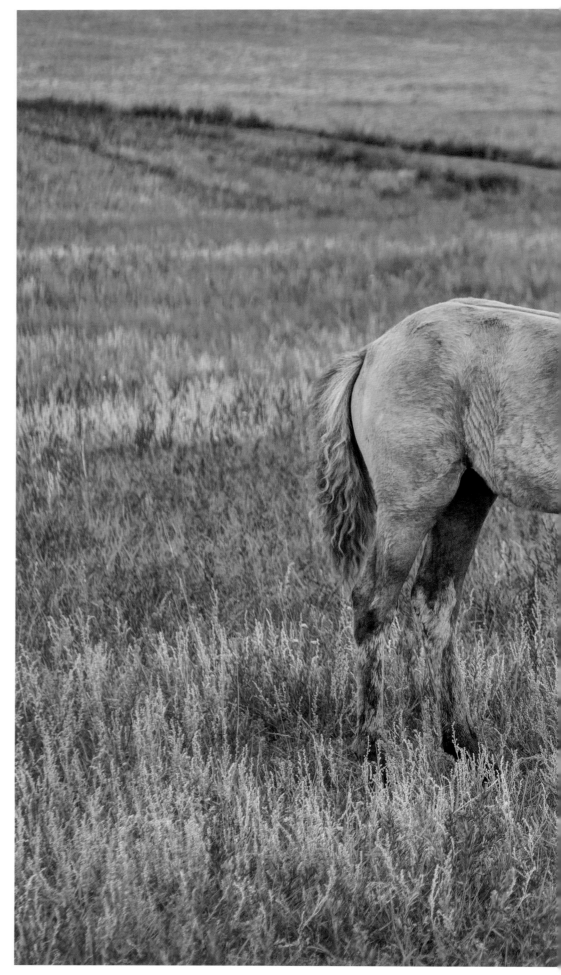

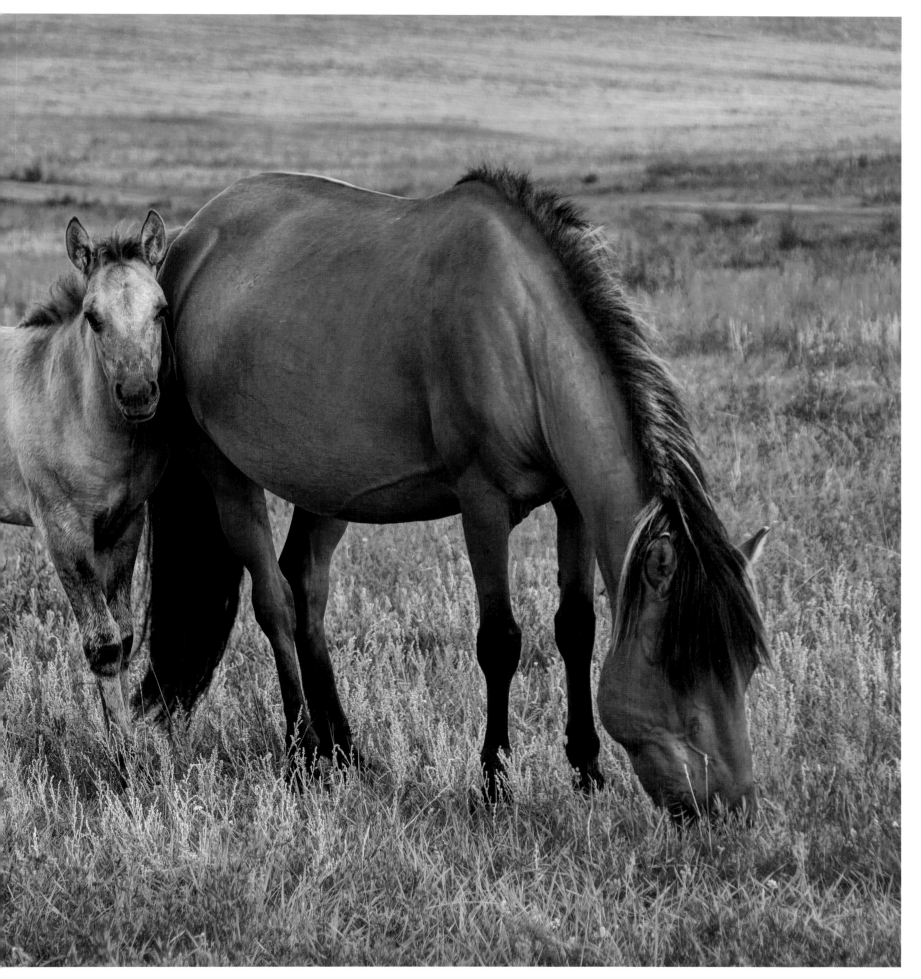

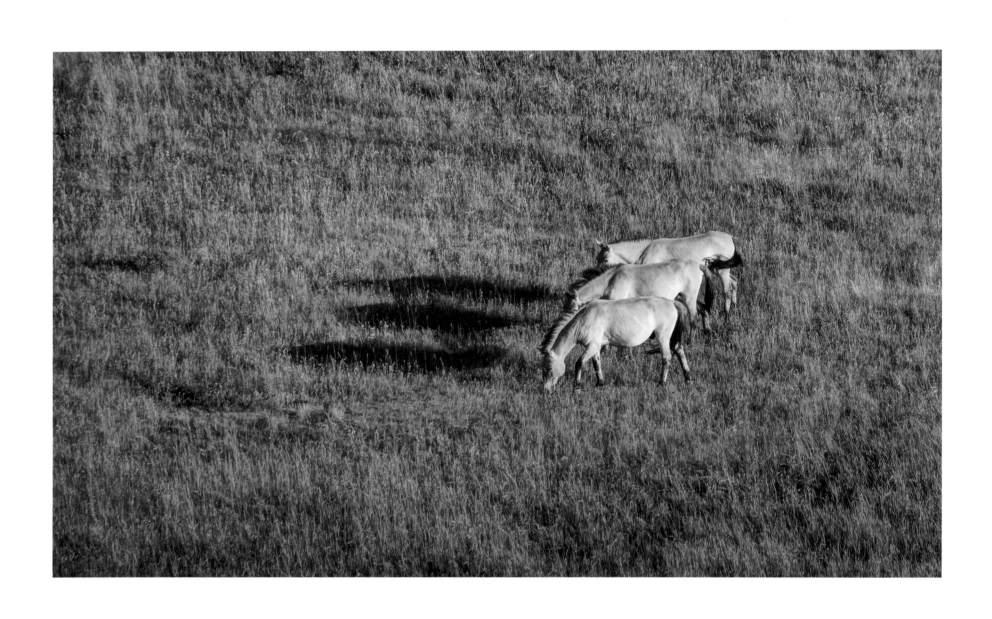

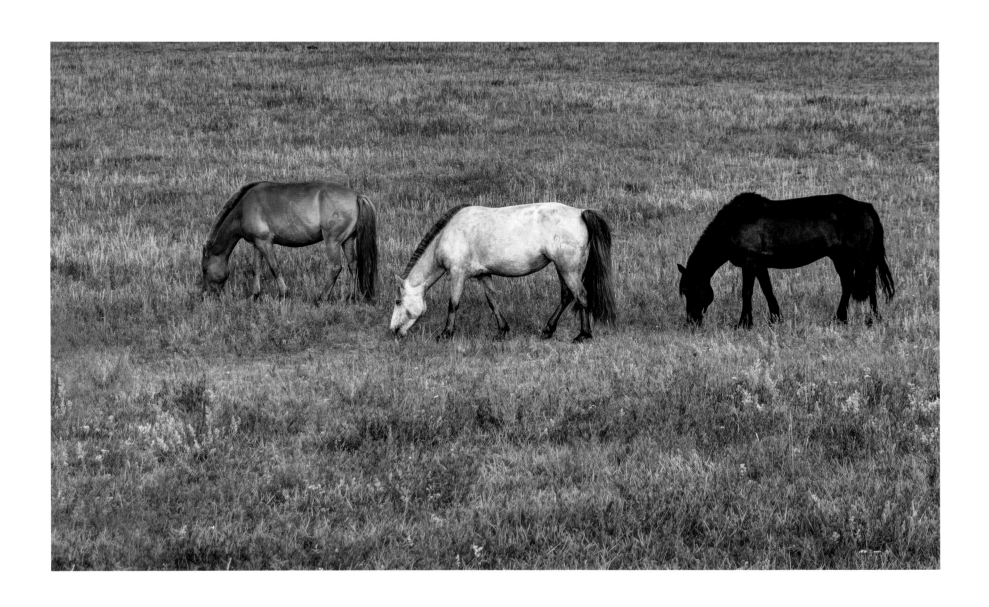

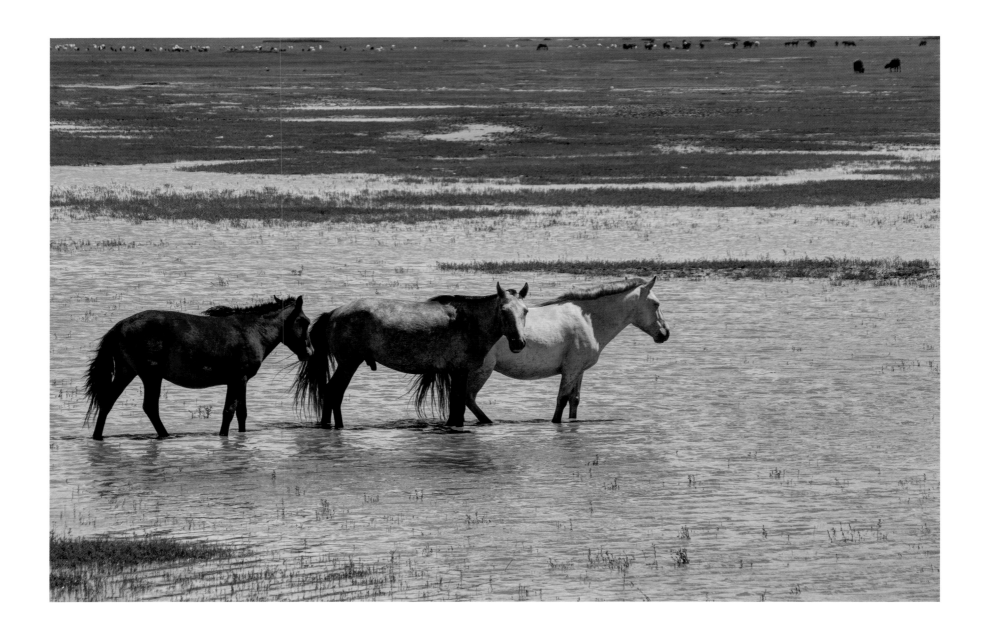

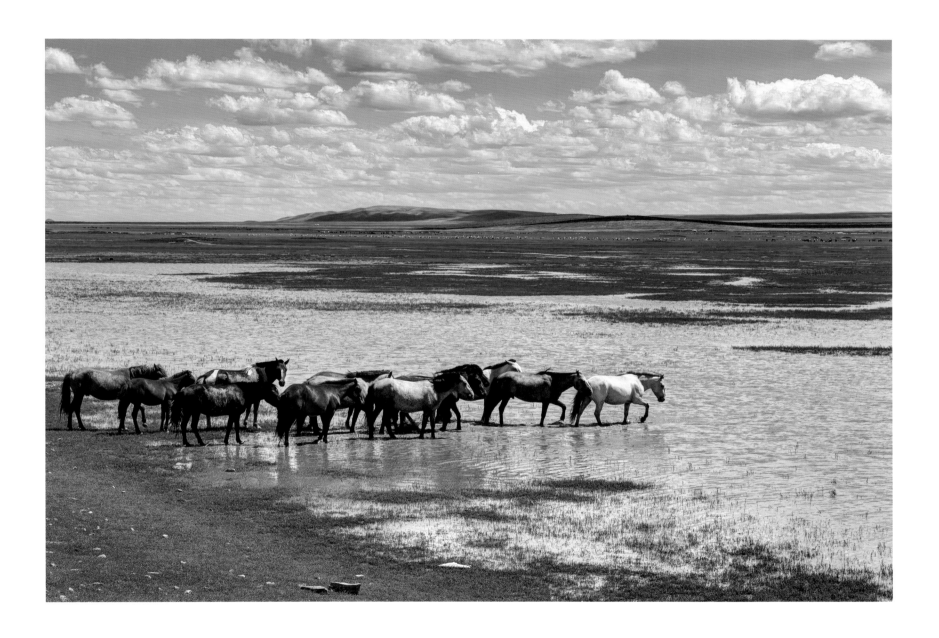

肯亞
Kenya

每年上演一年一度的動物大遷徙，肯亞馬賽馬拉國家公園，是攝影師的天堂。

Safari 獵遊。為了遊客的安全，被安排坐在改裝過的吉普車上拍攝。

成千上萬的火鶴群聚，只能用望遠鏡拍攝，若想靠近些，牠們便一起退得更遠。

第一次搭熱氣球升空拍攝。興奮之情，忘了懼高的恐懼！必須把握好時間，按快門，以防機會稍縱即逝。氣球飛得越來越高，看不見動物了，只有壯闊的大片草原。

2015 / 2016 東非肯亞馬賽馬拉國家公園

The annual animal migration takes place every year in the Maasai Mara National Reserve. It is a photographer's paradise.

The photos were taken on a safari from a modified jeep. For their own safety all tourists are required to remain seated in the car during the tour.

Thousands of flamingo flocks together. This can only be photographed with a telescope lens. If anyone tries to move in close, they will all retreat.

It was my first time shooting from a hot air balloon. I got excited and forgot my fear of heights! I had to pay attention to the timing and operate the shutter in time. I would not risk missing a single opportunity. As the balloon flew higher and higher, we could no longer make out the animals below, only the magnificent grassland remained.

Maasai Mara National Reserve, Kenya of East Africa in 2015, 2016

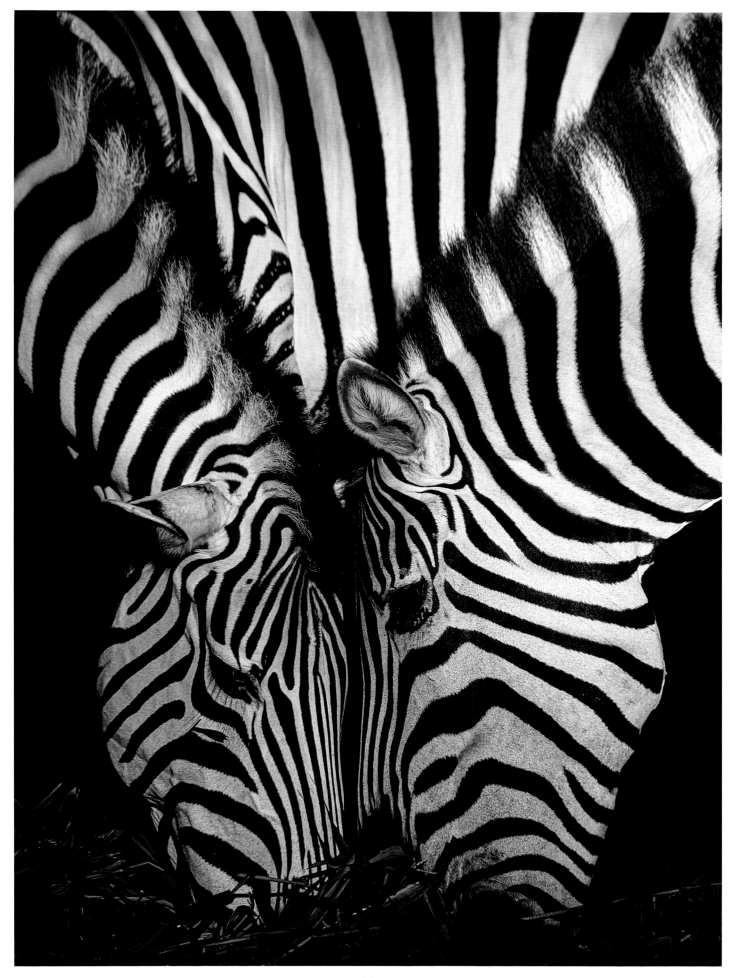

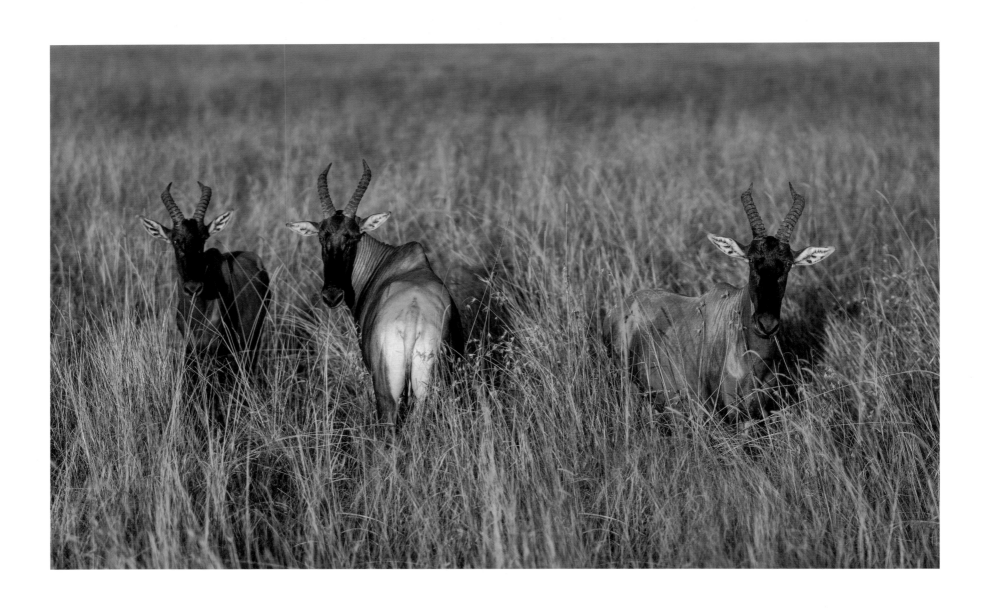

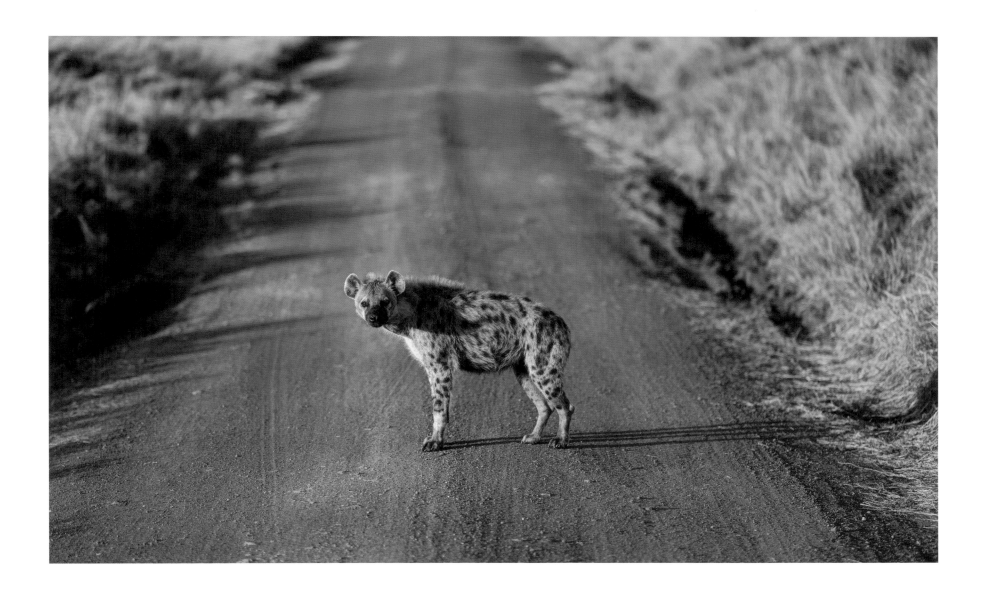

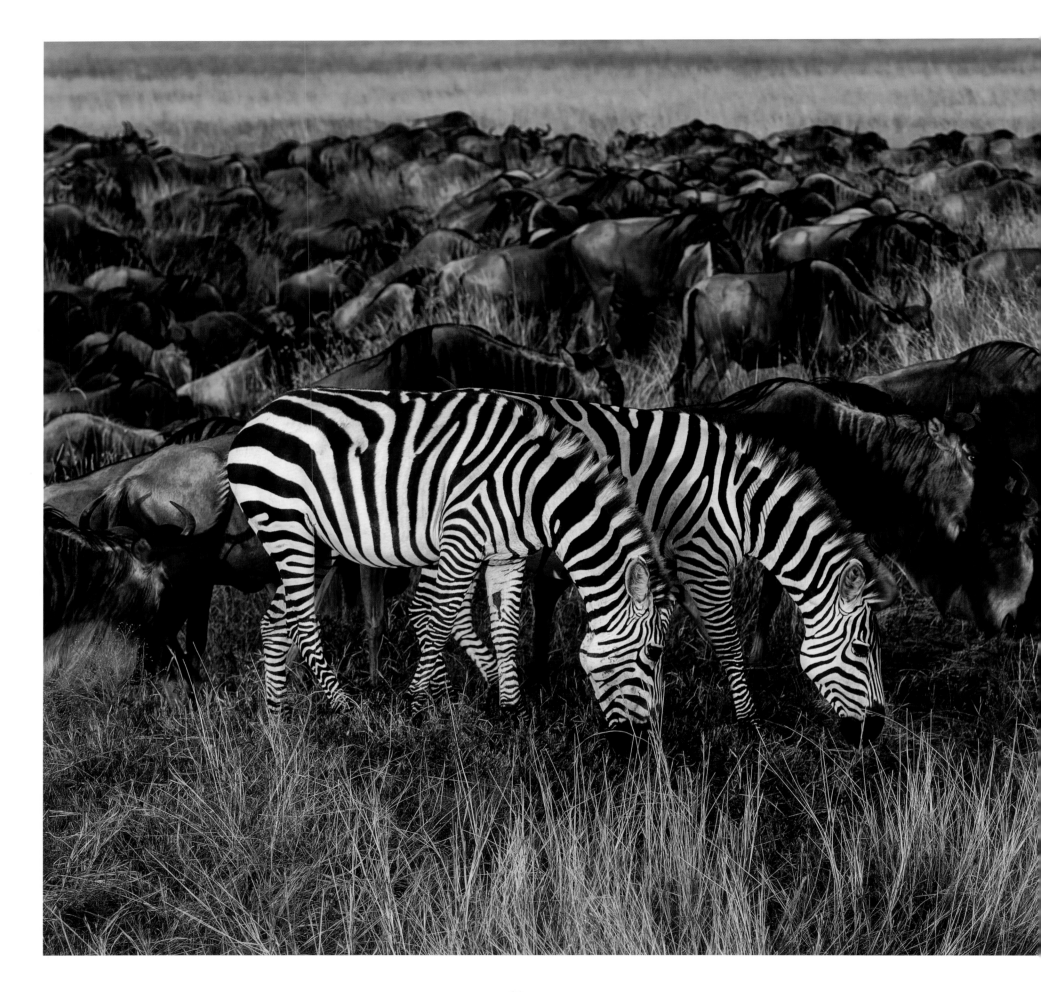

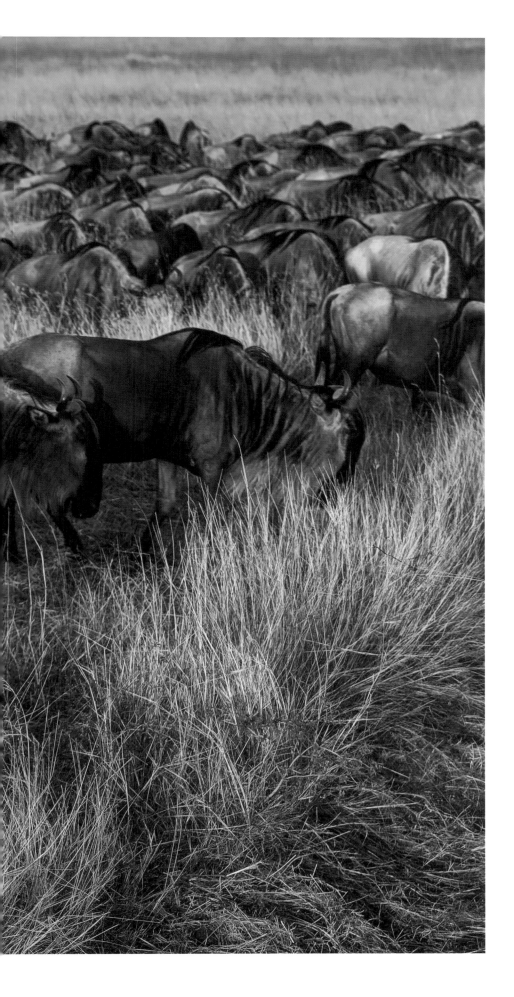

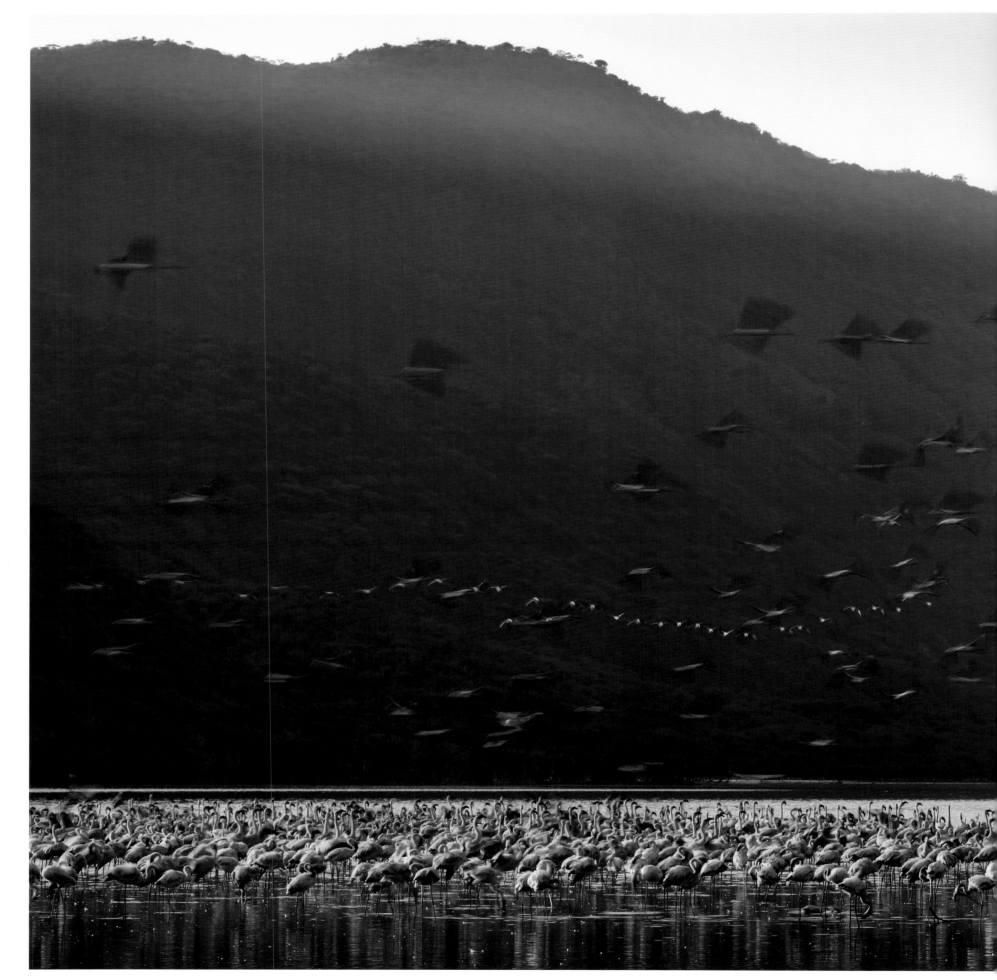

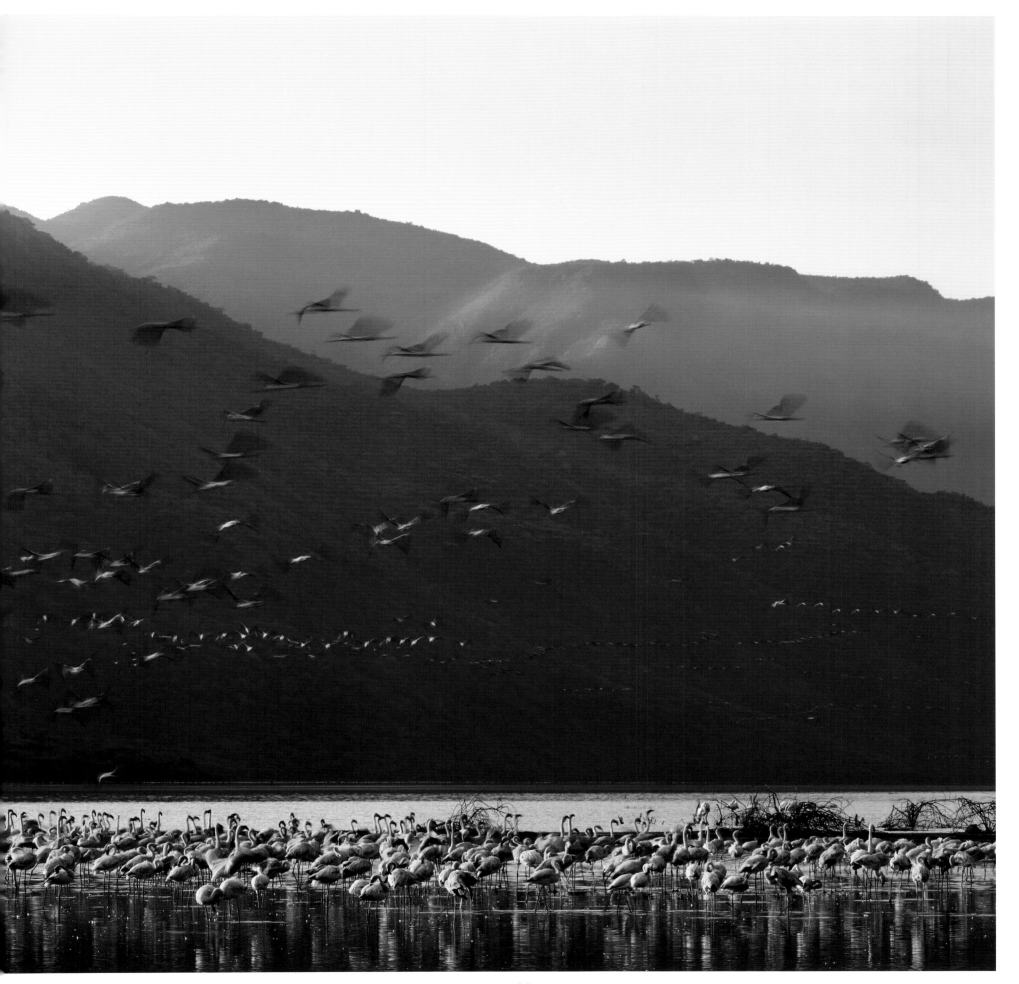

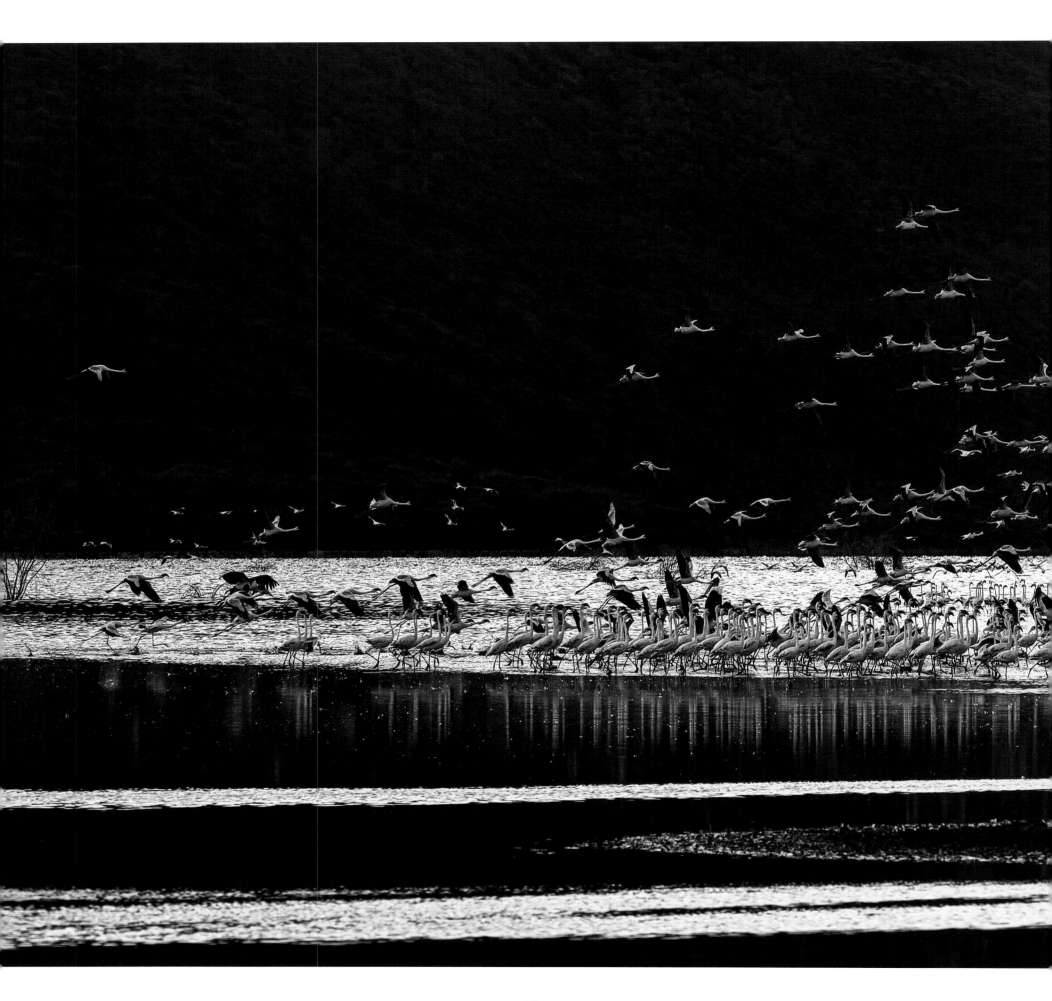

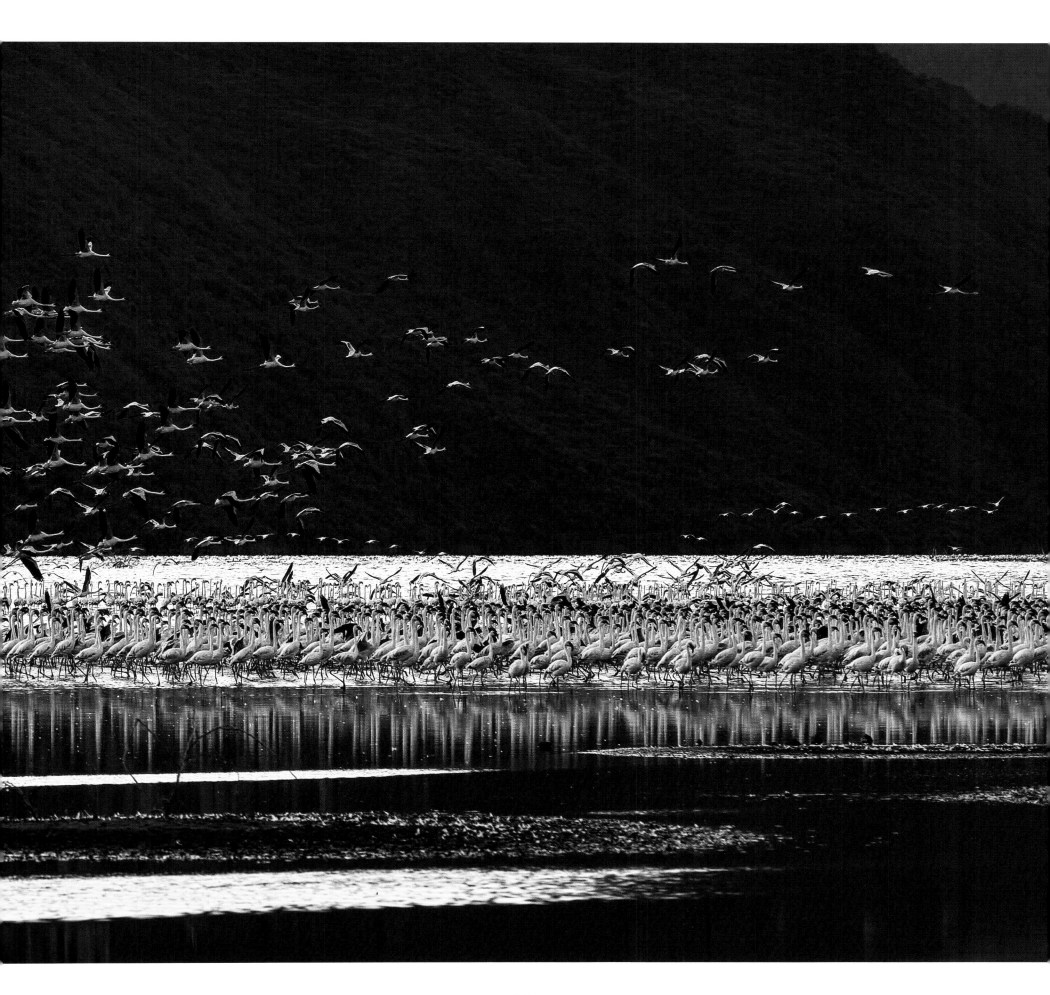

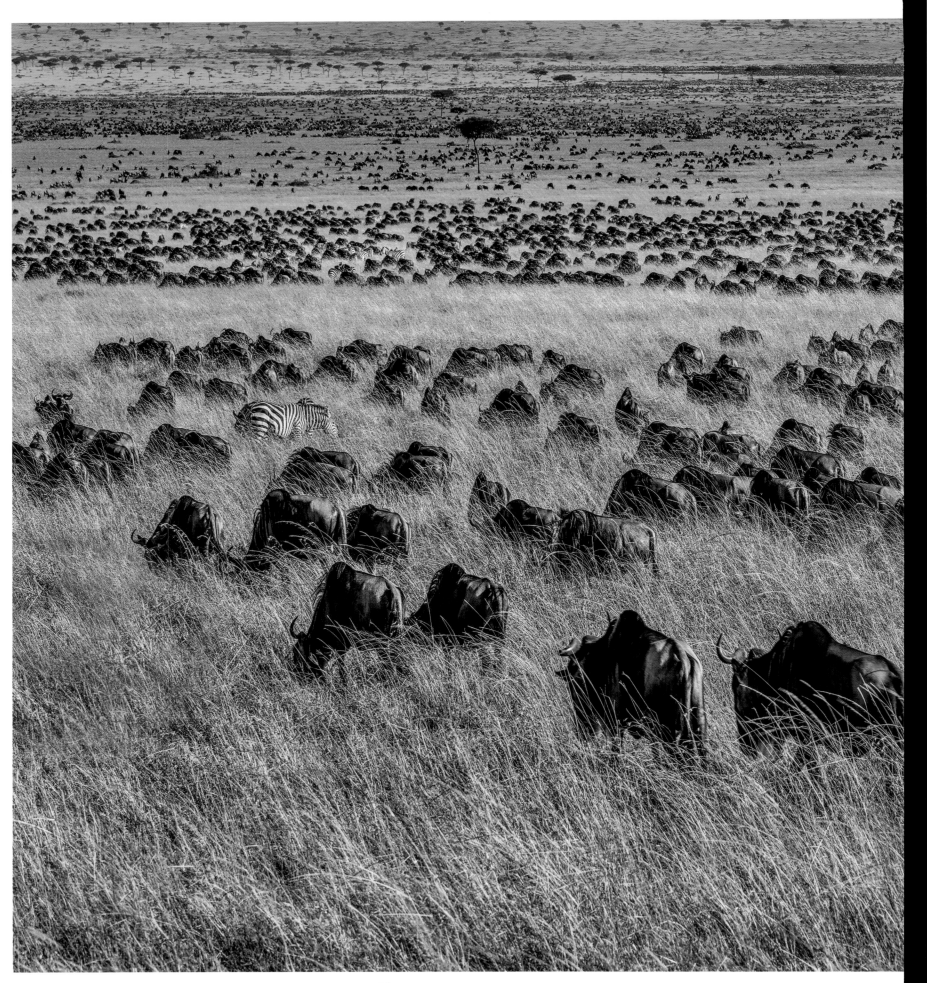

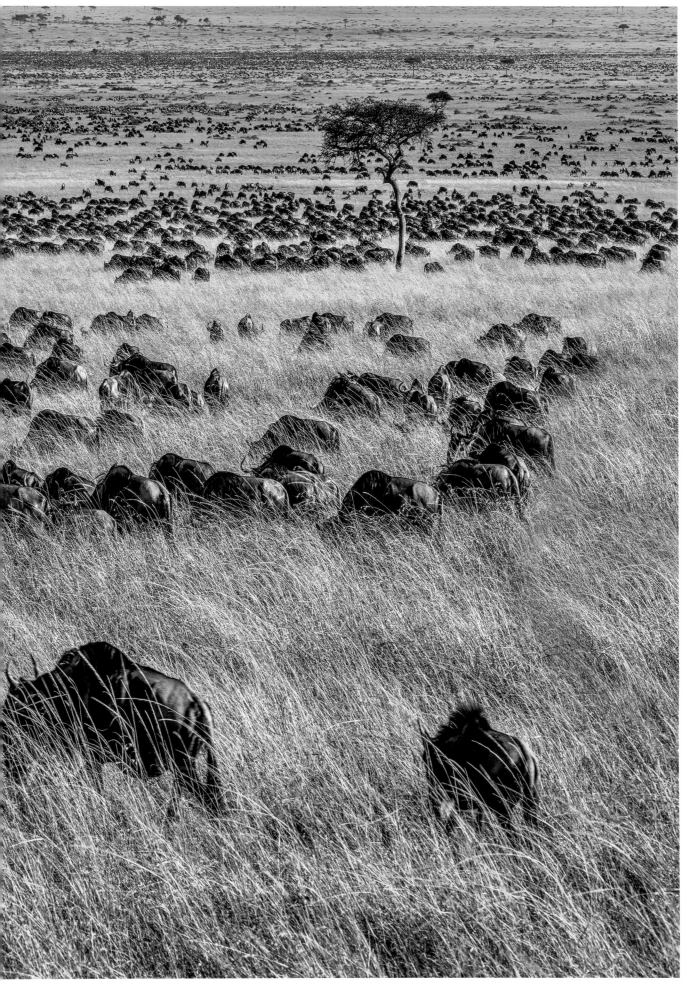

黃 山

Mount Huangshan

明代旅行家徐霞客有云：「登黃山，天下無山，觀止矣！」。

與黃山有緣，次次單飛！一個人的行攝，雖是孤寂，但創作是心與天地的對話，越是放空、不攀緣，越看得懂山。

黃山松的精神、怪石一絕、雲霧帶來的仙氣，構成一幅人間仙境。

鏡頭捕捉的瞬間，正是我心中的畫作「水墨黃山」。

2014 / 2015 / 2016 / 2018　中國安徽省黃山

The great traveler of the Ming Dynasty, Xu Xiake, once said, "When you climb
Huangshan, you see no other mountains in the world, and no greater view!"
I feel a strong bond with Huangshan and every time I have visited the mountain
I have travelled alone. Although a person's journey is lonely, my work creates
a dialogue between the heart and the world. The more one lets go and refrain
pursuing personal gains, the more you can understand the mountains.
The spirit of the pine on Mount Huangshan, the strange rocks, and the enchanted
atmosphere brought about by the clouds and mist constitute a fairyland on earth.
The moment captured with my camera is a "Huangshan Ink Painting" inscribed
on my heart.

Mount Huangshan, Anhui Province, China in 2014, 2015, 2016, and 2018

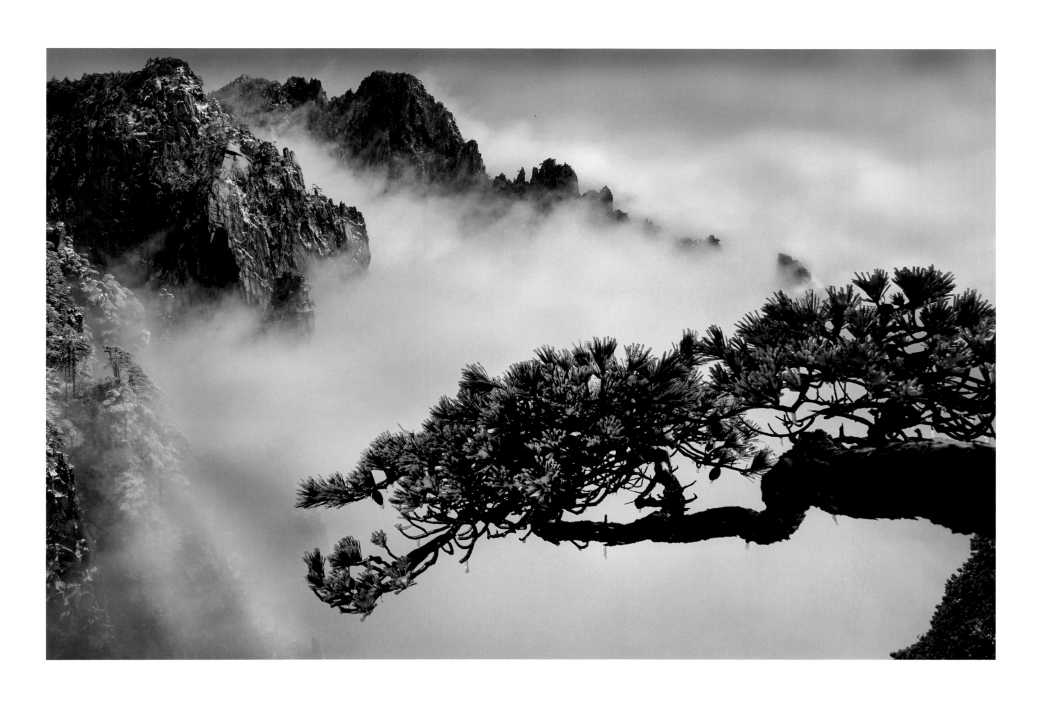

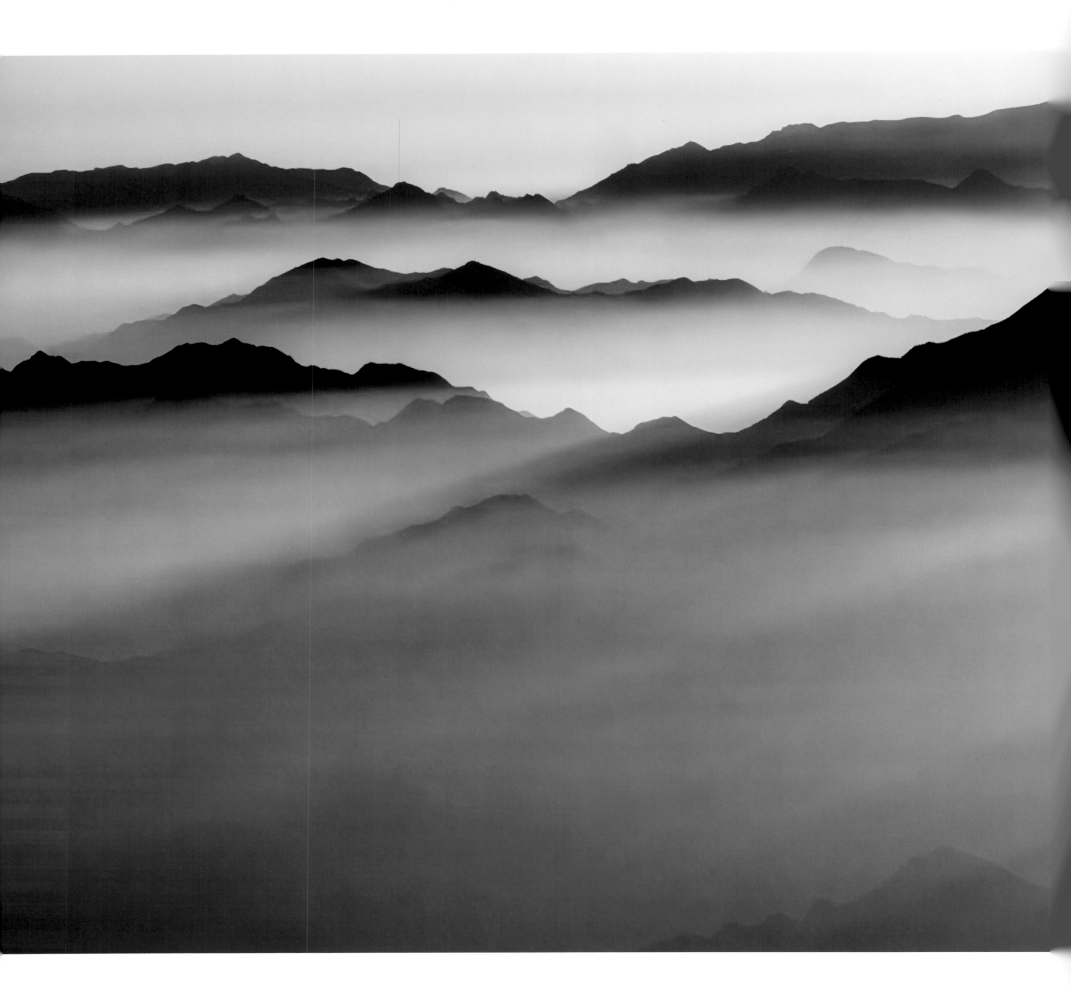

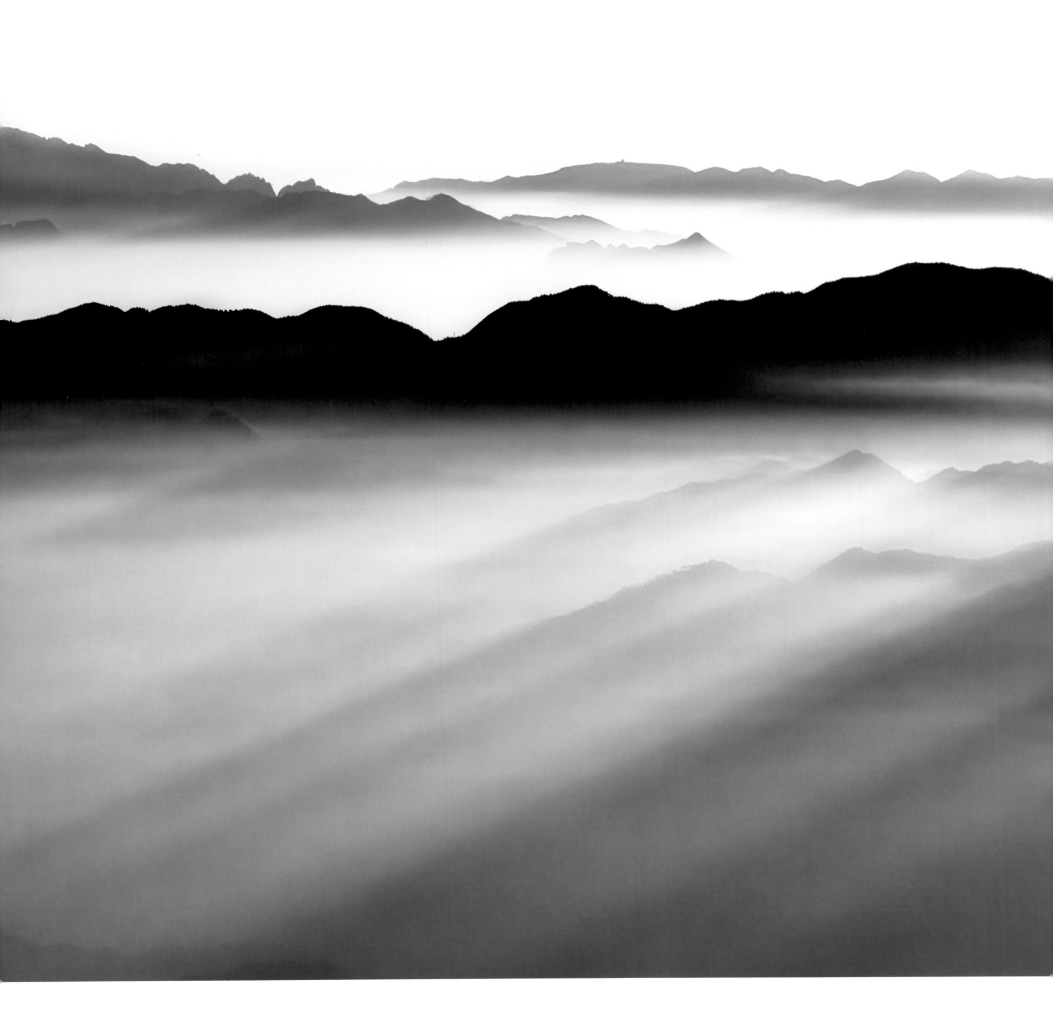

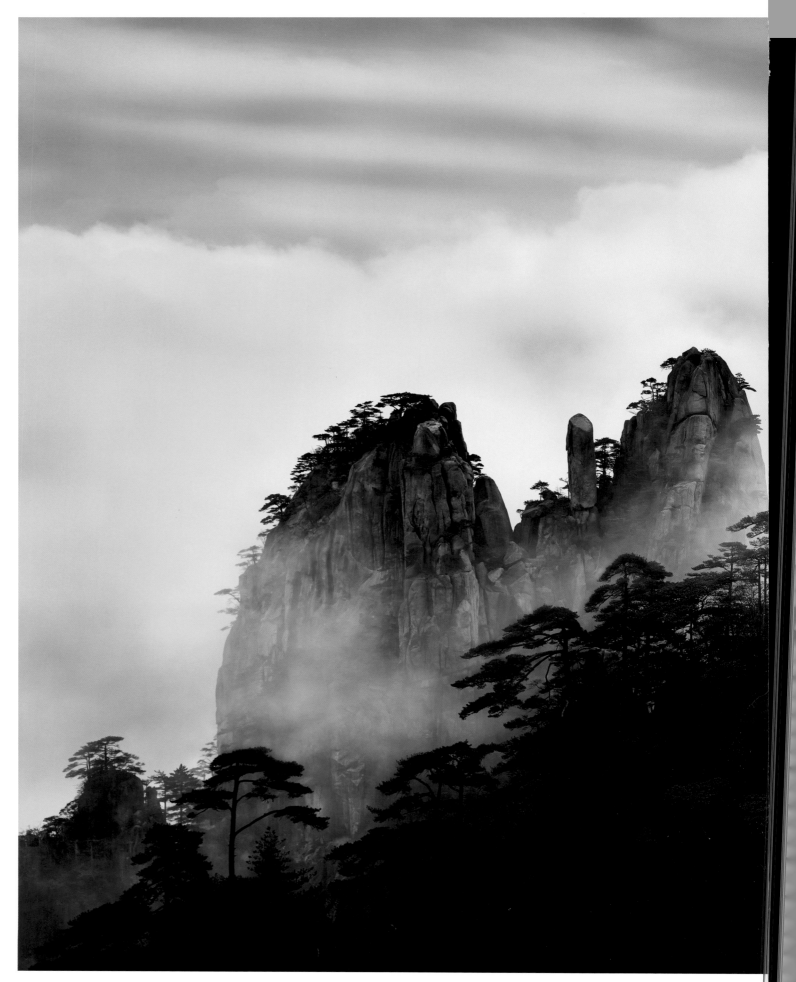

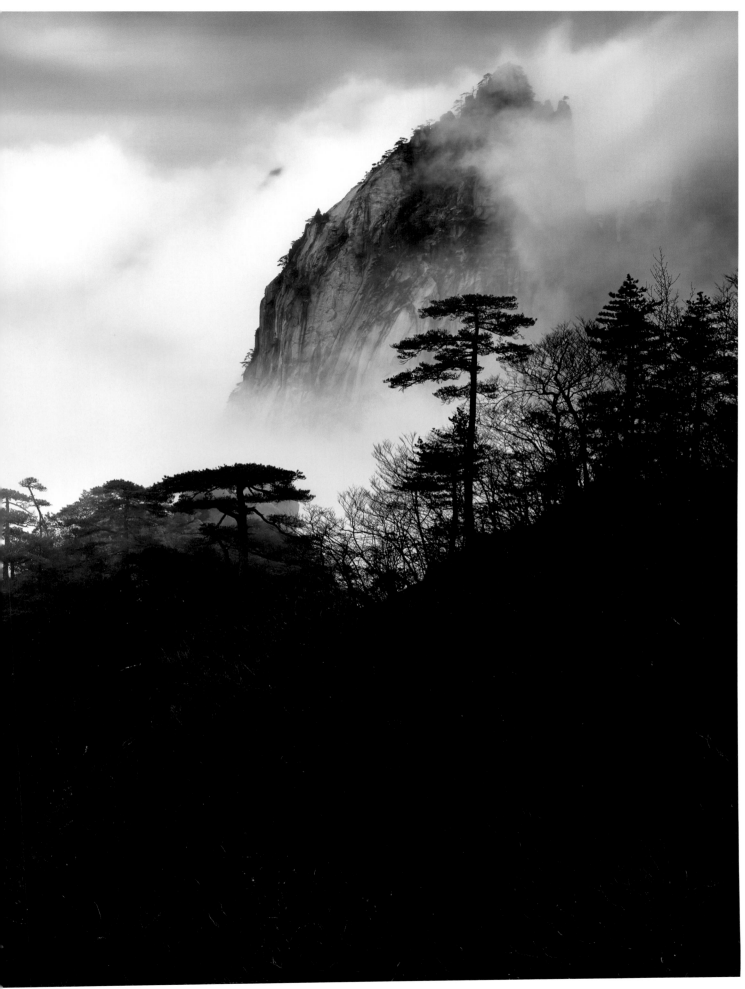

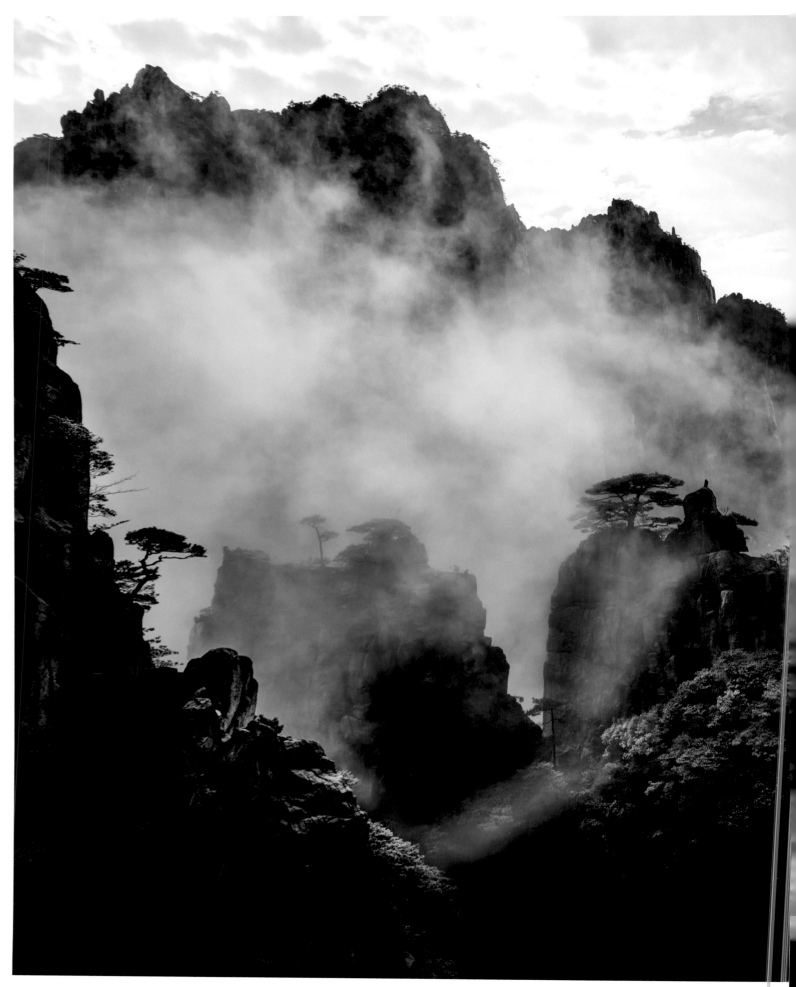

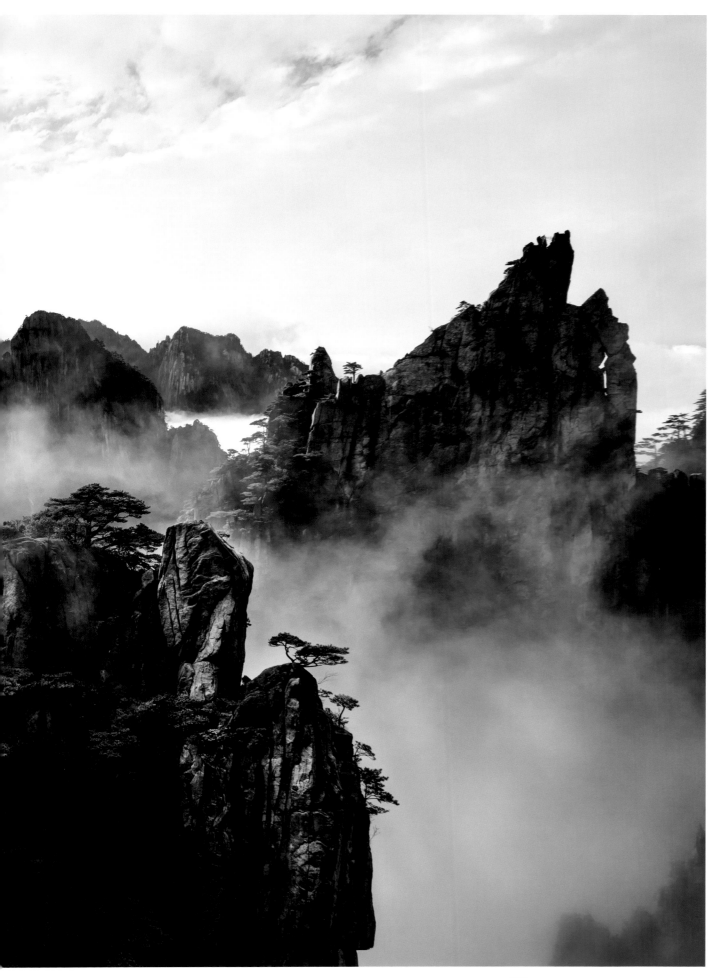

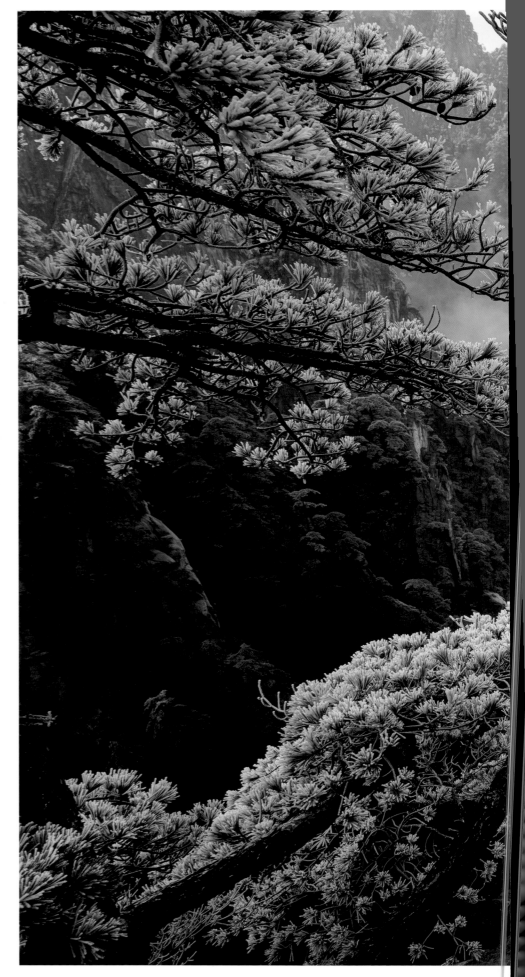

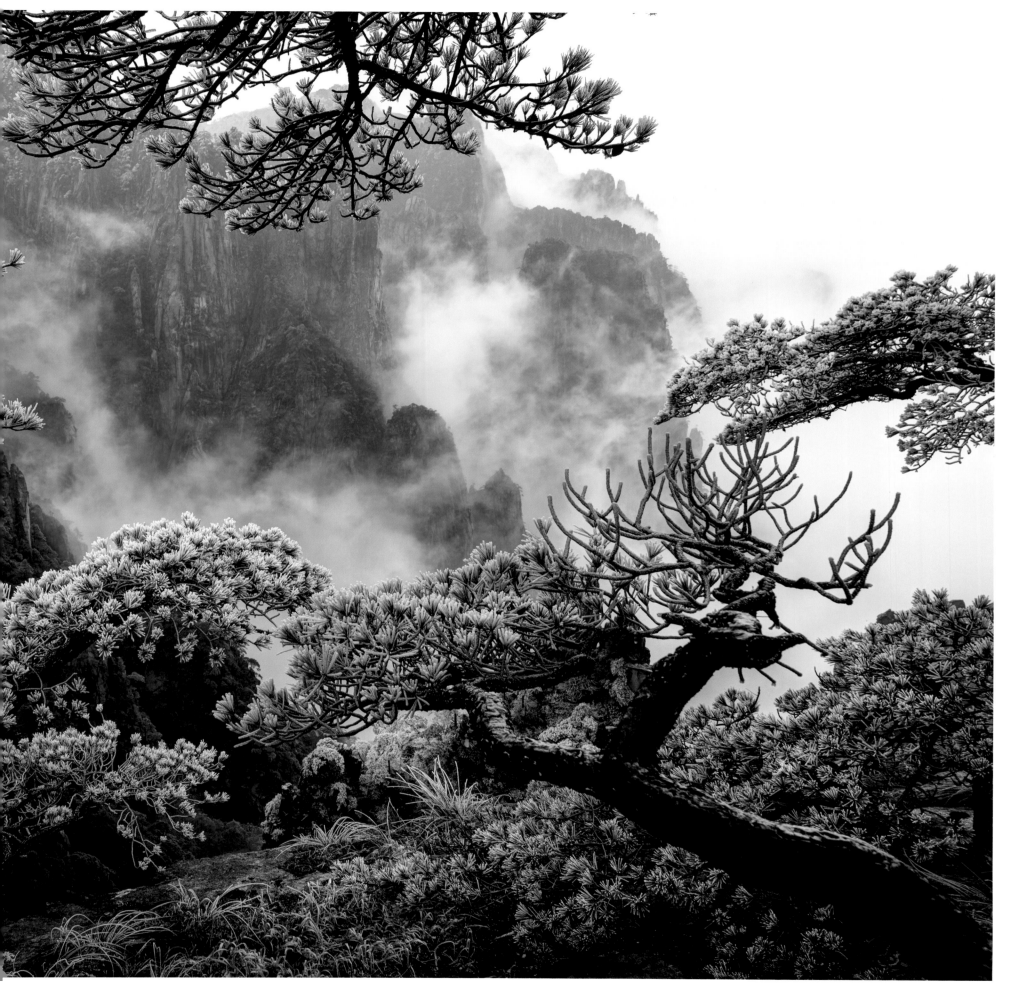

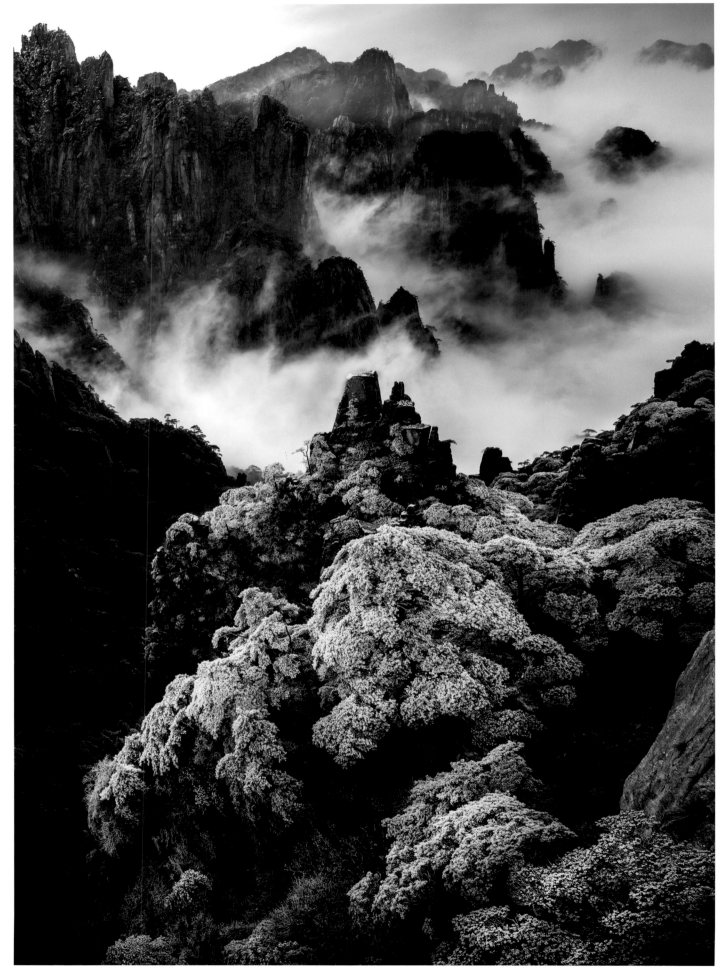

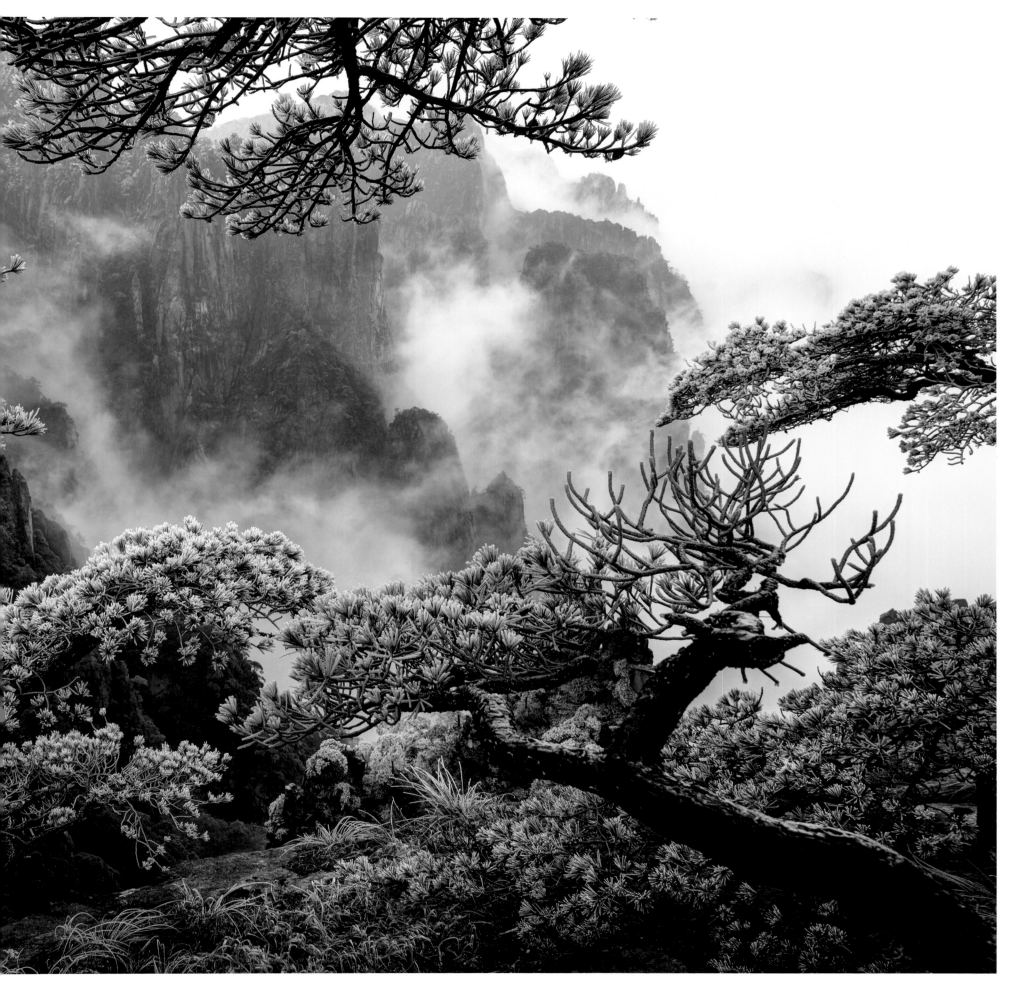

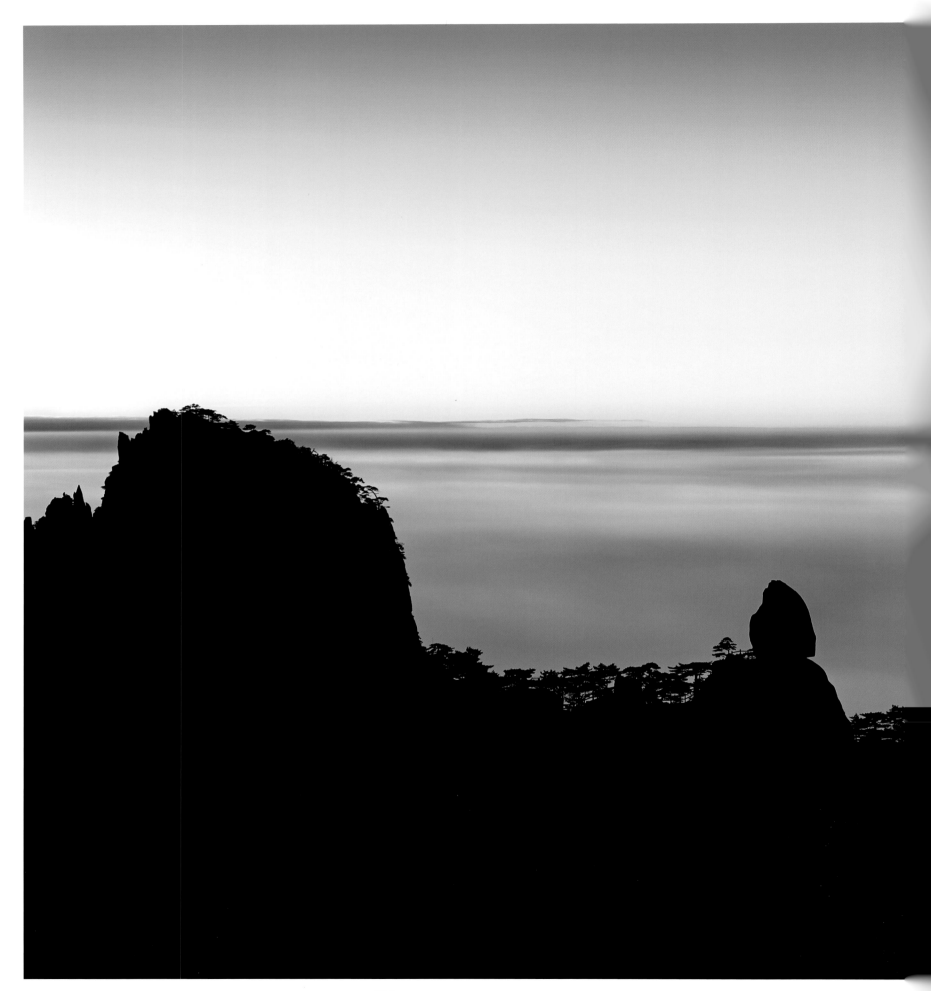

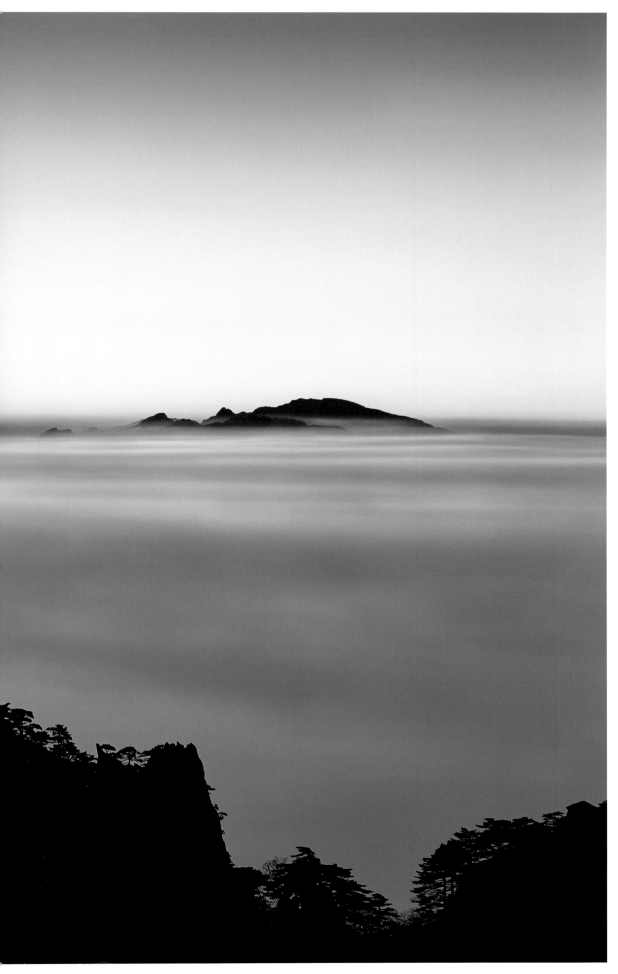

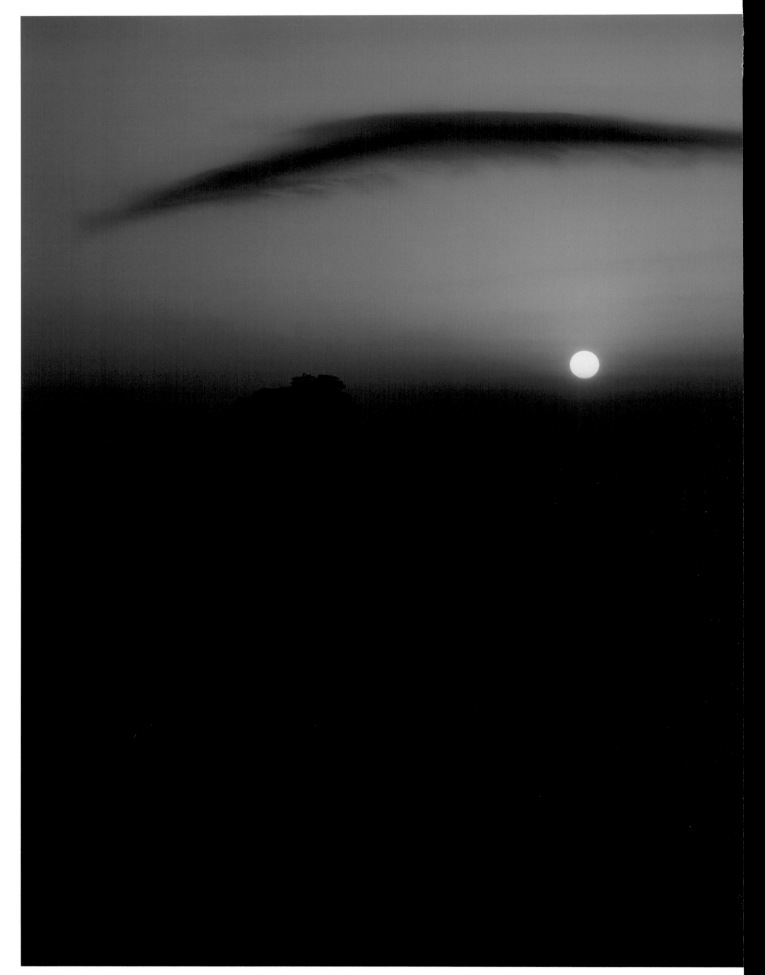

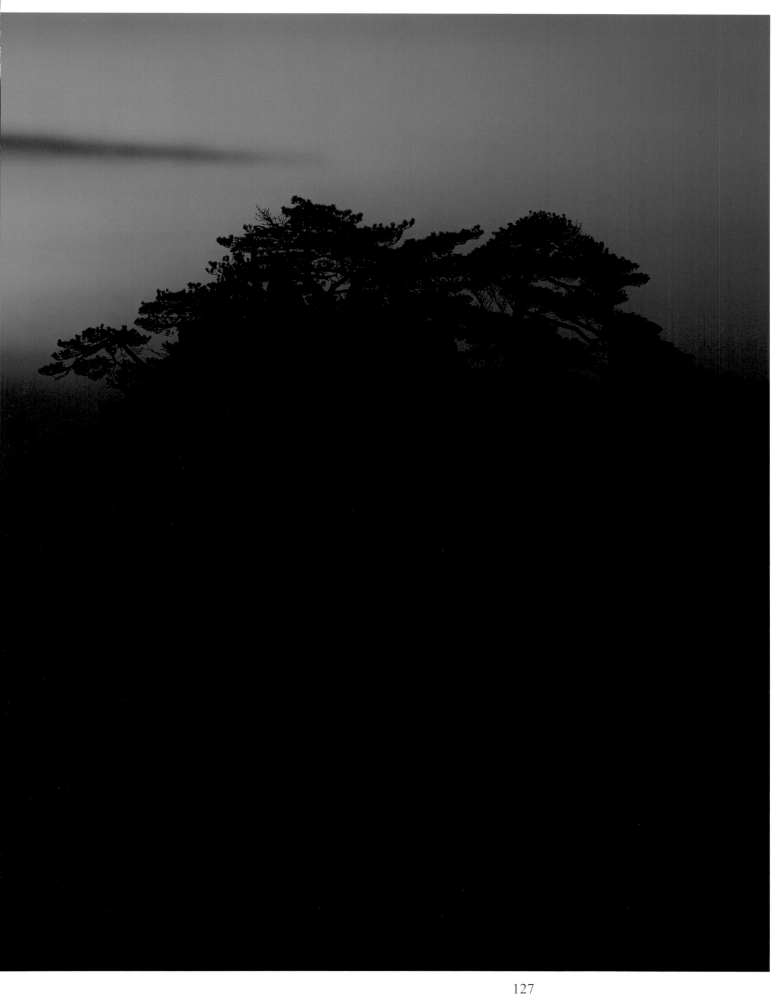

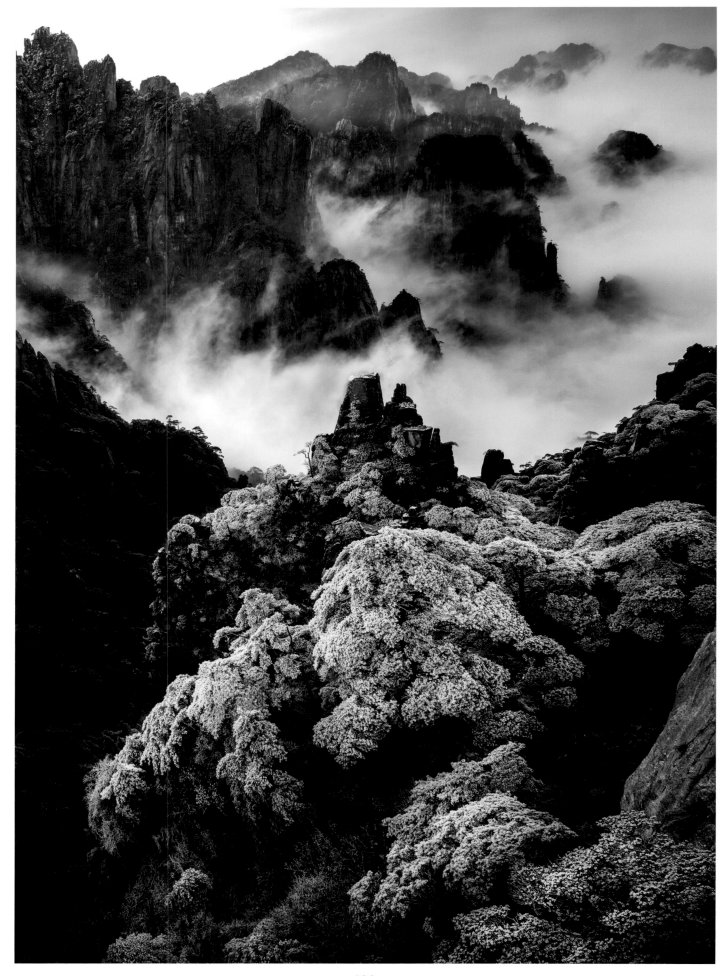

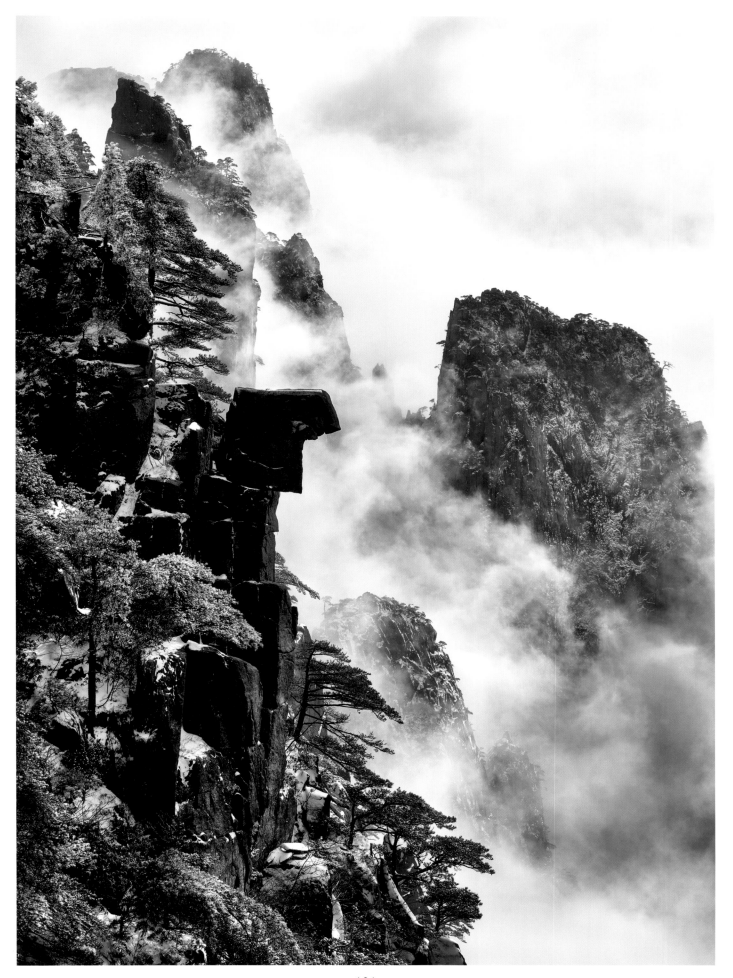

丹頂鶴

Red-Crowned Crane

又稱為「神鶴」。遷徙的丹頂鶴，因頭頂的紅肉冠而得名。一夫一妻制，有吉祥、忠貞、長壽的寓意。

求偶期間，此起彼落的鶴舞，讓賞鶴人的快門按個不停，心情也隨之起舞。

全世界目前發現有15種的鶴，丹頂鶴的數量最少，被聯合國列為瀕危的一級保護動物。

貼近鶴群，攝取一幅幅美麗的身影。不知是牠們從畫中走來，還是我走入了畫中？

2017 日本北海道 / 中國黑龍江
2019 韓國首爾

Also known as "fairy crane". The migrating red-crowned cranes are named for a patch of red bare skin on their crown. They are monogamous and long-lived birds, known as the symbol of auspiciousness, fidelity and longevity.

During mating season, the cranes dance in pairs one after another. These scenes make the observers feel as if they are dancing as well. They can't help pressing the shutter-release button on the camera to capture the sight.

There are currently 15 species of cranes in the world, of which the red-crowned crane is the rarest and classified as a first-class endangered species by the United Nations.

I got opportunities to get close to the cranes and capture their beautiful figures.

I am still not sure if they had stepped out of a painting, or if I had walked into the painting.

Hokkaido, Japan and Heilongjiang province, China in 2017, and Seoul, South Korea in 2019

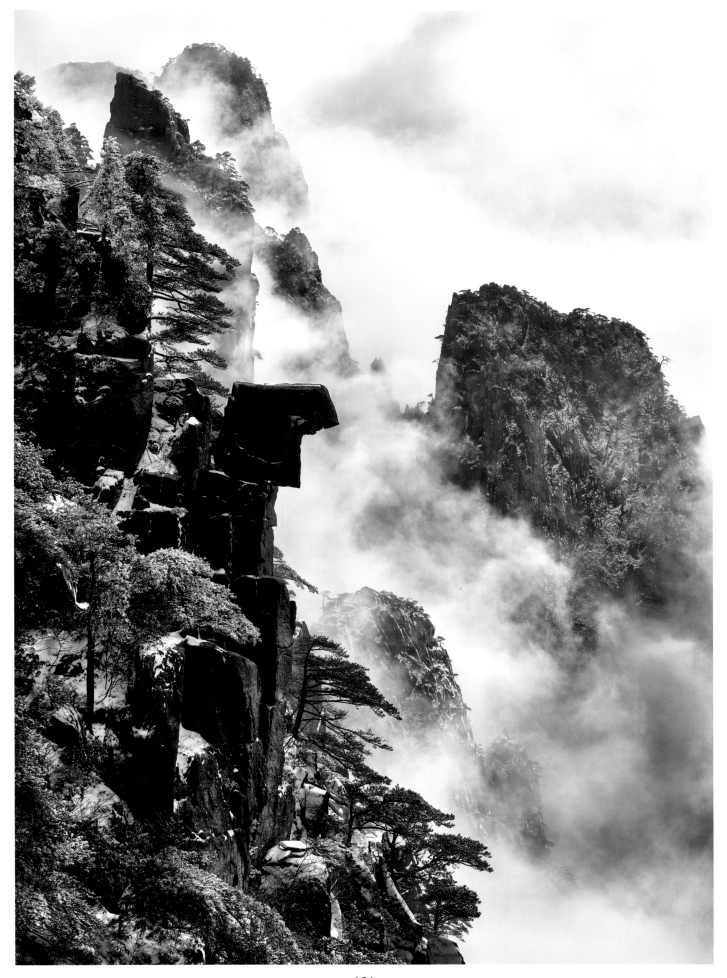

丹 頂 鶴

Red-Crowned Crane

又稱為「神鶴」。遷徙的丹頂鶴，因頭頂的紅肉冠而得名。一夫一妻制，有吉祥、忠貞、長壽的寓意。

求偶期間，此起彼落的鶴舞，讓賞鶴人的快門按個不停，心情也隨之起舞。

全世界目前發現有15種的鶴，丹頂鶴的數量最少，被聯合國列為瀕危的一級保護動物。

貼近鶴群，攝取一幅幅美麗的身影。不知是牠們從畫中走來，還是我走入了畫中？

2017　日本北海道 / 中國黑龍江
2019　韓國首爾

Also known as "fairy crane". The migrating red-crowned cranes are named for a patch of red bare skin on their crown. They are monogamous and long-lived birds, known as the symbol of auspiciousness, fidelity and longevity.

During mating season, the cranes dance in pairs one after another. These scenes make the observers feel as if they are dancing as well. They can't help pressing the shutter-release button on the camera to capture the sight.

There are currently 15 species of cranes in the world, of which the red-crowned crane is the rarest and classified as a first-class endangered species by the United Nations.

I got opportunities to get close to the cranes and capture their beautiful figures.

I am still not sure if they had stepped out of a painting, or if I had walked into the painting.

Hokkaido, Japan and Heilongjiang province, China in 2017, and Seoul, South Korea in 2019

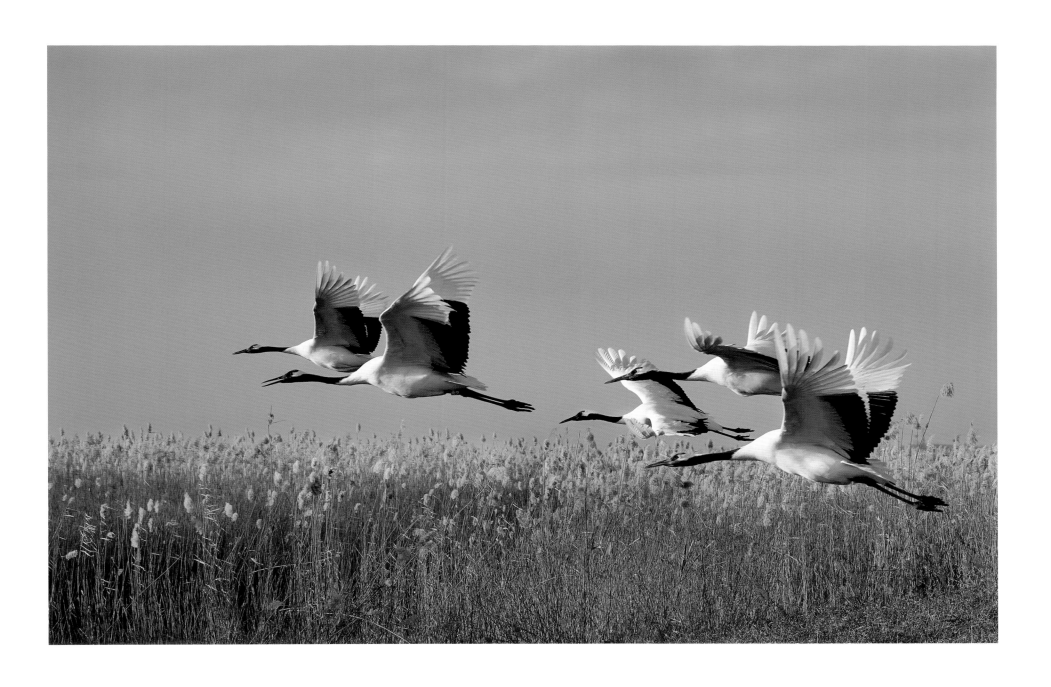

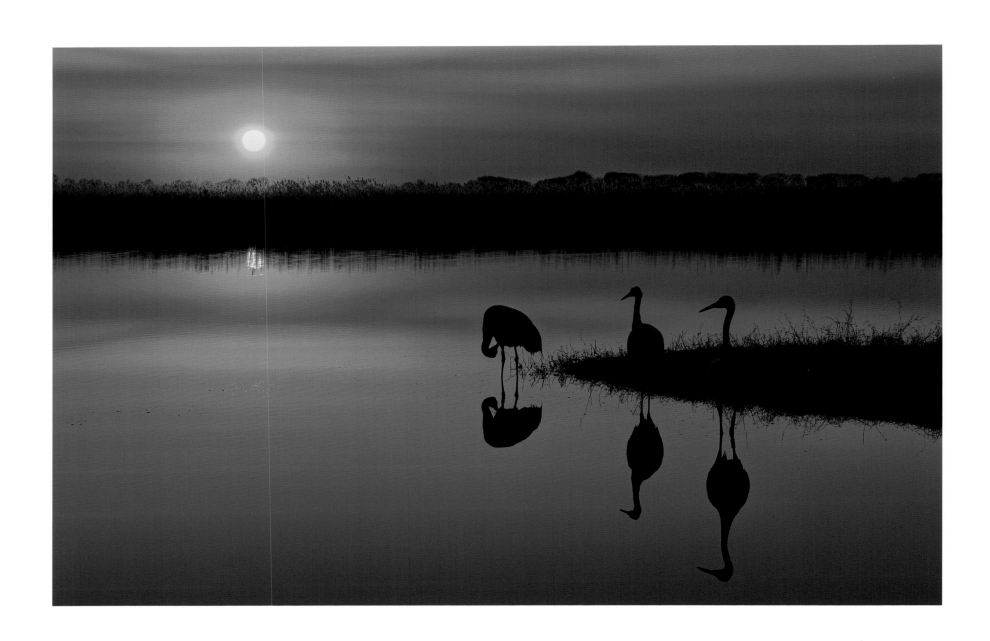

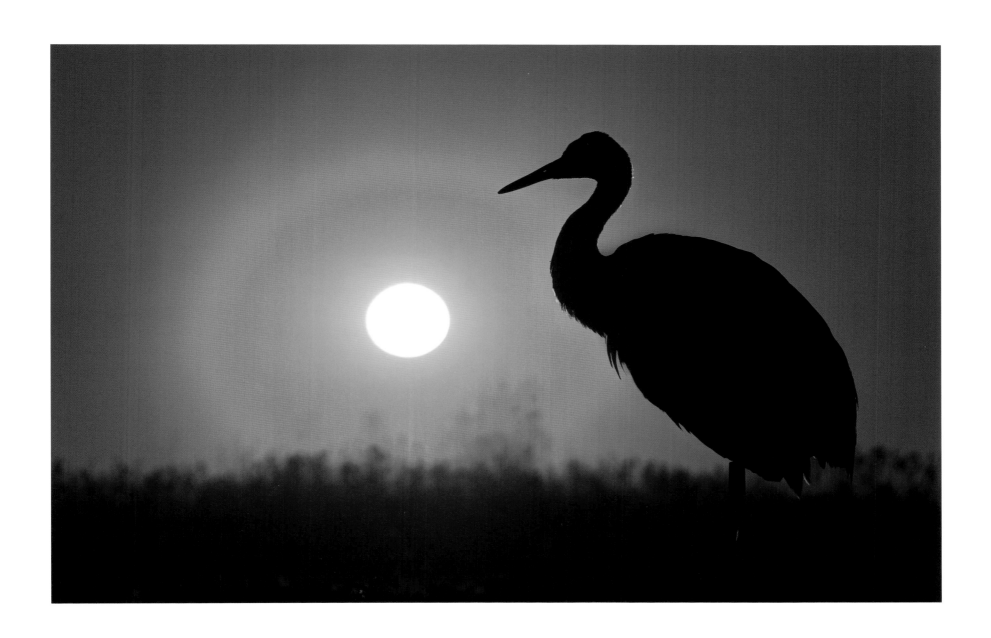

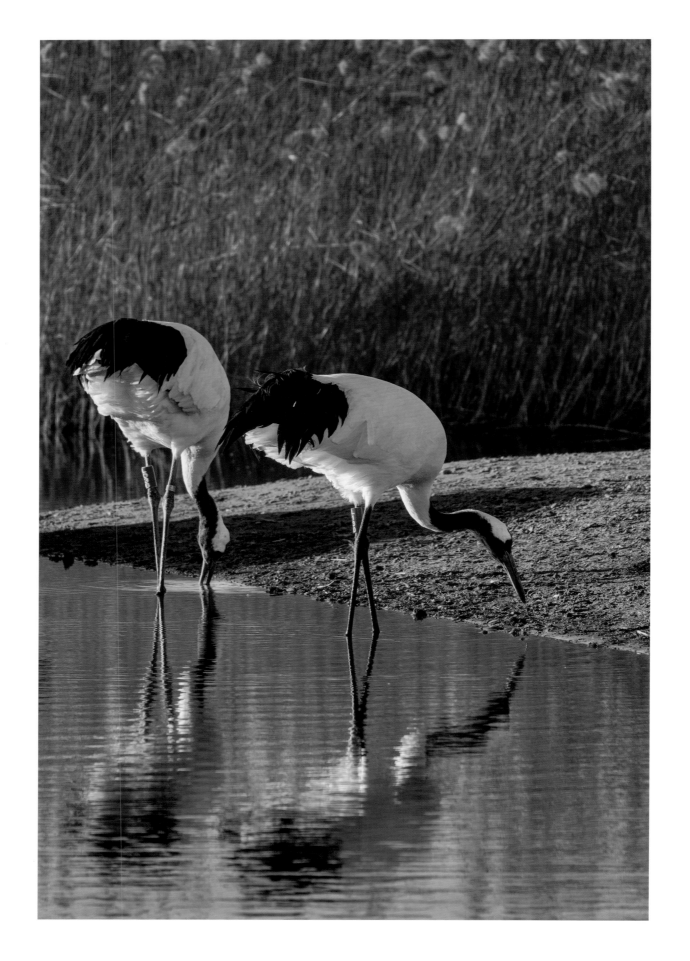

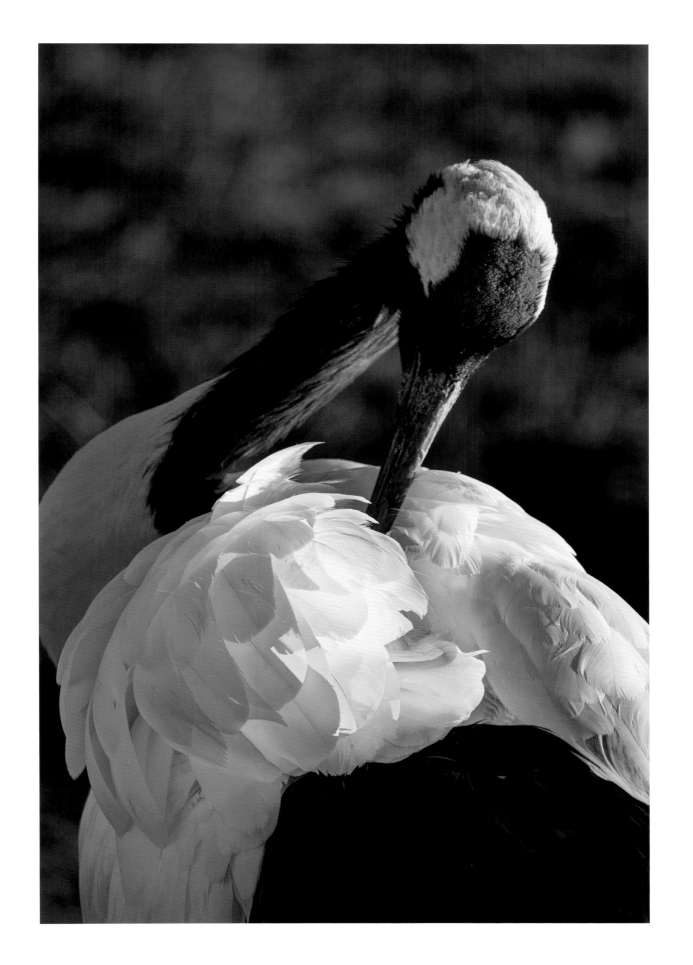

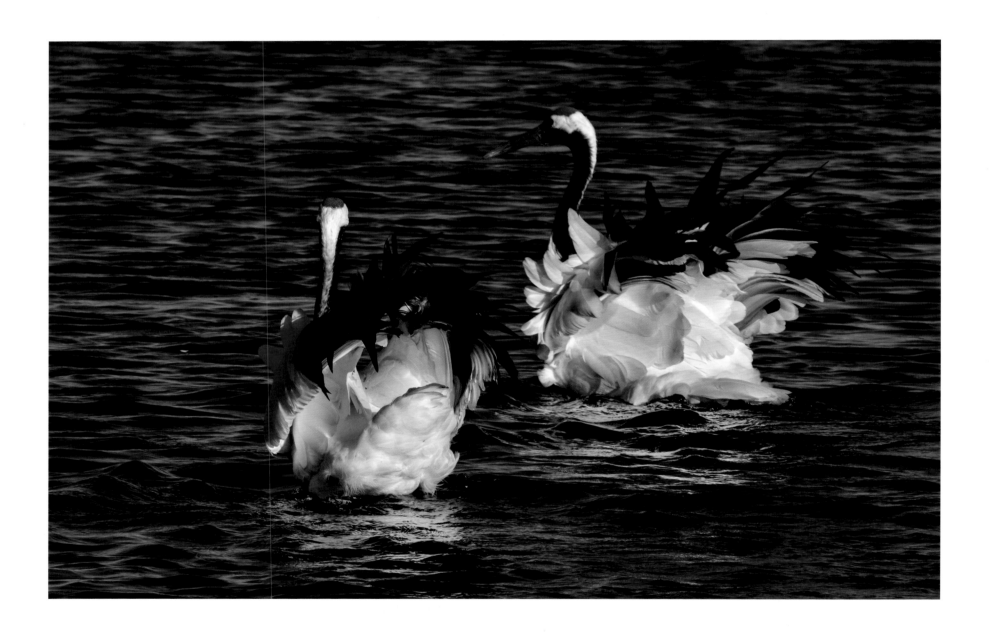

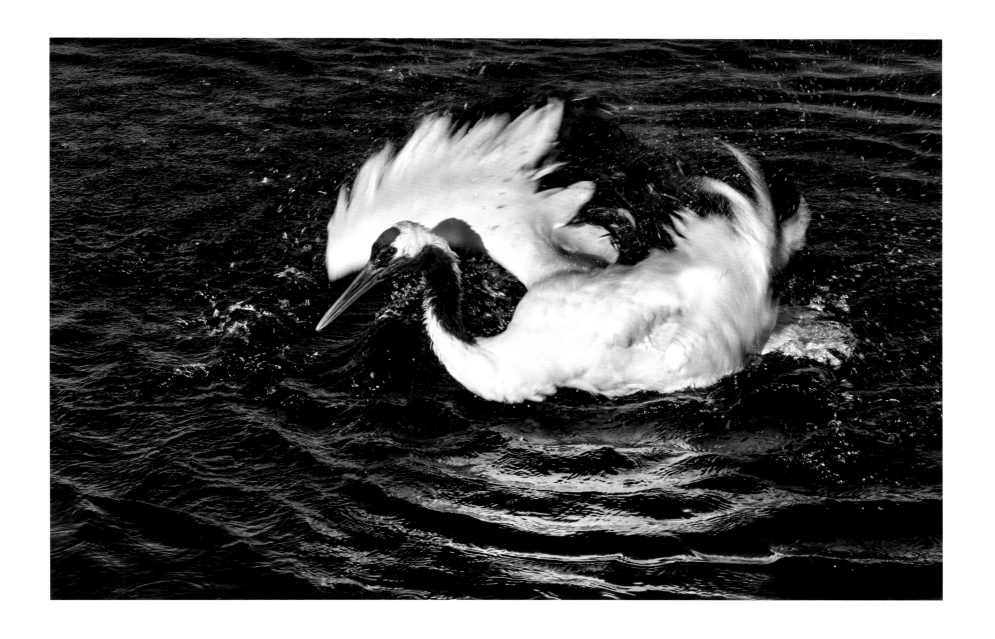

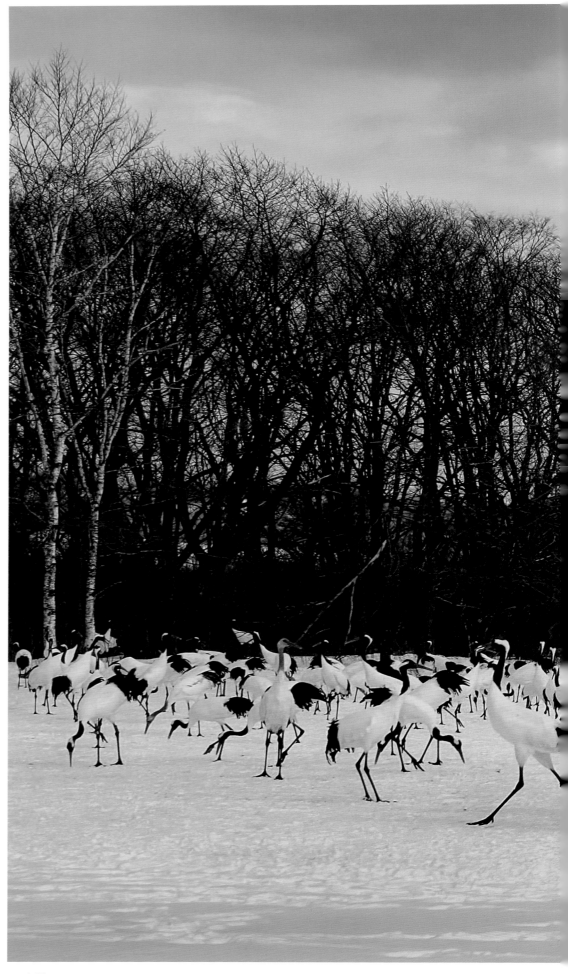

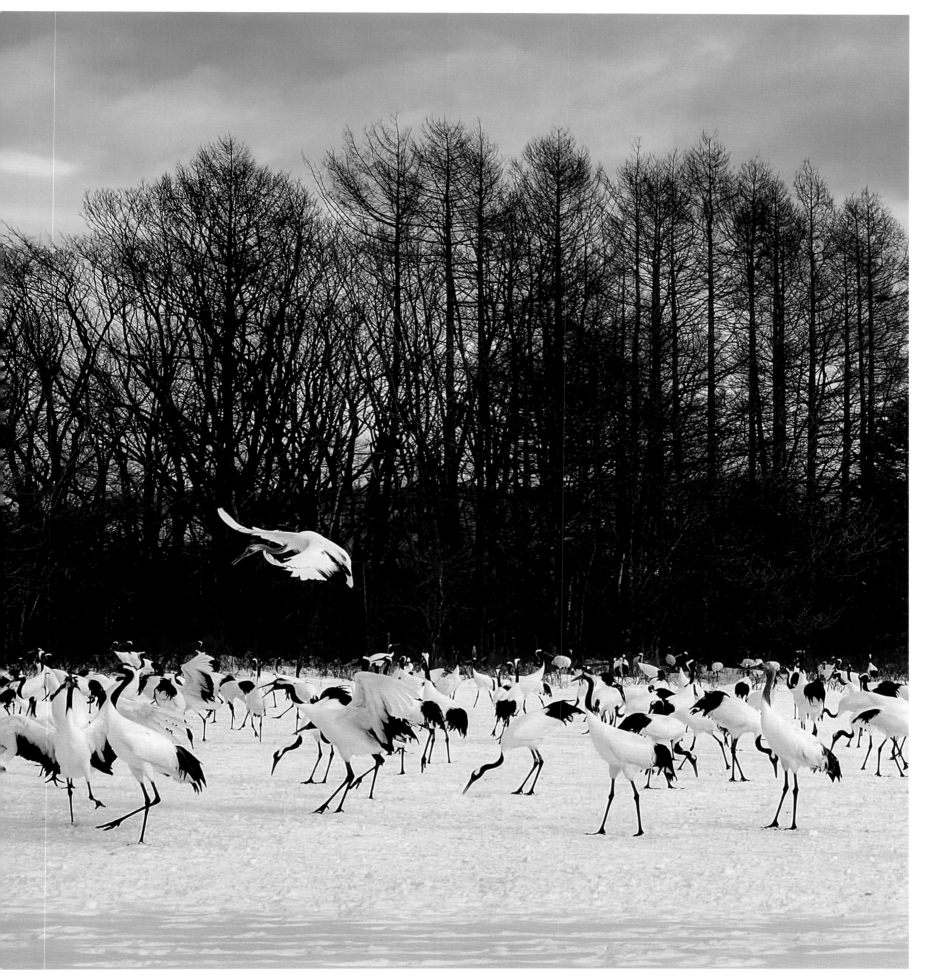

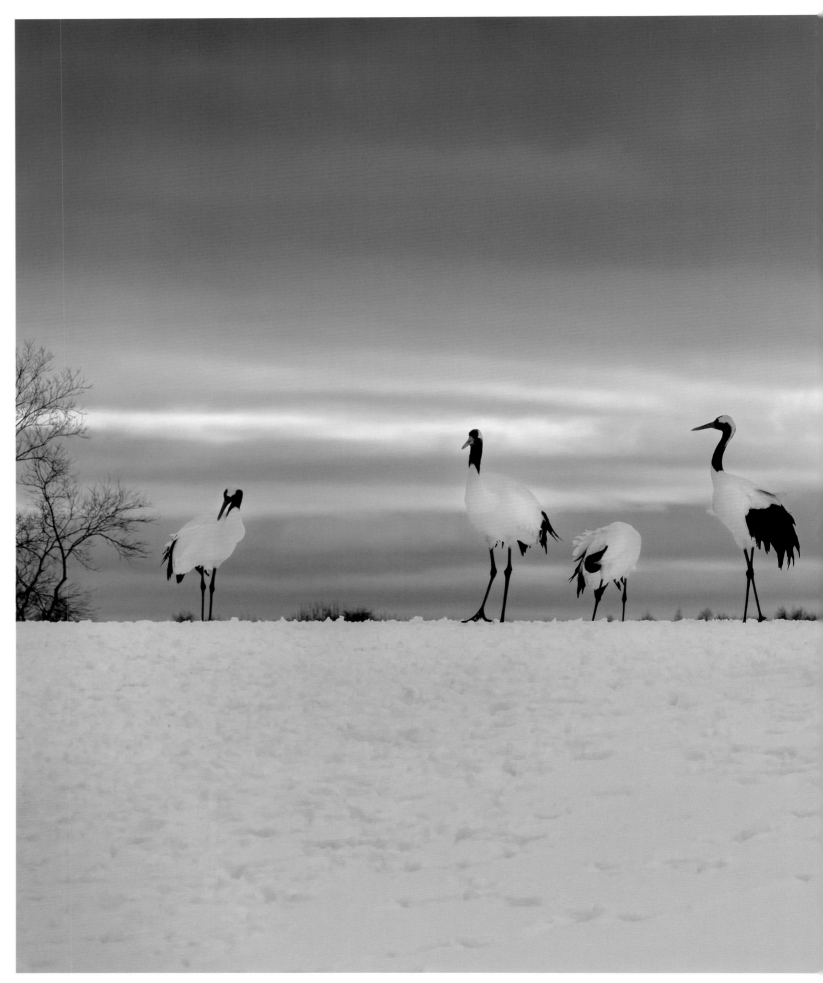

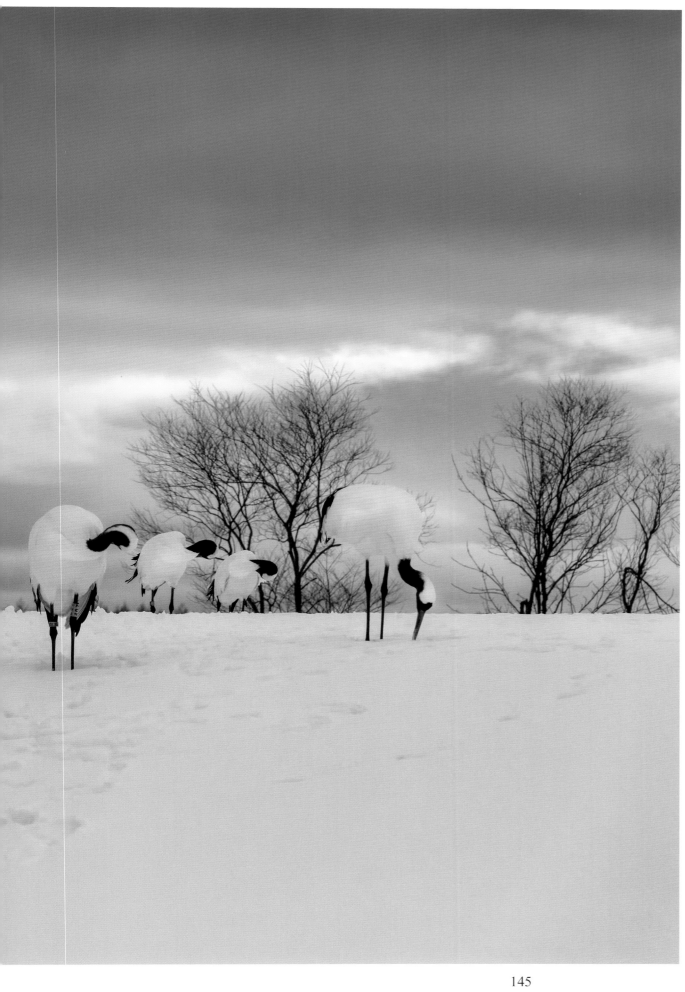

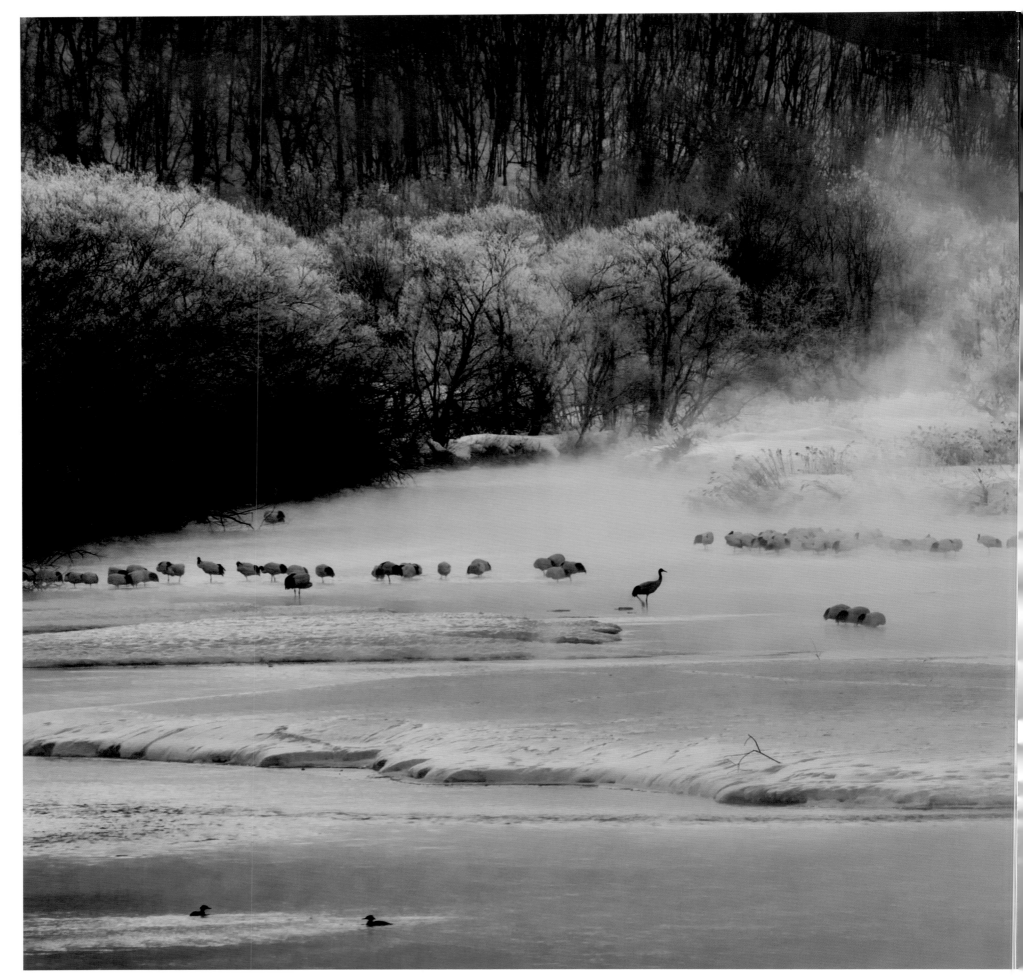

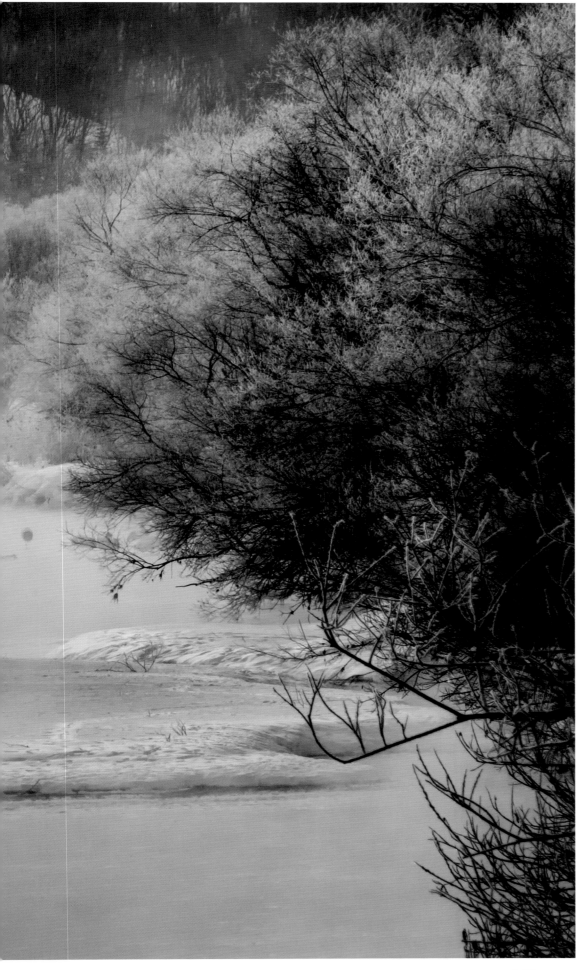

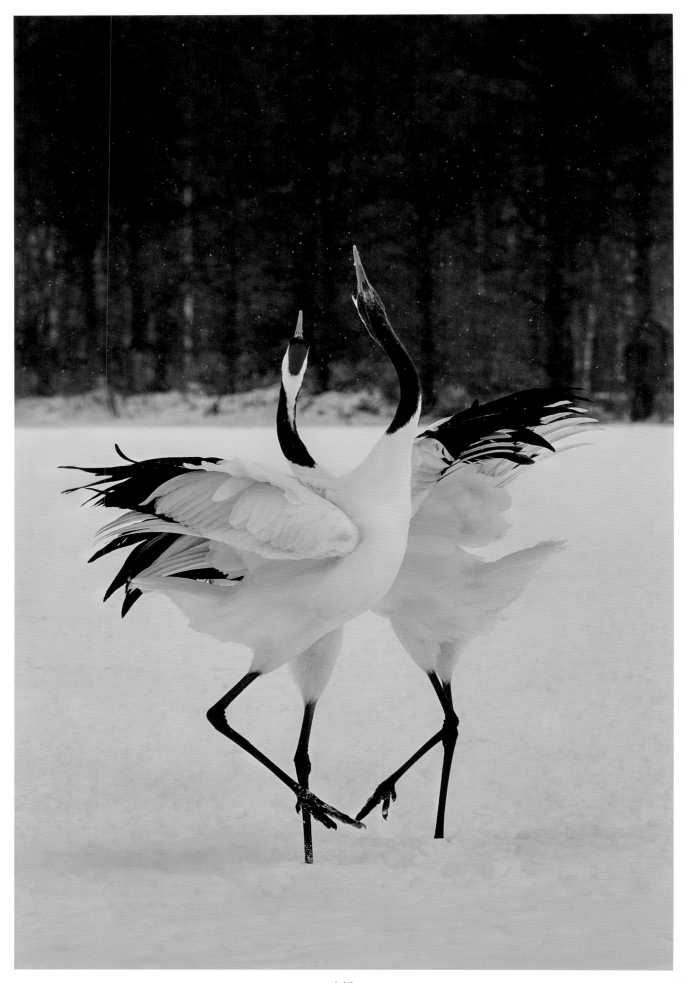

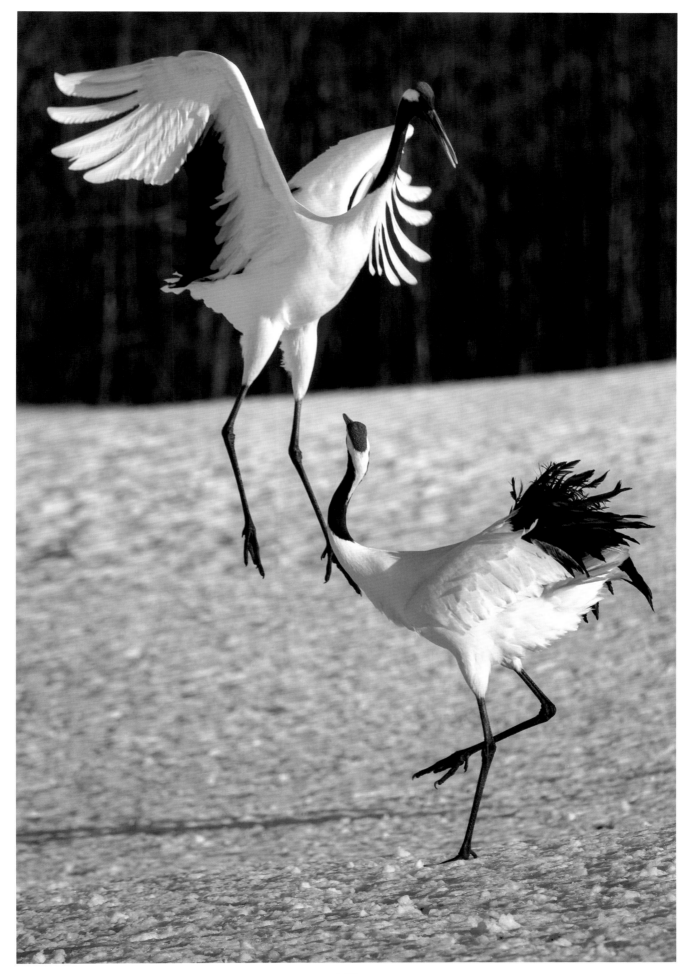

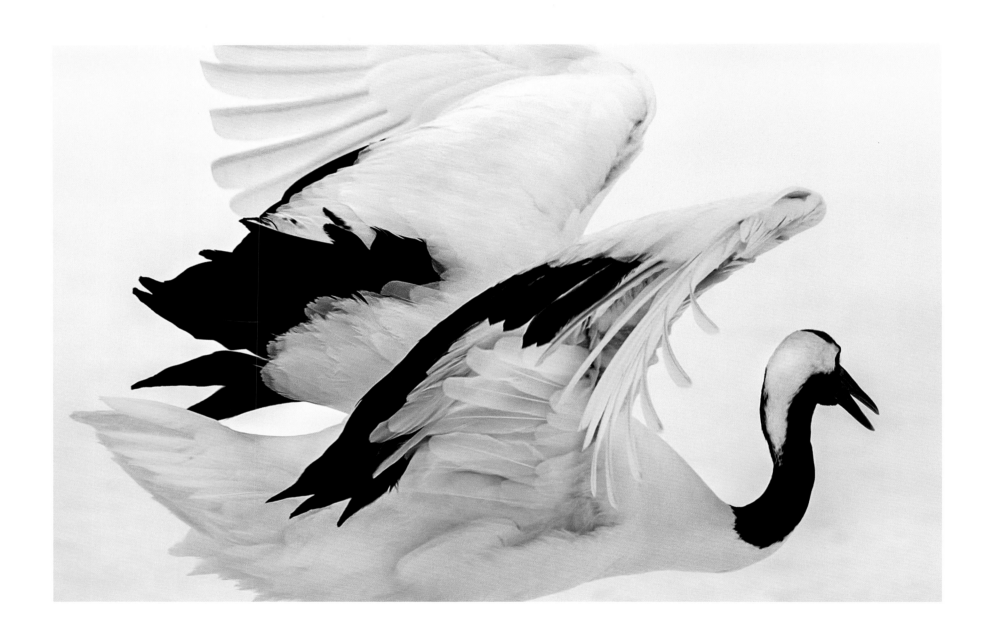

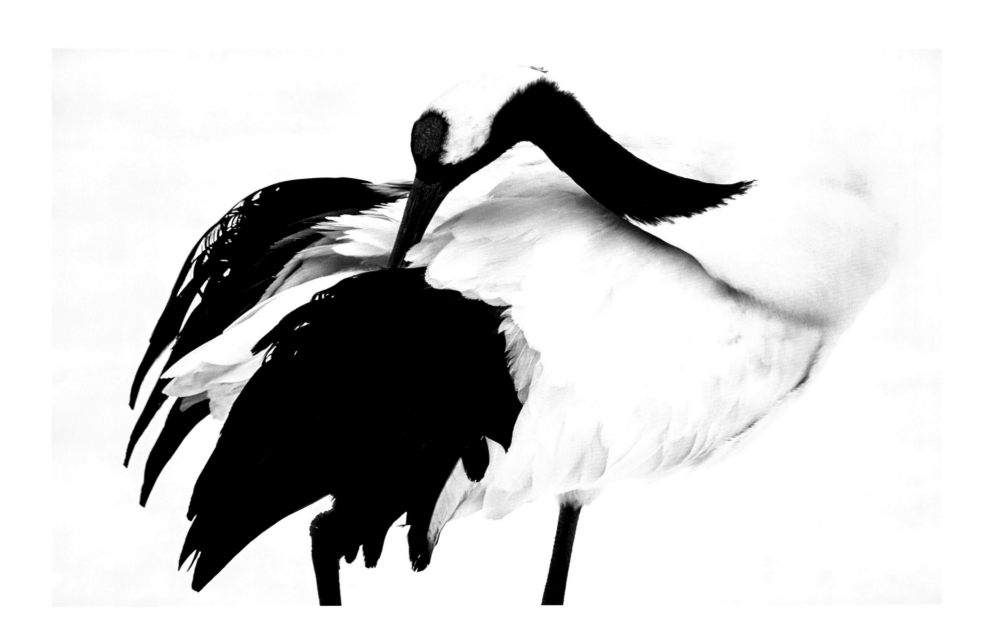

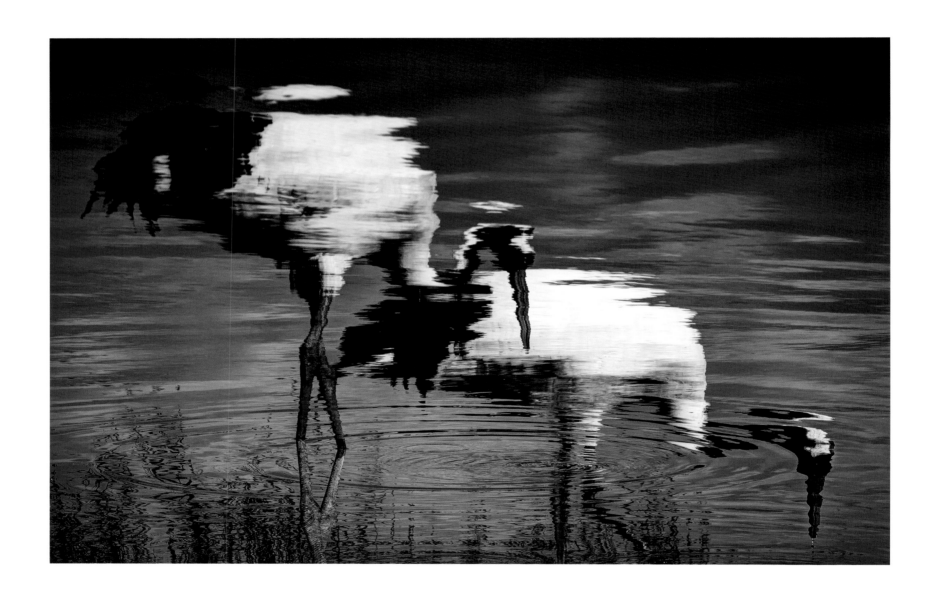

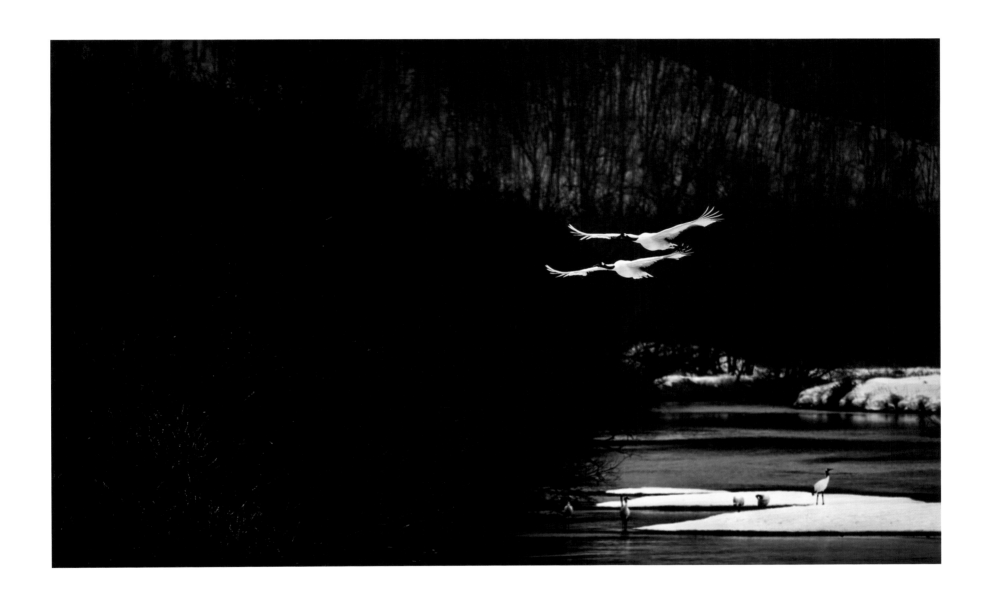

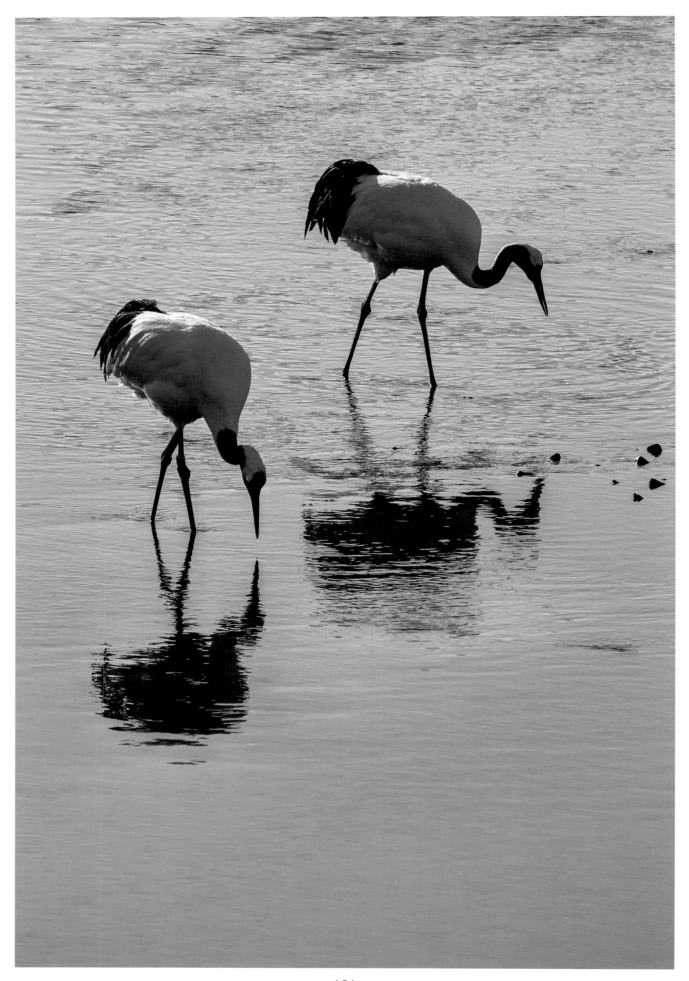

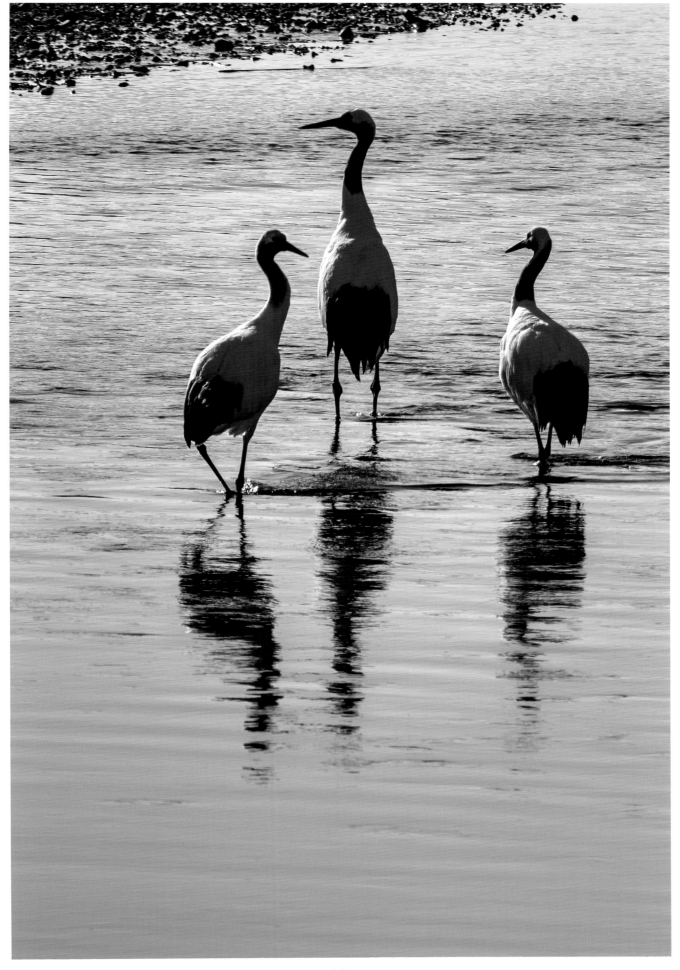

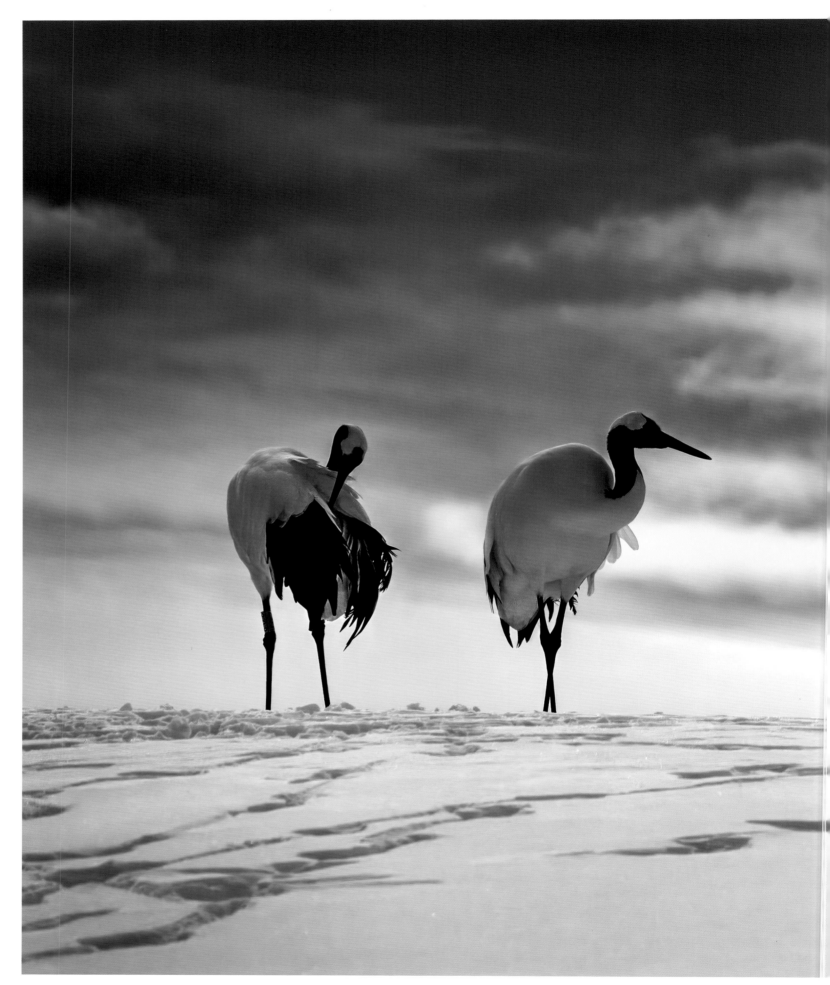

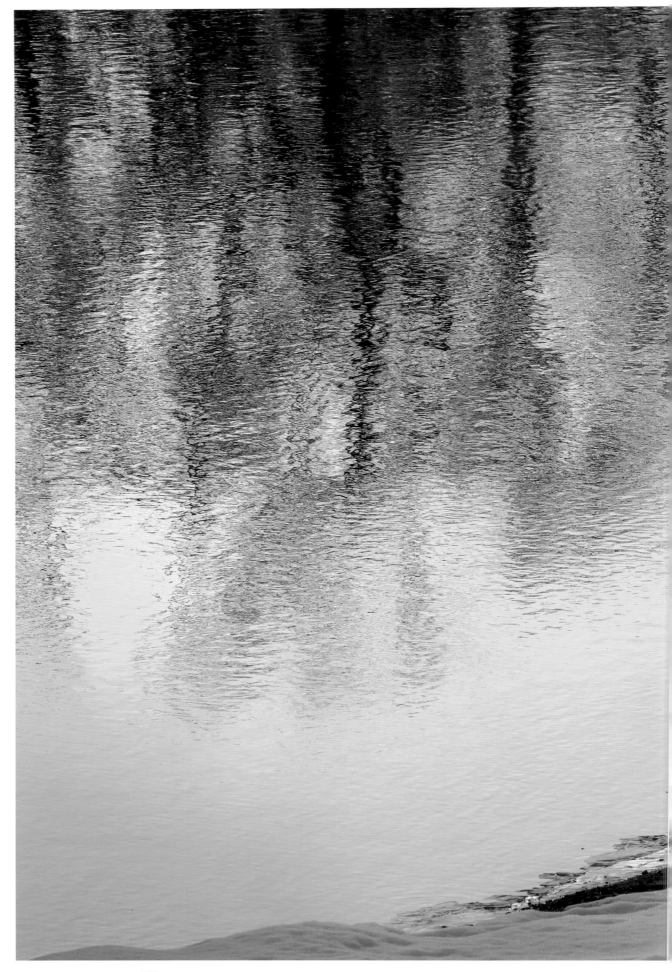

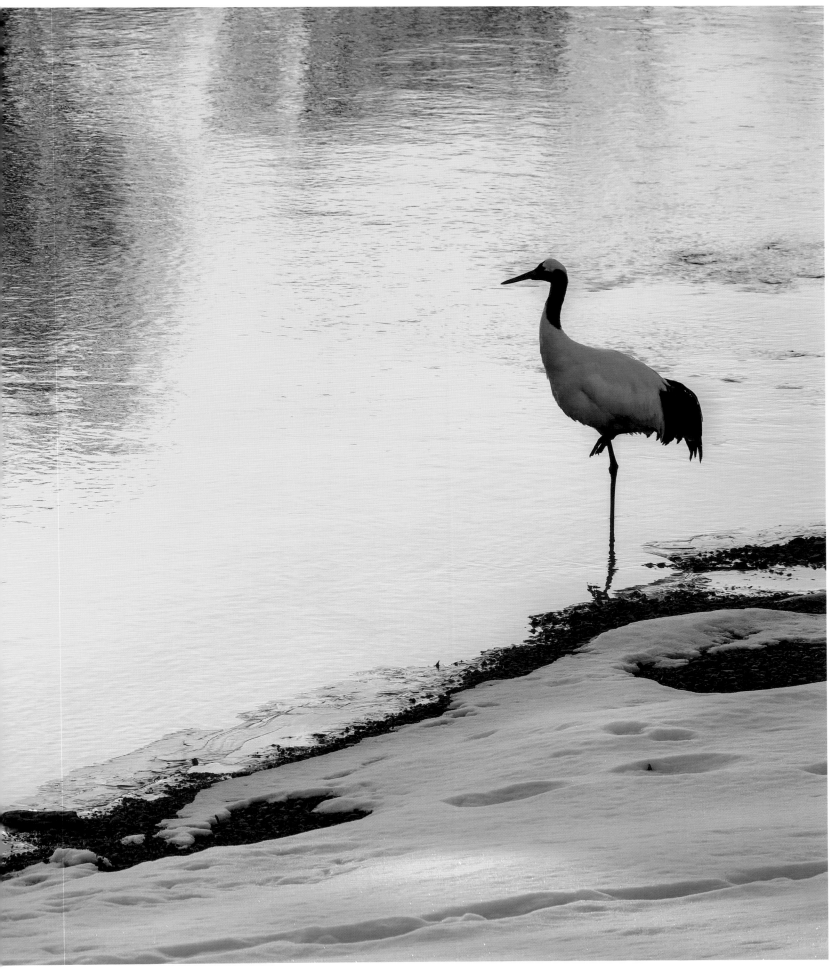

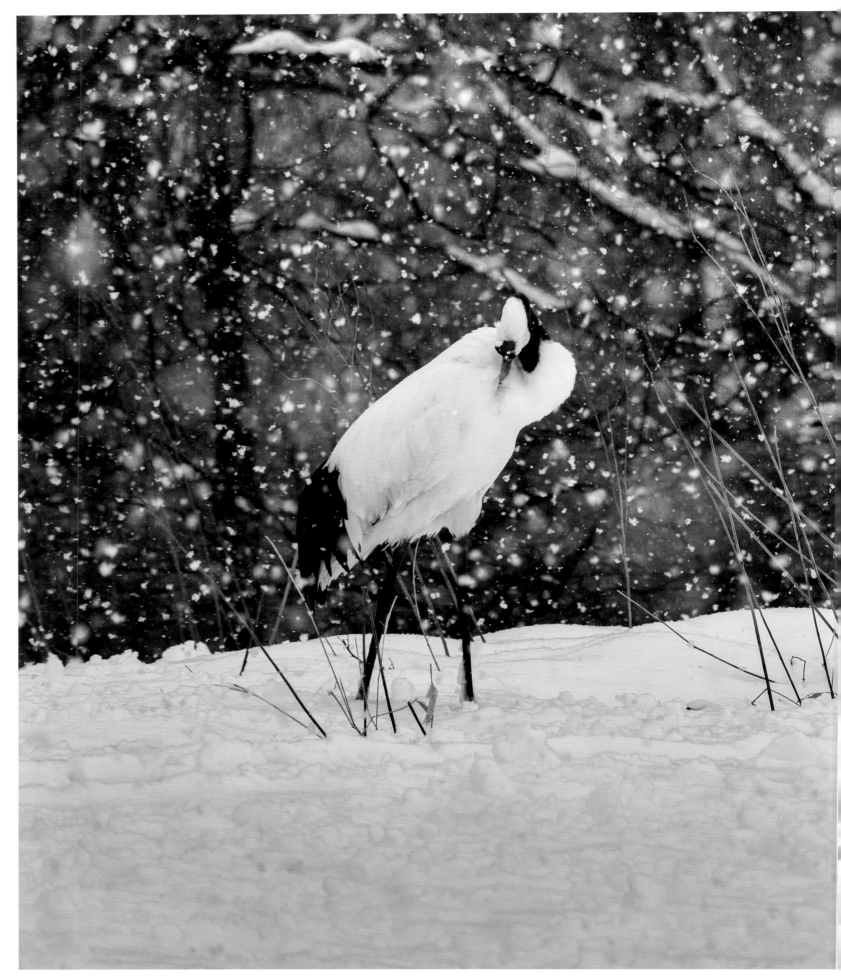

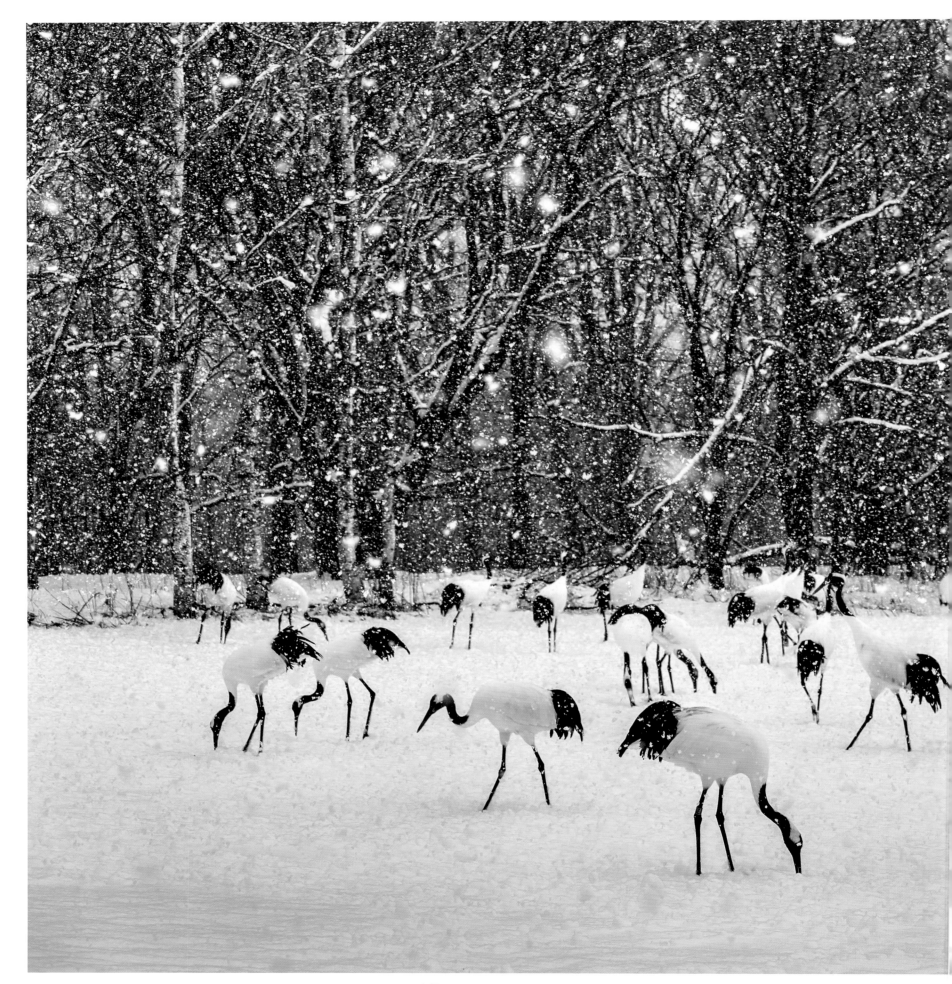

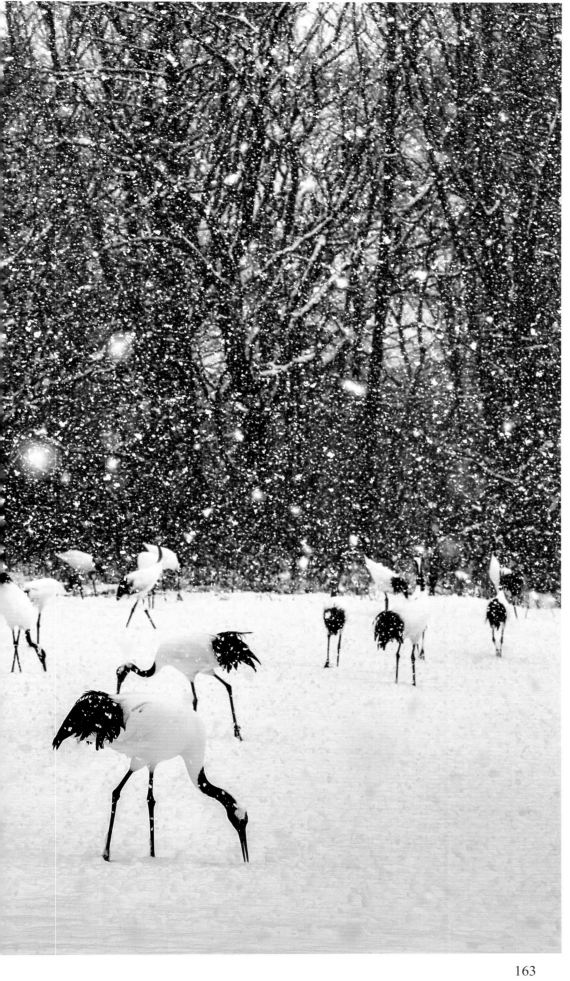

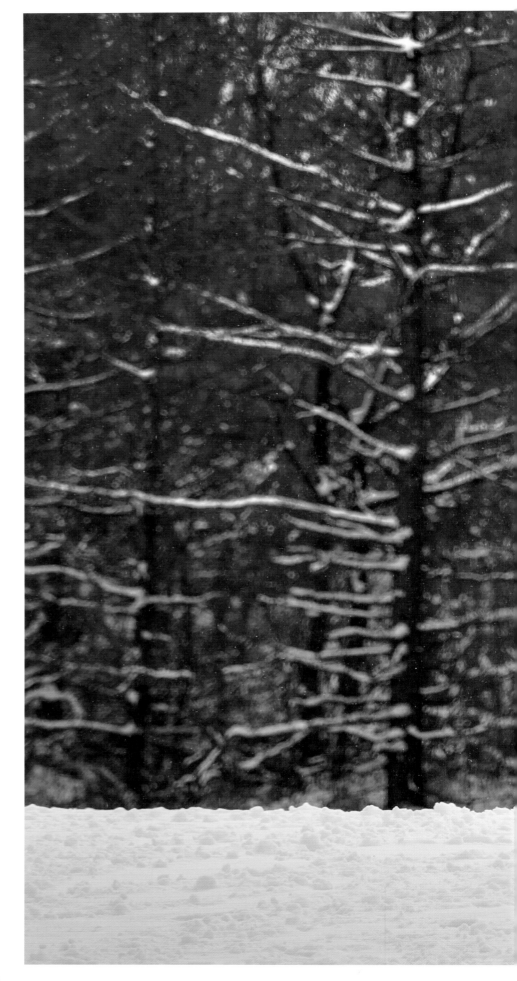

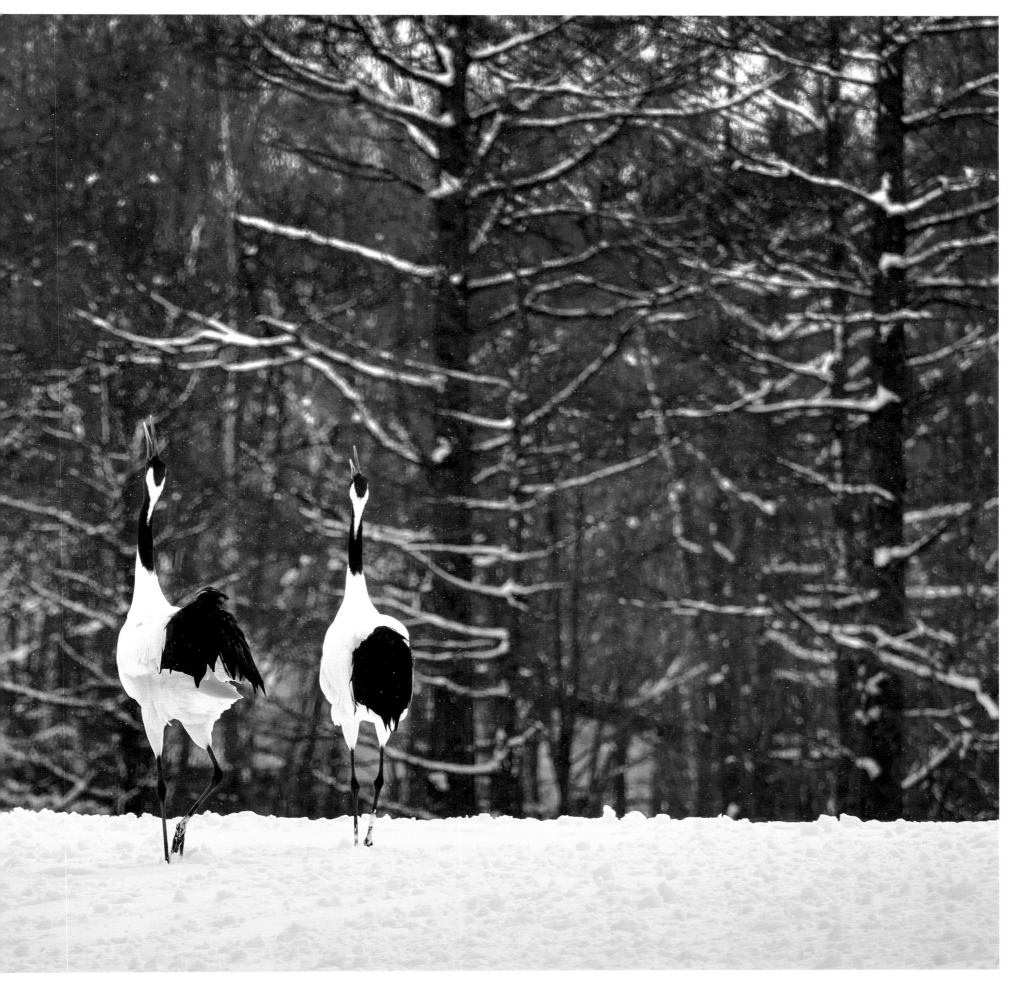

朱泓熹

1967 年生，台北人。

1989 年，入香港環球首飾公司（UBM, Jewellery AsiaNet）學習珠寶設計。

1998 年，創立蓮華軒（Home Lotus），志於藝術精品文物、佛教七寶的蒐藏與交流；
　　　　並精於寶石鑑定與設計。

1989-1999 年，擔任國立故宮博物院展覽組玉石類導覽義工。

1999 起，擔任法鼓山工務所攝影義工。

2013 年，「瑠璃世界」朱莉攝影個展／爵士攝影藝廊。

2013-15 年，「台北藝術攝影博覽會」台北。

2013 年，「台北攝影節」華山 1914 文創園區。

2014 年，「馬年大吉」攝影展／臺北市立社會教育館。

2014 年，「與佛有緣」朱莉弘體寫經展／國立國父紀念館。

2015 年，「福爾摩沙國際藝術博覽會」台北寒舍艾麗酒店。

2016-17 年，「書攝不二」朱莉書法攝影作品展／江蘇泰州南山律寺。

2021 年，台北 94 藝廊攝影個展。

著作：

《佛偈佛影》（2003），結合書法與攝影，記錄 1993 年至 2003 年的佛教聖地光影。

《師偈師影——聖嚴法師掠影集》（2009），感念恩師的心性導引。

後 記

從小，並沒有立志要成為一位攝影家。不可思議的因緣 ，卻將我一步步推向攝影的「不歸路」。然而，這路上風景誘人， 處處蘊藏著正能量。原來，拍照按快門也與掐念珠念佛無異！可使煩惱漸斷，智慧漸開！是自利利他的修行法門。

Postscript

I didn't aspire to be a photographer when I was a child. However, a remarkable fate led me towards photography, and I chose the road of no return. The scenery along that road has been extraordinary, and I've found positive energy everywhere I went. Finally, I've found out that taking a photo by pressing the shutter is little different from running prayer beads through your fingers and reciting prayers to Buddha! It becomes a habit, a ritual, that gradually reduces our worries and opens us up to wisdom. It is a religious practice that is of immense benefit to myself and others.

攝 不異空

朱泓熹　行攝 30 精選集

A Collection of Photography by **Hung-hsi, Chu**
30 years of Travel Images

Origin31

作者　　　　朱泓熹　0922 888 333
　　　　　　hunghsichu19670108@gmail.com

英文翻譯　　杜文田
美術編輯　　賴永鑫
影像處理　　莊哲祥
編輯協力　　李璧苑、謝翠鈺
企劃　　　　陳玟利

出版　　　　動向企管顧問有限公司｜統一編號 84793835
　　　　　　330004 桃園市桃園區北新街80號

董事長　　　趙政岷
出版發行　　時報文化出版企業股份有限公司
　　　　　　108019 台北市和平西路三段240號七樓
　　　　　　發行專線｜02-2306-6842
　　　　　　讀者服務專線｜0800-231-705｜02-2304-7103
　　　　　　讀者服務傳真｜02-2304-6858
　　　　　　郵撥｜1934-4724 時報文化出版公司
　　　　　　信箱｜10899 台北華江橋郵局第九九信箱
時報悅讀網　www.readingtimes.com.tw
電子郵件信箱　ctliving@readingtimes.com.tw
法律顧問　　理律法律事務所｜陳長文律師、李念祖律師
印刷　　　　虹舍藝術印刷事業有限公司
初版　　　　2023年1月20日
定價　　　　新台幣2600元

攝不異空：朱泓熹行攝30精選集 = A collection of
photography by Hung-hsi,Chu 30 years of travel
images/朱泓熹作. -- 一版. -- 臺北市：時報文化出版企
業股份有限公司, 2023.01
　　面；　公分. -- (Origin；31)
ISBN 978-626-353-401-8 (精裝)

1.CST: 風景攝影 2.CST: 攝影集

957.2　　　　　　　　　　　　　　　　111022022

ISBN 978-626-353-401-8
Printed in Taiwan

缺頁或破損的書，請寄回更換